LATERAL THINKING

Catalogue entries by

Tamara Bloomberg

Miki Garcia

Stephanie Hanor

Toby Kamps

Kelly McKinley

Rachel Teagle

Preface by Hugh M. Davies

Essay by Toby Kamps

Museum of Contemporary Art San Diego

LATERAL THINKING

ART OF THE 1990S

Published on the occasion of the exhibition *Lateral Thinking: Art of the 1990s*.

Lateral Thinking: Art of the 1990s is organized by the Museum of Contemporary Art San Diego. Major support has been provided by the National Endowment for the Arts, a federal agency, and MCASD's stART Up members. Additional funding comes from The James Irvine Foundation, the City of San Diego Commission for Arts and Culture, the County of San Diego, the California Arts Council, and the Institute of Museum and Library Services.

NATIONAL
ENDOWMENT
FOR THE ARTS

California
Arts Council

Exhibition Itinerary

Museum of Contemporary Art San Diego
La Jolla, California
September 16, 2001–January 13, 2002

Colorado Springs Fine Arts Center
Colorado Springs, Colorado
September 27, 2002–January 4, 2003

Hood Museum, Dartmouth University
Hanover, New Hampshire
January 3–March 14, 2004

Dayton Art Institute
Dayton, Ohio
July 17–October 17, 2004

ISBN: 0-934418-60-8 (hardcover)

ISBN: 0-934418-61-6 (softcover)

Library of Congress Control Number: 2001099800

Available through D.A.P./Distributed Art Publishers, 155 Sixth Avenue, 2nd Floor, New York, NY 10013, Tel: (212) 627-1999 Fax: (212) 627-9484

Edited by Patricia Draher Kiyono
Designed by John Hubbard
Coordinated by Stephanie Hanor
Produced by Marquand Books, Inc., Seattle
 www.marquand.com
Color separations by iocolor, Seattle

All photographs by Philipp Scholz Rittermann unless otherwise indicated below.

p. 115 (above), courtesy Roger Ballen; p. 118 (above), courtesy Bonakdar Jancou Gallery, New York; pp. 9, 126 (below), Becky Cohen; cover, pp. 20 (above), 42–43, Todd Eberle; p. 124 (above), courtesy Sean Kelly Gallery, New York; pp. 17 (above), 20 (below), 21, 26–27, 30, 45, 50, 51, 68, 71, 73, 78, 79, 92, 95, 116, 119 (below), 121 (below), 130, 134 (above), Pablo Mason; pp. 24, 136 (below), Frank Oudeman; p. 8 (left), Muzammil Pasha, Reuters, Timepix; p. 97, courtesy Marcos Ramírez ERRE; p. 133 (below), courtesy Armando Rascon; p. 8 (right), Sayed Salahuddin, Reuters, Timepix; p. 128 (above), Gareth Winters; p. 123 (below), courtesy Zindman/Fremont.

Cover: Vanessa Beecroft, *VB 39, U.S. Navy SEALS, Museum of Contemporary Art San Diego, 1999*, 1999 (see pp. 42–43)

Title page: Gary Hill, *Learning Curve (still point)*, 1993 (see p. 63)

Page 12: Mark Dion, *Landfill (detail)*, 1999–2000 (see p. 121)

Pages 26–27: James Drake, *Que Linda La Brisa/How Lovely the Breeze (Samantha and Jacaranda)*, 1999 (see p. 51)

Pages 112–113: Gary Simmons, *Gazebo*, 1997 (see p. 135)

Back cover: Edward Ruscha, *Better Get Your Ass Some Protection*, 1997 (see p. 103)

Endsheets: Roman de Salvo, *Power Maze with Sconce*, 1998 (see p. 46)

Printed and bound by CS Graphics Pte., Ltd., Singapore

CONTENTS

PREFACE: BEYOND BAMIYAN

"What kind of art will artists be making in the next ten years?" Museum directors and curators are asked this question all the time, and the honest answer is that we haven't a clue because artists are nothing if not unpredictable (ergo *Lateral Thinking*). When pressed, it's always safe these days to say something like, "Well, while video and photography as tools for art-making are clearly in ascendancy, it is also true that artists still persist with the great abiding subjects like life and death."

The artwork that immediately comes to mind is Bill Viola's *Heaven and Earth* (1992)—a brilliantly succinct statement that perfectly melds contemporary technology with a timeless theme. Paired, facing monitors, aligned in a broken vertical column, host mirrored slow-moving video images of the artist's mother and son at the respective transitional moments of death and birth. The gap generated between the two curved screens is like a huge sparkplug; the empty, charged space is the void bridged by the father, son, and artist. This masterpiece—more specifically, the form and presentation of the video installation—would be unimaginable before Viola. Yet its powerful emotional content—the grand theme of filial and paternal love—can reassuringly be traced back through a succession of great artists to the very earliest impulse to record our presence through the act of making art. It is precisely Viola's ability to represent and reinvent this abiding theme, and thereby give it renewed relevance for our time, that marks his genius.

Lateral Thinking: Art of the 1990s is a selective overview of art made in the past decade. This culling of works, purchased by or donated to the museum since 1990, is the residue of ten years of intense exhibition and program activity in an ongoing curatorial attempt to sort out the artistic ideas of our time. It is also an institutional portrait and the product of many people's work, thinking, and generosity. Certainly not all the works represented will survive the test of time and remain relevant and valued in the decades ahead. Yet, if we have done our work well, many of these works will prove to be part of a useful legacy and document of the times we have lived through. In the present viewing, they should provoke thinking and discussion as we take stock of our place in history at the beginning of a new millennium.

Looking back and surveying the art of the past decade is probably as useful a tool as any for divining the art of the future. Earlier twentieth-century art historians would have led us to believe that the messy progress or evolution of modern art in the past century unfolded in logical, tidy, decade-long "isms"—Cubism, Surrealism, Abstract Expressionism. While this simple conceit is a convenient handle on the unruly unfolding of art, the illusion of consistent movements emerging in orderly succession has been hard to maintain since the advent in the 1960s of Pop Art and Minimalism. The most recent attempts at "isms," Neo-Expressionism and Postmodernism, reveal an eroding confidence in the category game, as both refer backward to art of earlier times. Even today, while critics still talk of post-identity in the hope of naming the zeitgeist, most would acknowledge that the prospect of ever limiting the global art world to one "ism" is hopelessly nostalgic and undesirable. In truth, the earlier categories were undoubtedly an attempt to protect the viewer from the confusion of the sausage-making that art-making really is, and a laudable effort to bring order after the fact.

Indeed, the art of the last thirty years is best characterized as an artistic free-for-all: the messy vitality of individual artistic free expression unfettered by precedent or

expectation, as exemplified in the work of Bruce Nauman and Robert Gober. Both are brilliant artists who harness a broad range of technologies and techniques to hone in on messages and emotions as multivalent and complex as the world they inhabit.

The title *Lateral Thinking* is a tacit admission that our collecting activity is not and could not be logical and linear. The decade just passed is too close for us to easily assess, and the artists with whom we have worked are, thankfully, much too complex to submit to such simple sorting out. As an institution, the museum continually tries to put itself at the service of artists by following their lead and providing support for their experiments. By exhibiting, acquiring, and interpreting their work for diverse audiences, our museum helps to advance the art of our time through serving as a primary and active patron to living artists. While we undoubtedly run the risk of failing to showcase important and underrecognized artists (most painfully those who may be in our own community), it won't be for lack of looking. If we have a credo, it is to show enthusiasm for a new artist, at the risk of being premature, rather than to fail by withholding approbation. The greatest sin for a contemporary museum would be to show only established artists and thereby play no role in the discovery and support of new talent.

Lateral Thinking also obliquely alludes to latitude and longitude, more specifically to an axial shift in geography and point of view that has occurred at the museum over the past two decades. The long-held and previously unquestioned perspective of an east-to-west intellectual axis, of looking back to New York and Europe for our artistic lead and inspiration, has been aggressively replaced by an emerging north/south intellectual and artistic axis. This new emphasis has led us progressively to work with artists of our own San Diego/Tijuana twin cities (the multidisciplinary art initiative *Dos Ciudades/Two Cities*, 1989–1993); with border artists (the traveling exhibition *La Frontera/The Border: Art about the Mexico/United States Border Experience*, 1993–1994), and now, increasingly, with the growing ranks of strong artists from throughout Latin America (the traveling exhibition *Ultrabaroque: Aspects of Post–Latin American Art*, 2000–2001). Rather than viewing ourselves as occupying a marginal position in the lower left-hand corner of the United States, we in San Diego/Tijuana revel in our pivotal role straddling the most heavily trafficked international border in the world. We are centrally poised at the critical isthmus of north and south, of First and Third Worlds, of trade in goods and exchange of both people and ideas that will define the "new world order" of the current millennium.

Artists also think laterally. They find the inspiration for reinvention and revelation in innovation or creativity—"thinking outside the box"—attempting to escape the convention of rational, linear thinking. Robert Gober's *Drains* (1990) provides an ideal example of how an elegantly simple but extraordinarily radical perceptual shift can provoke profoundly new intellectual and emotional understanding. By changing from horizontal to vertical the orientation of a mundane utilitarian device—the ubiquitous "found object" of a household drain—Gober both cancels the function and transforms the meaning. Inserted in the wall at eye level, *Drains* confronts the viewer as an alien orifice that seems to suck the very air from the containing room. The drain's cross hairs imply a target, and the darkness beyond evokes the abyss. Gober, openly gay, alludes elliptically to the scourge of AIDS as draining our culture—the disorienting axial shift thereby creating a powerful metaphor for loss.

Post–September 11, one looks for harbingers in art and other sources that might have predicted such terrible events. We are told that "HUMIN" (human intelligence at the CIA) and antiterrorist strategists could not conceive of a coordinated threat such as multiple, suicide plane hijackers. Yet, in our popular culture, an abundance of B movies, pulp fiction, and graphic video games have been attacking the World Trade Center for years. If not the dastardly acts themselves, perhaps the motivation—the fundamentalists' fervent hatred and dedicated, evil planning—is most difficult for our Western minds to fathom. Yet the current hazy sense of unease, the vague dread, the anxiety about airplanes and anthrax we all now experience are familiar to those who have lived with AIDS. As James Atlas, writing in *The New York Times* (October 7, 2001), pointed out, "Like AIDS and other deadly viruses that traverse international borders aboard jet aircraft, terrorism thrives on mobility."

Perhaps the greatest current threat to our culture and way of life is to underestimate the profound resentment of and hatred for America that permeates the thinking of millions of people in the Third World. We must not make the fatal myopic mistake of assuming that, by weeding out a few Taliban terrorists, we can return peace to the garden; we must recognize that the earth itself has become toxic. For too many years, we have consumed more than our fair share of the earth's bounty (see Mark Dion's *Landfill*, 1999–2000). The resulting enormous discrepancies between rich and poor have reached the breaking point. Far too many people have little to lose and some, in anger, will pursue any extreme to prevent us from enjoying the fruits of life as we know it. Nothing less than a vast redistribution of global resources and opportunities will create a climate that allows poor Palestinians, Rwandans, Mexicans, and Afghans to believe that democracy is preferable to jihad.

Another insidious challenge to the open society we defend is the antimodern fundamentalism of Islam, Christianity, Judaism, or any other intolerant strain of extreme

8

belief. We must be vigilant and recognize that the danger of closed-minded blind faith is as great from the likes of Bible-thumping Pat Robertsons as it is from Koran-quoting Bin Ladens. The unchallengeable *fatwa* echoes the Protestant preacher's condemnation to fire and brimstone. Yet the struggle, the separating abyss, is not so much between religions as between cultures. On one hand, there are those who embrace the progress and optimism of the modern world and revel in the resulting liberation of thought and deed; on the other hand are those who would reject such personal freedoms and turn back to a medieval time of institutionally imposed limits on belief, thought, and action.

The clear warning of a virulent religious intolerance came in March 2001 when the Taliban ordered the destruction of two giant ancient Buddhas carved into the cliff overlooking the fertile valley of Bamiyan. This government-ordered act of iconoclastic intolerance—the destruction of the most revered holy images of another faith—was a terrifying example of regression and a fateful harbinger of evil acts to come.

The before and after photographs of the Bamiyan Buddhas show timeless religious art brutally reduced to meaningless modern rubble. The negative void, the frame violently emptied of all content and meaning, can be countered by the liberation of mind and the expansion of perceptual possibilities emblematic in the exuberant embrace of the positive void in Robert Irwin's breakthrough art work, 1°2°3°4° (1997). This powerful artistic antidote—literally a breath of fresh air, an opening of possibilities, the infinite clear blue field seen through the window, framing context familiar since the Renaissance—presents optimistic and reassuring evidence that, in part through art, the forces of light will indeed prevail over a return to darkness.

Hugh M. Davies
The David C. Copley Director
October 20, 2001

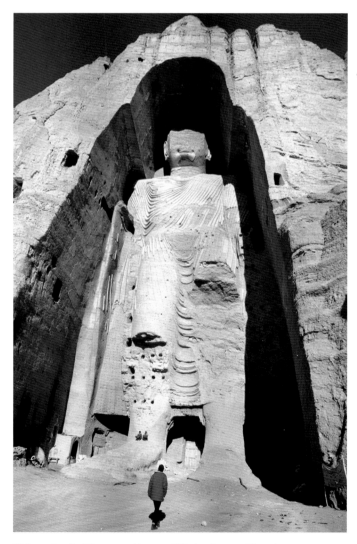

Visitors view Buddha statue, Muzammil Pasha, Reuters, Timepix

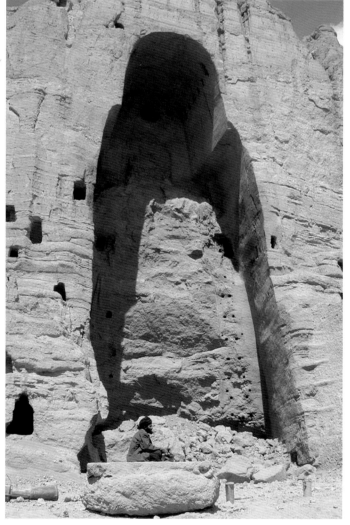

Taliban fighter sits on rubble, Sayed Salahuddin, Reuters, Timepix

OPPOSITE: Robert Irwin, 1°2°3°4°, 1997

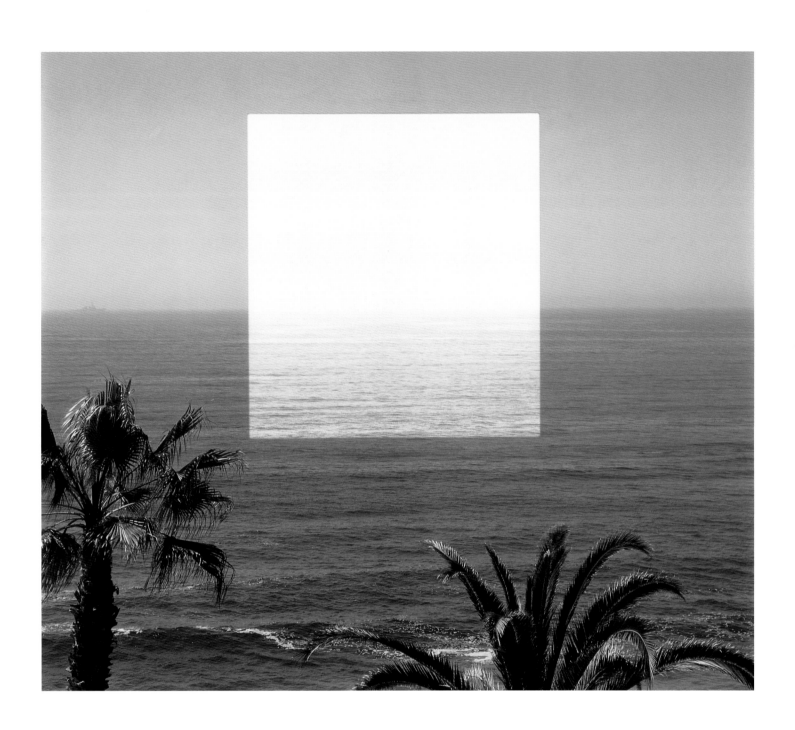

Lateral Thinking: Art of the 1990s examines the activities of the Museum of Contemporary Art San Diego, by surveying a diverse group of international artists who created new work during a complex and dynamic decade. This publication, which accompanies the traveling exhibition of the same name, is the third collection catalogue our museum has produced. With its predecessors, published in 1989 and 1996, it provides a unique perspective on our curators' decision making over the last decade of the twentieth century. The 1990s—sandwiched between the hype of the 1980s and the millennial angst of Y2K—was a time of upheaval and innovation. During that period, MCASD organized more than ninety-five exhibitions of contemporary art and acquired or commissioned some 265 works of art made during the decade. The selection represented in these pages exemplifies the most central goal of MCASD: to serve as both a repository for the art of our time and as a catalyst for the creation of new art—regionally, nationally, and internationally.

Major support for *Lateral Thinking* has been provided by the National Endowment for the Arts, a federal agency that has championed museums like ours for more than thirty years. By its sponsorship, the Endowment recognizes the responsibility museums have to foster creativity and collect and preserve works of art for the future, and to make their collections widely accessible through projects such as this. Likewise, the California Arts Council has been a strong supporter of our museum's educational efforts for many decades, this exhibition and publication being no exception. Additional funding has come from the City of San Diego Commission for Arts and Culture, and the Institute of Museum and Library Services. For the continued support and encouragement of these enlightened government cultural agencies, we are grateful.

Lateral Thinking has benefited greatly from the contributions of the museum's International Collectors and Contemporary Collectors, our highest-level donor groups, over the past seventeen years. Since 1985, the Collectors have contributed in aggregate more than $3 million toward the purchase of fifty-eight works, thereby making an indelible mark on the museum's collection. Twenty of the fifty-one artworks in this exhibition came by way of the Collectors' support. Without question, their intelligent, spirited engagement with the art of their time has contributed greatly to the life of this institution, and we are most appreciative.

As always, a project of this size and scope depends on the efforts of many dedicated and knowledgeable individuals. I especially want to thank our Curator, Toby Kamps, who oversaw all aspects of the project and contributed an incisive essay summarizing the artistic ideas behind a decade whose outline is only now becoming legible. Toby was ably supported by his curatorial team, including Assistant Curators Stephanie Hanor and Rachel Teagle, Registrar Mary Johnson, Research Assistant Tamara Bloomberg, Registrarial Assistant Meghan McQuaide, Curatorial Coordinator Tracy Steel, Education Coordinator Gabrielle Bridgeford, Curatorial Assistant Kim Schwenk, Chief Preparator Ame Parsley, Preparator Dustin Gilmore, former Curator of Education Kelly McKinley, former Librarian Amy Schofield, and former Curatorial Intern Miki Garcia. Elizabeth N. Armstrong, former Senior Curator, contributed to the project's earliest stages. Nearly all museum staff members have worked on this exhibition and catalogue in one way or another. Their names are listed at the back of this book,

and—on behalf of Toby Kamps—I extend my deep gratitude to them all.

In producing this catalogue, Philipp Scholz Rittermann expertly photographed dozens of works of art, creating in the process a first-rate visual document of the permanent collection. Stephanie Hanor ably coordinated the production of the catalogue, while Lynda Forsha, our former Curator, made many contributions toward the book's content and handsome design. She was also the primary contact with John Hubbard of Marquand Books, who is responsible for the catalogue design and production. Marquand Books, under the leadership of Ed Marquand, has been responsible for all three collection catalogues to date, and we are grateful for the careful attention each publication has received. We would also like to thank Patricia Draher Kiyono for her wise editorial counsel.

I am especially pleased that *Lateral Thinking* will be seen in a number of communities around the United States, thus sharing the museum's curatorial vision with a larger audience. I gratefully acknowledge my colleagues at the institutions that are presenting the exhibition: Cathy Wright, Director of the Colorado Springs Fine Arts Center; Derrick R. Cartwright, Director of the Hood Museum, Dartmouth College, Hanover, New Hampshire; and Alexander Lee Nyerges, Director of the Dayton Art Institute, Ohio.

Assembling an important collection of contemporary art is possible only through the generosity of individuals, foundations, businesses, and government agencies, all of whom enable a dedicated staff and volunteers to do their jobs. The *Lateral Thinking* exhibition and catalogue are testaments to the generosity of the museum's patrons and the professional skills of its staff. The Board of Trustees of this museum have wholeheartedly supported the kind of "lateral thinking" that has resulted in a collection which is uniquely ours. For their generous support and wise leadership, I express thanks on behalf of the future generations who will learn from and experience the visions and expressions of the artists represented in this publication.

Hugh M. Davies

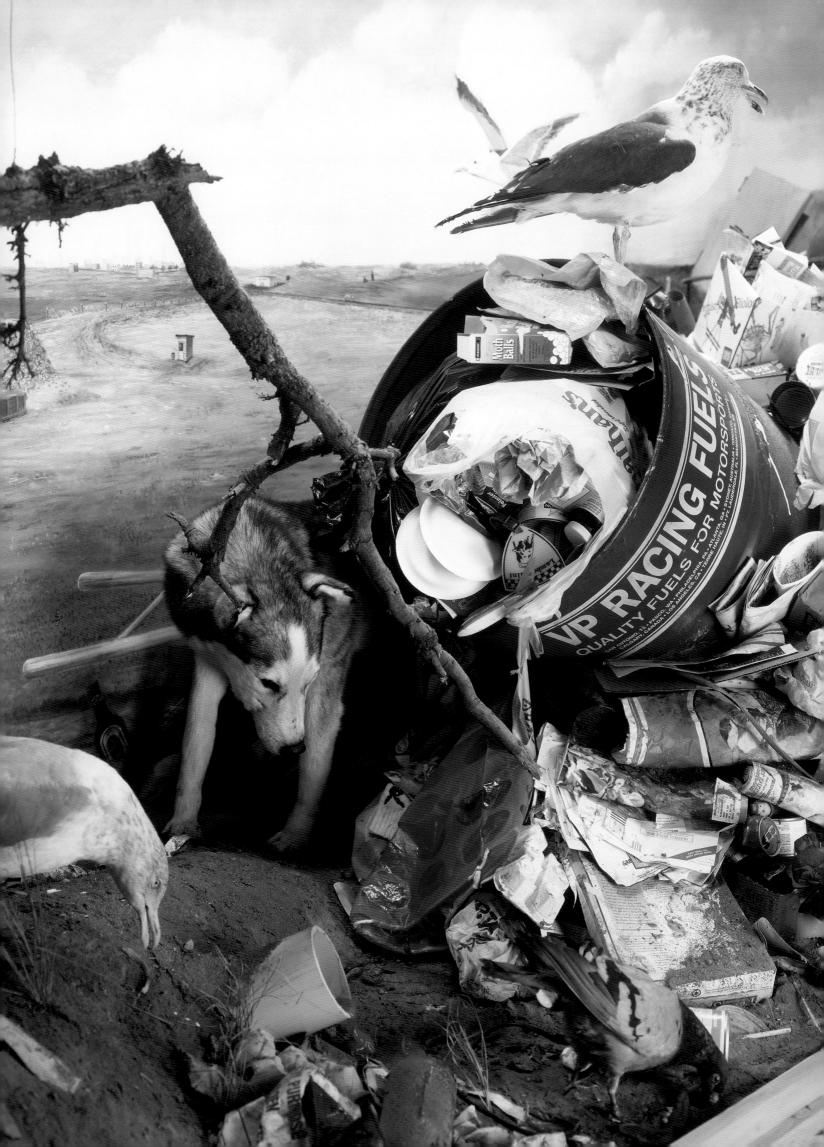

LATERAL THINKING:
ART OF THE 1990S

Toby Kamps

Sometime in the final months of the second-to-last decade of the previous century, actor and photographer Dennis Hopper exclaimed, "The nineties are going to make the sixties look like the fifties!" Today, Hopper, whose drug-addled character Billy in the film *Easy Rider* has become an icon of the chaotic 1960s, could not appear to have been more wrong, about life in the United States at least. In this country, the decade of safe sex, day trading, and power yoga was accompanied by little of the social turmoil seen by the decade of free love, draft dodging, and civil-rights crusading. Instead, with its prevailing focus on prosperity and peace (excepting the glitch of the Gulf War), the United States of the 1990s appeared to have more to do with 1950s-style industry and expediency—albeit of a more diverse and fractious cast—than with 1960s-style struggle and change.

On a global scale, however, Hopper's prediction of mind-blowing revolution was dead-on. Although not always utopian in aim and seldom resolving old-fashioned problems of war, famine, or poverty, vast political and technological changes dramatically transformed life around the world. Numerous peaceful and violent revolutions and clashes changed global boundaries and balances of power. Tremendous medical and scientific discoveries advanced our understanding of the body and the world. Global expansions of business and stock markets reformed the ways we generate and distribute wealth. And new computing and communication technologies changed the ways we collect and share information.

Although Dennis Hopper probably did not intend to graph social evolution when he made his tongue-in-cheek prognostication, he comically anticipated the difficulties of defining the 1990s. Coming at a crucial point in history—the end of the second millennium—the decade was marked by discord. Old models for understanding society were exhausted, and enormous aspirations were accompanied by intractable disconnects. Despite tremendous advances, individuals and societies, First and Third Worlds, and humans and the environment seemed increasingly at odds. People appeared bewildered by the directionlessness of their moment. (In a U.S. Postal Service survey, the top three choices to illustrate the stamp commemorating the decade were cell phones, the movie *Titanic*, and endangered species.)[1] Today, the objective history of the 1990s is a matter of record, but we are only beginning to grasp its emotional history—its temperament and spirit.

Lateral Thinking: Art of the 1990s attempts to define a decade through visual art. This exhibition and publication project of the Museum of Contemporary Art San Diego illuminates the products and intentions of an important international group of painters, sculptors, photographers, installation makers, and video artists active in the 1990s. The selected works of art—purchased, commissioned, or received as donations by the museum—suggest a range of concerns shaping a complex period, the dynamics of which continue to unfold and affect life today.

The title of this exhibition borrows the term "lateral thinking," coined by British educational philosopher Edward de Bono to describe alternative reasoning strategies. Traditionally, de Bono says, ideas evolve through sequential processes; a hypothesis is tested through a set of logical, linear inquiries. Transformational leaps of inspiration are possible when insight and humor are used to restructure conventional patterns: "Vertical thinking follows the most likely paths, lateral thinking explores the least likely. . . . With lateral thinking, one uses information not for its own sake but provocatively in order to bring about repatterning."[2] This valorization of curiosity, synergy, and serendipity—factors central to all forms of creativity—appealed to the curatorial team at MCASD. It seemed appropriate to a decade in which artists looked beyond conventional styles and movements for new forms of expression.

The term also illuminated the museum's attempts to, using a 1990s phrase, "think outside the box." Throughout its more than sixty-year history, the museum's challenge has been to represent important international, national, and regional developments while also serving as an independent catalyst for the creation of new art and artistic debate. Employing its own form of lateral thinking—a kind of free-ranging cultural scanning—the museum participates in important mainstream dialogues and brings attention to significant new artists and developments as well as to established but underexamined figures and movements. Before discussing the hard evidence of MCASD's endeavors—the 1990s works in its permanent collection—it is useful to briefly consider some of the factors affecting the real world and the art world during the decade.

THE REAL WORLD

The changes on the global stage in the early 1990s were enormous. Beginning in 1989 with the voluntary dissolution of Communist rule in Hungary and Poland, the remaining European Socialist nations of East Germany, Yugoslavia, the Soviet Union, Czechoslovakia, Romania, Bulgaria, and Albania all switched to market-driven democracies, occasionally fragmenting or uniting into new or historically established nations in the process. At the same time, the Republic of South Africa began dismantling its racist system of apartheid, representative governments were established in Argentina, Chile, Paraguay, El Salvador, and Nicaragua, and peace seemed possible in the Middle East and Northern Ireland. These astonishing events, many of them unimaginable only a few years earlier, led many to believe that the world stood at the edge of a new, utopian epoch.

A group of scholars and elected officials, led by Francis Fukuyama, a U.S. Department of State policy planner, proposed that civilization had reached a new point on the evolutionary curve.[3] In the influential 1992 book *The End of History and the Last Man*, Fukuyama presented an optimistic interpretation of the change fulminating in Europe and around the world: "What is emerging victorious, in other words, is not so much liberal practice as the liberal idea. That is to say for a very large part of the world, there is now no ideology with pretensions to universality that is in a position to challenge liberal democracy, and no universal principle of legitimacy other than the sovereignty of the people."[4] Today, after the terrorist attacks of September 11, 2001, and after a decade marked by bloody conflicts in the former Yugoslavia, Rwanda, and across the globe, the world seems as treacherous and volatile as ever.

Fukuyama's analysis, however, does reflect the beginning of what has been called a postideological age. The binary opposition of capitalism and communism, whose deadlock over how to allocate wealth proved so useful in dividing the globe into spheres of influence and assigning meaning to national struggles, has not been replaced by another overarching system. In this vacuum, market-driven economic and business movements (including neoliberalism, globalization, and "new economy" stock speculation), speeded by new communication technologies, wrested sovereignty from nations and increased disparities between rich and poor. The attention of nations and individuals also shifted from externally imposed concepts such as class and economics to more personal themes of identity and culture. Worldwide, there has been a tendency toward balkanization—fragmentation, nationalism, and distrust based on immediate, strongly felt, personal, or cultural principles like religion, ethnicity, gender, and even lifestyle.

Of course, whether you were a software engineer in Seattle, an artist in London, or a pensioner in Minsk had a lot to do with how you experienced the 1990s, but it is possible to make a few generalizations about the period. Fin-de-siècle periods commonly mix exuberance and anxiety, and the last decade did so with extra millennial gusto. In industrialized nations, ordinary citizens led lives of air-conditioned, cruise-controlled, and fully cabled luxury that would make the Vanderbilts envious. The internet and cell phones allowed them to live and work at unprecedented speeds and to access mind-boggling amounts of information. Yet these same technologies enabled mass retreat from public life into home-entertainment cocoons. Sensationalistic media spectacles like the Los Angeles riots, the O. J. Simpson trial, and the Monica Lewinsky scandal sparked bitter conflicts among individuals and communities over values, cultural differences, and the relative nature of truth itself. At the same time, in the poorest nations, famine, AIDS, and religious fundamentalism often reversed decades of progress.

Gabriel Orozco, *Melted Popsicle*
(Paleta derretida), 1993

The year 1990 was an *annus horribilis* for contemporary art in the United States. Three years after the stock market crash of 1987, prices at major New York auctions plunged precipitously during a brief global recession that hit Japan, a major art-buying country, particularly hard. This drop hurt markets for contemporary art and virtually ended the widespread practice of buying new and historical works as investments. Galleries around the world closed their doors, and a generation of young art stars, accustomed to sellout shows, found themselves with dramatically reduced markets.

In the same year there began a protracted clash surrounding the National Endowment for the Arts and the idea of public funding for art. Reacting to the controversies surrounding a traveling exhibition of sexually explicit photographs by Robert Mapplethorpe that received federal funding, NEA director John Frohnmayer vetoed approved grants for the sexually frank work of performance artists Karen Finley, John Fleck, Holly Hughes, and Tim Miller. The artists sued and eventually won the amount of their original grants as a settlement, but the NEA was forever changed. A clause requiring grantees to take into consideration "general standards of decency and respect for the diverse beliefs and values of the American public" became part of their contracts, and by 2001, the agency's annual budget was $97.6 million, down from $171.2 million in 1990.[5] Today art-presenting organizations, especially in the performing arts, still feel the impact of reduced federal support and the loss of an important fund-raising seal of approval.

Always adept in the ways of social Darwinism, however, the art world adapted to the changes of the early 1990s, gaining considerable commercial momentum and changing the face of art in the process. By the mid-1990s, Soho, home to New York's vanguard galleries since the 1960s, was overrun by designer clothing boutiques, but Chelsea, the old meatpacking district, boasted dozens of serious and successful galleries. And vibrant new scenes and markets evolved in Los Angeles, Berlin, and London. Artists continued to wrestle with perennial subjects such as the body, society, and the built and natural environments. They also created new images and objects that cut to the heart of life during that decade. Although the range of artistic endeavors in the 1990s was broad, a few characteristics emerge as salient.

THERE WAS A MOVEMENT AWAY FROM THEORY.

In a chastened market and an ideologically uncertain moment, artistic strategies of the 1980s—appropriation, critiques of commodification, deconstruction—seemed empty or calculating. Instead, artists took up accessibility, communication, humor, and play. As a style, Postmodernism, positing stylistic eclecticism, social criticism, and end-of-history irony, appeared bankrupt; as an attitude, however, it was the definitive zeitgeist. The art of the 1990s, with its interest in complexity, multivalency, and ambiguity, mirrored an uncertain, transitional period.

THE ART WORLD BECAME MORE DIVERSE.

According to critic Jan Avgikos, "The '90s was the first time ever in which the legions of artists—gay, lesbian, female, persons of color, and scores of disenfranchised others—previously denied voice were admitted into the institutions of art."[6] Although often expected to articulate their differences, many women, racial minorities, and sexual "others" joined the exhibition rosters at museums and galleries.[7]

CREATIVE PRACTICE EXPANDED.

Many 1990s artists viewed the studio as a laboratory for ideas rather than a source of definitive statements. They employed handmade processes, community interaction, and intentionally self-deprecating themes to lay bare the creative process. (Some faulted these low-budget and occasionally low-ambition approaches for a lack of critical focus; others saw a promising movement away from elitism and toward everyday relevance.) Not limiting their practices to any one "signature" medium, many artists moved between sculpture, painting, photography, installation, film, and performance, and ventured into the fields of design, clothing, and architecture.

NEW TECHNOLOGIES PRESENTED EXCITING OPPORTUNITIES.

Computers became essential tools. Artists used digital cameras, scanners, and graphic design programs to collect or construct imagery for work in new media, for the Web, and as purely digital media. Video became a predominant medium, while sophisticated and affordable formats along with powerful editing and projection systems allowed artists to rival the totalizing worldview of film directors.

OLD TECHNOLOGIES TOOK ON NEW LIVES.

Despite being pushed to the brink of obsolescence by digital-imaging technologies, photography experienced a tremendous flowering in the 1990s. New large-scale color printing techniques, widespread interest in real life as a subject, and commercial acceptance transformed photographers into the equals of painters and sculptors. Painting, too, whose long-rumored demise seemed possible after the brushy excesses of 1980s movements like Neo-Expressionism, Neo Geo, and graffiti art, enjoyed a renaissance, as artists, freed from stylistic hegemonies, explored the medium.

THE PERMANENT COLLECTION

What do the 265 paintings, sculptures, photographs, drawings, prints, videotapes, installations, and other works from the 1990s in MCASD's permanent collection tell us? First, they reflect the history of the institution, of course, since many were purchased from or commissioned for exhibitions at the museum. Then, like all works of art, they address timeless subjects such as the human figure, landscape, and history. Third, they reveal the preoccupations of our time—the themes and ideas shaping life at the end of the twentieth century. Here are some of those timely themes and works that reflect them.

Doris Salcedo, *Untitled*, 1995 (detail)

MEMORY

The act of remembering assumed a new urgency during the 1990s. The fact that long-held ideas of historical cause and effect were eroding, combined with a state of continual information overload, challenged individuals to piece together coherent pictures of world events. Artists zeroed in on the gaps, the ignored, and the unseen in their attempts to find human-scale points of leverage on the continuum of history.

By imbuing everyday objects with powerful emotions, Colombian sculptor Doris Salcedo envisions a new form of commemorative art. In her untitled work of 1995, Salcedo draws on the stories of the *desaparecidos* (disappeared ones) killed in her country's drug wars. She transforms a common wooden wardrobe into a chilling memorial by sealing its seams and cracks with a thin skin of concrete. Laden with mute menace, the resulting sarcophaguslike form stands in for a missing person and conjures images of a home violently invaded. Like many of her contemporaries in the 1990s, Salcedo exploits the fact that familiar objects can penetrate our defenses to surprise our psyches.

Mexican artist Silvia Gruner also exploits the catalytic connections between everyday objects and life stories. Through a constellation of text, video, and sculptural elements, *El Nacimento de Venus (The Birth of Venus)* (1995) tells her family's story of Holocaust survival and migration. A bag of tiny pink soaps shaped like pre-Columbian female figures rests on an industrial scale reading 106 pounds— the artist's weight. This assemblage is a central element in a slowly unfolding narrative that conflates her family's saga with the history of *mistizaje* (the mixing of cultures) in Latin America.

In the video installation WEIGHING . . . and WANTING (1997–1998), South African artist William Kentridge uses a unique form of stop-action animation. Images in charcoal are erased and redrawn to illustrate the troubled thoughts of a nameless white man in a pinstripe suit as he moves through interiors and landscapes rich in psychological and political symbolism. The work's title, taken from the story of the condemned King Belshazzar, lends biblical gravity to the protagonist's plight and, by extension, to a nation's quest to overcome racism.

Silvia Gruner, *El Nacimento de Venus
(The Birth of Venus)*, 1995 (detail)

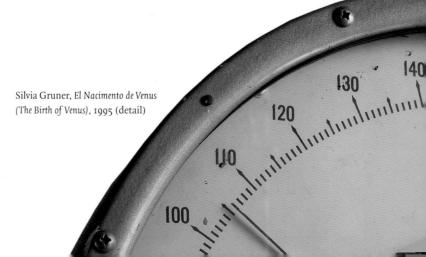

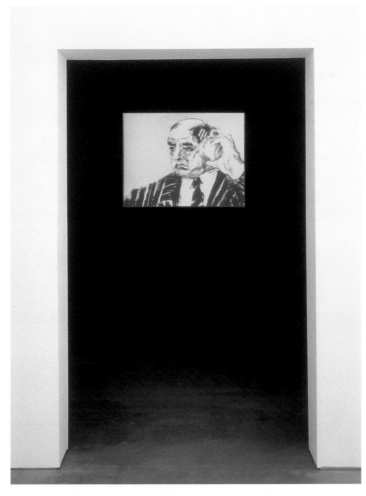

William Kentridge, *Untitled from WEIGHING . . . and WANTING*,
1997–1998 (installation view)

During the 1990s, when the existential uncertainty of the age seemed to be counterbalanced by widespread interest in psychopharmaceuticals and non-Western spiritual practices, consciousness, the state of being alive and sentient, became a central concern. Artists employed video, with its fast-cutting, engulfing images and sounds, along with a wide range of other media to explore states of mind. In the video sculpture *Learning Curve (still point)* (1993), Gary Hill stretches the writing arm of a school chair to terminate in a vanishing point under a small video monitor displaying an endlessly breaking wave. Recalling schoolroom daydreams and elegant natural processes, Hill's work suggests a Zenlike model for navigating waves of information.

Robert Irwin's site-specific installation 1°2°3°4° (1997) features three holes cut in the panoramic windows of one of the museum's oceanfront galleries. The simple surprises of unfiltered daylight and sea breezes activate the bodily sensorium—our animal intelligence—making hearing, feeling, and smelling part of the contemplative experience. Never the same twice (Irwin says the fourth degree is time), this simple architectural intervention does landscape painting one better by importing the world into the galleries.

Damien Hirst, the most notorious of a generation of sensationalistic young British artists, tests the boundaries between mind and body, morbid humor and showmanship. His sculptures, many incorporating blood and animal parts, shocked a world obsessed with youth, immortality, and sanitation. MCASD's installation, *When Logics Die* (1991)—a hospital gurney equipped with autopsy equipment and two grisly color photographs of fatalities, one accidental, the other a suicide—archly suggests that neither science nor art can adequately explain the enigmas of life and death.

Damien Hirst, *When Logics Die*, 1991 (detail)

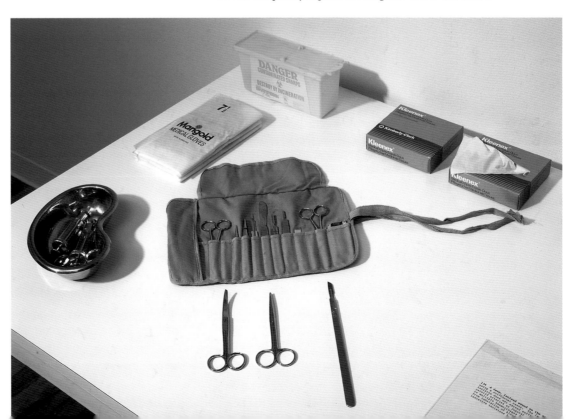

INFORMATION

The quest to filter life's daily avalanche of images and facts is the subject of much 1990s art. In the painting *To the Police* (1997), the collaborative team of Beattie & Davidson (Drew Beattie and Daniel Davidson) apply rap DJs' sampling techniques to painting. Grabbing elements from the visual chaos of New York—found images of boom boxes, bathtubs, and fairy castles, and words of street characters—they create a giddily simultaneous portrait of optical overload. In *2nd Corpse* (2000), New York sculptor Loren Madsen gives three-dimensional form to shocking U.S. homicide statistics. His cadaverlike graph in laminated plywood drolly curves and undulates to express rates of gun and nongun homicide. In an untitled work of 1995, Belgian-born, Mexico City–based Francis Alÿs collaborated with two of Mexico City's famous *rotulistas* (signpainters), hiring them to interpret and expand on one of his small cityscape paintings. The resulting works undermine the sanctity of a singular artistic vision by expressing the intelligence of a creative community. *Better Get Your Ass Some Protection* (1997) and *"Do As I Say Or . . ."* (1997), two small paintings on rayon by the Los Angeles pop-conceptualist artist Ed Ruscha, draw on urban culture to play a linguistic shell game. The paintings' rectilinear geometries, one discovers, represent the menacing words of their titles, covered over by censoring bars or literally "rubbed out" by bleach.

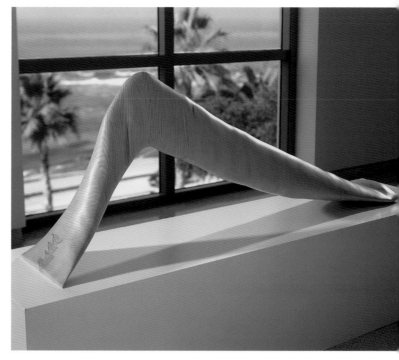

Loren Madsen, *2nd Corpse*, 2000

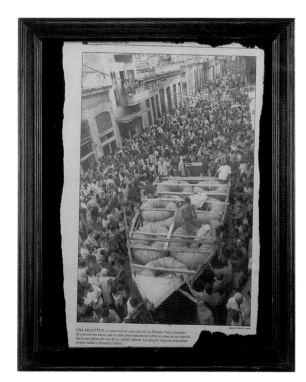

José Bedia, *¡Vamos Saliendo Ya! (Let's Leave Now!)*, 1994 (detail)

PLACE

Because of advances in global communications and the extreme mobility of individuals and money, the world became much smaller during the 1990s. As the global and the local inextricably intertwined, many artists addressed themes of migration and place. Mixing real objects and schematic images on a boat-shaped piece of canvas, *¡Vamos Saliendo Ya! (Let's Leave Now!)* (1994) by Cuban artist José Bedia emblematizes his own migration as well as the flight of thousands of his compatriots to the United States. Bedia, a practitioner of the Afro-Caribbean religion Palo Monte, freights his painting with symbolic images and objects—a photograph of a crowd carrying a raft through Havana, Spanish text urging departure, and a sacred antelope horn—to evoke the plight of Cuban refugees and the legacy of the African diaspora.

La Cariatide dei poveri (The Caryatid of Poverty) (1998), by Venetian artist Fabrizio Plessi, is a floor-to-ceiling work combining battered suitcases, bare lightbulbs, and video images of airport security X-rays. Inspired by television footage of refugees fleeing the war in Yugoslavia, and named for a column in the form of a human, the work acknowledges the hardships and pressures felt by those in exile.

Tijuana-based sculptor Marcos Ramírez ERRE addresses a politically and psychologically loaded space in *Toy an Horse* (1998), a maquette based on a large-scale wooden sculpture straddling the United States–Mexico border line during inSITE97, a binational exhibition of public art in San Diego and Tijuana. Who is invading whom? Ramírez's two-headed Trojan horse asks. Which flow is more pernicious, northbound illegal migration or southbound cultural imperialism?

THE BODY

As in all secular eras, the body—the locus of being—was a central motif in the art of the 1990s. Wide-ranging takes on corporeality emerged from a period in which research revealed our biological destinies and virtual reality technologies allowed us to escape our earthly shells. Kiki Smith atomizes the body in *Untitled (Skin)* (1990), a bas-relief breaking down a wax cast of a man's body into hundreds of one-inch squares. Evincing both the cool logic of a mathematical grid and the roiling fleshiness of a body in extremis, Smith's sculpture is a memento mori for the age of bioengineering.

Matthew Barney earned an international reputation while still an undergraduate at Yale with a videotape of himself rappelling across the ceiling of his studio wearing nothing but a climbing harness. Combining startling new expressions of sexuality, psychology, and mutation, Barney has made a dazzling array of sculptures, installations, photographs, and films suggesting a hermetic, posthuman cosmology. His Cremaster series of feature-length films—MCASD's *T.L: ascending HACK descending HACK* (1994) is a still from *Cremaster IV*—read like collaborations between Busby Berkeley and Salvador Dalí and hint at strange forces lurking below the skin.

Sculptors Martin Kersels and Charles Long express new symbioses of technology and the body. In Kersels' motorized sculpture *Twist* (1993), a prosthetic leg attached to a rope made from thousands of rubber bands is wound up by an electric winch until it breaks loose and spasmodically flails against the gallery wall, hinting that human frustrations are alive and kicking in an age of cyborgs. Long's sculpture *Fred* (1999), an endearing mascot for the digital age, transmogrifies a standard-issue orange extension cord into an electrical brontosaurus that has swallowed a basketball-sized jolt of current.

In *Head with Flowers* (1996) painter Fred Tomaselli creates an image of life enhanced by psychedelic rather than electronic or mechanical technologies. In thick layers of plastic resin Tomaselli sets hemp and daytura leaves (both of which have psychoactive effects), colorful illustrations of flowers and organs, and a diagram of the cerebral cortex made out of plant stems to create an optically exuberant emblem of the hallucinogenic power of art and drugs.

Matthew Barney, *T.L: ascending HACK descending HACK*, 1994

AMBIANCE

Perhaps because the real world seemed so complex and changeable, many people in the 1990s withdrew into private spheres, concentrating on Martha Stewart–style nesting and enhancing life through design, architecture, and fashion. In art, the decade abounded with work investigating or creating ambient spaces—architectural environments, participatory installations, and experiential works combining electronic music and sounds. Matthew Cusick's painting *Diamonds are Forever* (1998) and Roman de Salvo's wall sculpture *Power Maze with Sconce* (1998) both explore the built environment. Cusick's image of a towel-clad woman testing the water of a hot tub fetishizes the ultramodern glass-and-stone houses of Palm Springs architect Albert Frey in which a 1960s James Bond film was set. Painted in the cool, mechanical style of an architectural rendering, the image expresses a nostalgia for the Playboy Mansion of infinite possibility. Made from hand-bent electrical conduit and standard hardware-store fixtures, de Salvo's absurdly tangled hall light playfully inserts aesthetic form into a mundane structure, putting, as the artist jokes, "the fun in functionality."

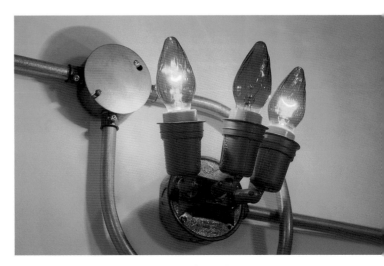

Roman de Salvo, *Power Maze with Sconce*, 1998 (detail)

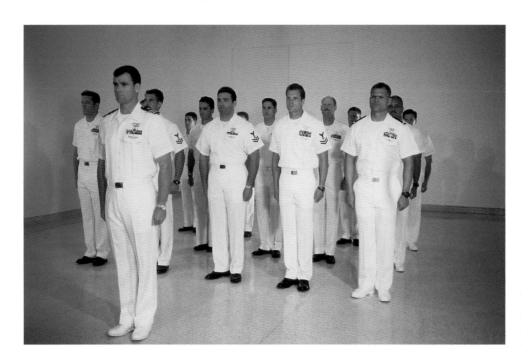

Vanessa Beecroft, USNAVY,
1999, performance at the
Museum of Contemporary
Art San Diego, June 5, 1999

PORTRAITURE AND THE "NEW SUBLIME"

Many writers have suggested that during the 1990s, the location of the sublime—the awe-inspiring mystery of life—shifted from nature to culture. Perhaps reflecting a widespread feeling that the natural world had been domesticated, artists increasingly turned to people—individuals and societies—for inspiration. Portraiture was an abiding focus of artists' attention and the museum's collecting. Los Angeles photographer Sharon Lockhart synthesizes anthropological and allegorical modes in *Enrique Nava Enedina: Oaxacan Exhibit Hall, National Museum of Anthropology, Mexico City* (1999). Depicting a worker repairing the museum's stone floors, this triptych plays with the transparency of display cases, the worker's protective screen, and the frame's real Plexiglas glazing, and seems to ask

whether the dark-skinned Señor Nava Enedina himself is an ethnographic specimen.

Two commissioned works use observation and science to portray a small but significant community—the thirty members of the museum's board of trustees. As its title suggests, Byron Kim's *Synechdoche: Barbara Arledge, C. W. Kim . . . Victor Vilaplana* (1994) uses parts to portray a whole. The grid of twenty-five panels, each painted to match the forearm of a trustee, objectively records the skin colors of the institution's governing officers. Iñigo Manglano-Ovalle's *Paternity Test (Museum of Contemporary Art San Diego)* (2000) presents a chromatically dazzling array of photographic DNA signatures of MCASD's trustees (made from swabs of cheek cells) to hint at the complex factors that make us alike and distinctive.

Iñigo Manglano-Ovalle, *Paternity Test (Museum of Contemporary Art San Diego)*, 2000

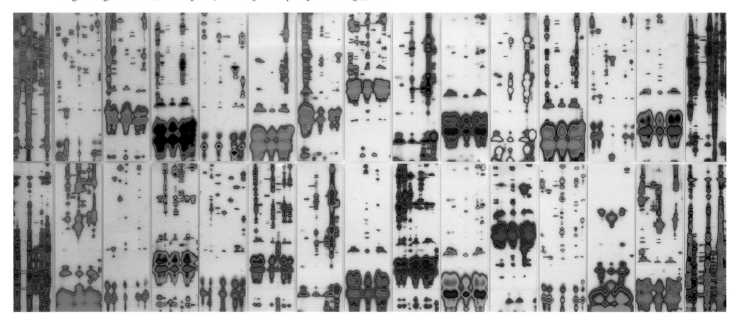

Because in the 1970s and 1980s the high seriousness or in-your-face contentiousness of attempts to explicate race, sex, and gender yielded limited results, artists in the next decade tended to be equal opportunity offenders. In the hope of provoking more open discussion, they played fast and loose with taboos and stereotypes. John Currin's painting *The Hobo* (1999), for instance, mixes Old Master technique with old-fashioned cheesecake in an image of a flirtatious ingénue setting out on a picaresque journey dressed in diaphanous underthings and glittering jewels. Postfeminist women, Currin winks, want to be independent *and* sexy.

Vanessa Beecroft's large photograph *VB 39, U.S. Navy SEALS, Museum of Contemporary Art San Diego, 1999* (1999) subverts conventional gender-biased modes of seeing. Beecroft documents seventeen San Diego–based elite SEAL commandos standing at attention and parade rest in the museum's galleries in what she calls an "intersection of military and art aesthetics." By transforming a group of supremely self-possessed men into sculpture, Beecroft wins a skirmish in the aesthetic battle of the sexes and demonstrates that she can wield a libidinal, possessing gaze as confidently as any man.

Understanding that identity is a performance as well as an intrinsic quality, photographer Cindy Sherman, known for her elaborately staged self-portraits, depicted herself in the guise of various Hollywood types, the starlets, movie extras, and socialites who inhabit Southern California. In an untitled work of 2000, Sherman transforms herself into a toast-tan workout queen in a track suit and tiara. This satiric *vanitas* image reminds us that the facade we show the world is a fragile hook on which to hang our sense of self.

Los Angeles painter Salomón Huerta, in *Untitled Figure* (2000), offers a heraldically composed image of a bald, dark-skinned man seated with his back to us. Adopting the flat, high-keyed colors and immaculate surface of West Coast "finish fetish" sculptors of the 1970s, Huerta's work points

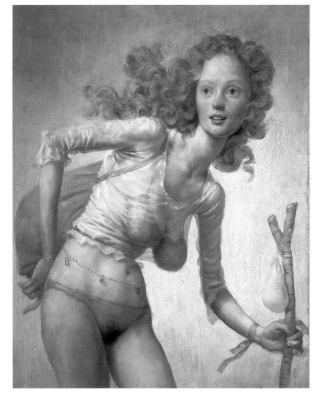

John Currin, *The Hobo*, 1999

out the difficulty of knowing another in the era of racial profiling.

The construction of identity also is the subject of *Jesus Christ* (1993) by the Czech sculptor David Černý and the series Que Linda La Brisa/How Lovely the Breeze by the Texas photographer James Drake. *Jesus Christ*, a build-it-yourself lifesize model of the crucifixion wrapped in plastic and labeled for sale, is a scathingly iconoclastic comment on the influx of Christian missionaries into the Czech Republic after the collapse of socialism and state-encouraged atheism. The photographs from Que Linda La Brisa/How Lovely the Breeze (1999) document transvestite prostitutes in a run-down brothel in Ciudad Juárez, Mexico, as they prepare themselves for work. Drake's photos expose the fluidity of gender and the hardships experienced by those whose sexual preferences force them into dangerous trades.

James Drake, *Que Linda La Brisa/How Lovely the Breeze (Lisa, Samantha, and Tanya)*, 1999

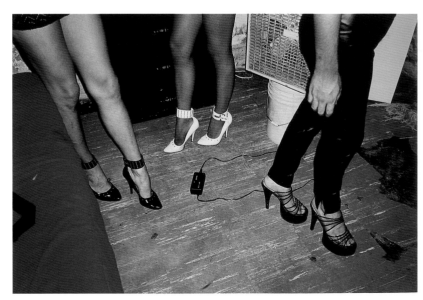

Jean Lowe, *Living with Nature*, 1996–1997

NATURE

Nature, too, remained an important theme in the art of the 1990s, but for many the proliferation of Internet use, sport-utility vehicles, and adventure travel transformed the physical world into something observed rather than directly engaged. Responding to this estrangement, artists like Michael Ashkin, Mark Dion, and Mat Collishaw tested our understanding of places by creating astonishingly detailed replicant worlds, analog virtual realities that allow the viewer to step out of and observe life. In *No. 29* (1996) and *No. 101* (1999), two tabletop-scale dioramas of polluted or neglected landscapes, Ashkin provides a God's-eye view of the Earth and the insidious effects of human habitation. For the commissioned work *Landfill* (1999–2000), Dion created a life-size habitat display, complete with simulated terrain, taxidermied animals, and a painted backdrop, depicting the scavenger ecology of a big-city dump. The fact that nearly all the trash that *Landfill*'s dogs, rats, and birds pick through is made from or refers to animals poignantly illustrates the ecological havoc wrought by civilization. And in *Shrunken Heads* (1998), British artist Mat Collishaw employs an ingeniously simple yet convincing form of video projection to animate a model of a country village with tiny, rampaging hooligans, creating a miniature morality play for a generation reared on TV sentimentality and violence.

Jean Lowe's *Living with Nature* (1996–1997), a decorator set consisting of a landscape scene and papier-mâché bookshelf painted in extravagant, faux-Baroque style, confounds our expectations. Instead of the bucolic landscapes and learned tomes one might expect in an upper-class home, Lowe provides more contemporary and crass symbols of materialism: a sprawling subdivision and titles like *The Search for Values: A Guide to Outlet Stores.*

Michael Ashkin, *No. 101*, 1999

David Reed, *#312-3 (for Ellen Browning Scripps)*, 1992–1996–1998 (detail)

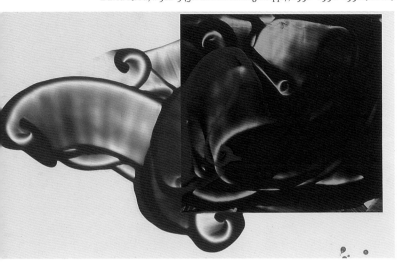

Painter David Reed and ceramist Kenneth Price build ambiguity and complexity into their sumptuous explorations of color and shape. Reed, a San Diego native, plays with distinctions between mechanical and handmade marks in his panoramic abstract painting *#312-3 (for Ellen Browning Scripps)* (1992–1996–1998). Using elaborately handworked oil-based and synthetic pigments, Reed paints undulating, rippling forms reminiscent of drapery folds in baroque paintings that at times look like photographs or bas-reliefs. Drawing on diverse sources, including Technicolor cinema, Abstract Expressionism, and the light of Southern California, Reed animates his compositions with unsettling impurity. Price, a pioneer in fine art ceramics during the 1960s, unites biomorphic form and otherworldly color in *Yang* (2000). Named for the male half of the yin-yang dualism, the fireplug-size sculpture continually threatens to morph into something new: a wave, a phallus, a tongue.

BEAUTY

In a collection of essays entitled *The Invisible Dragon* published in 1993, critic Dave Hickey took a provocative stab at defining an unfolding decade by suggesting that beauty would be the central issue in 1990s art.[8] Hickey argued that form had taken a back seat to content because of the dominant influence of "therapeutic institutions," networks of museums and galleries dedicated to legitimizing art's and their own places in society. Art, these institutions preached, is good for us. Work that did not illustrate social themes or channel cathartic emotions seemed guilty of self-indulgence and pandering to the market. During the 1990s, however, when artists generally lacked the sociocritical edge of their predecessors, beauty again had room to flower. Visual pleasure, surprise, familiarity, strangeness, and the interplay of subject and treatment—all attributes of the beautiful—provided rich territories. It was a cagey decade, however, and artists often worked skepticism and surprise into their attempts to evoke the beautiful.

The Controversy Surrounding the "Veronese" Vase (From the office of Luigi Zecchin) (1996), a sculptural installation by Josiah McElheny, depicts a struggle between rationality and inspiration in a search for transcendent form. From a shelf of unsuccessful prototypes and a bulletin board filled with mechanical drawings, McElheny concocts a story of the evolution of the Venini glass factory's famous vase modeled after a vessel in Paolo Veronese's Renaissance painting of the Annunciation. None of them correct in shape, color, or translucency, the scores of carefully labeled test vases point out that creativity may be primarily sheer work but the tiny element of inspiration is crucial.

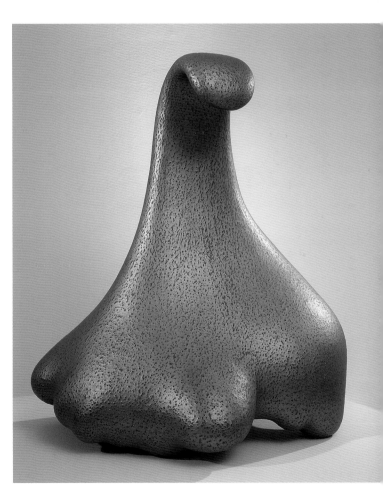

Kenneth Price, *Yang*, 2000

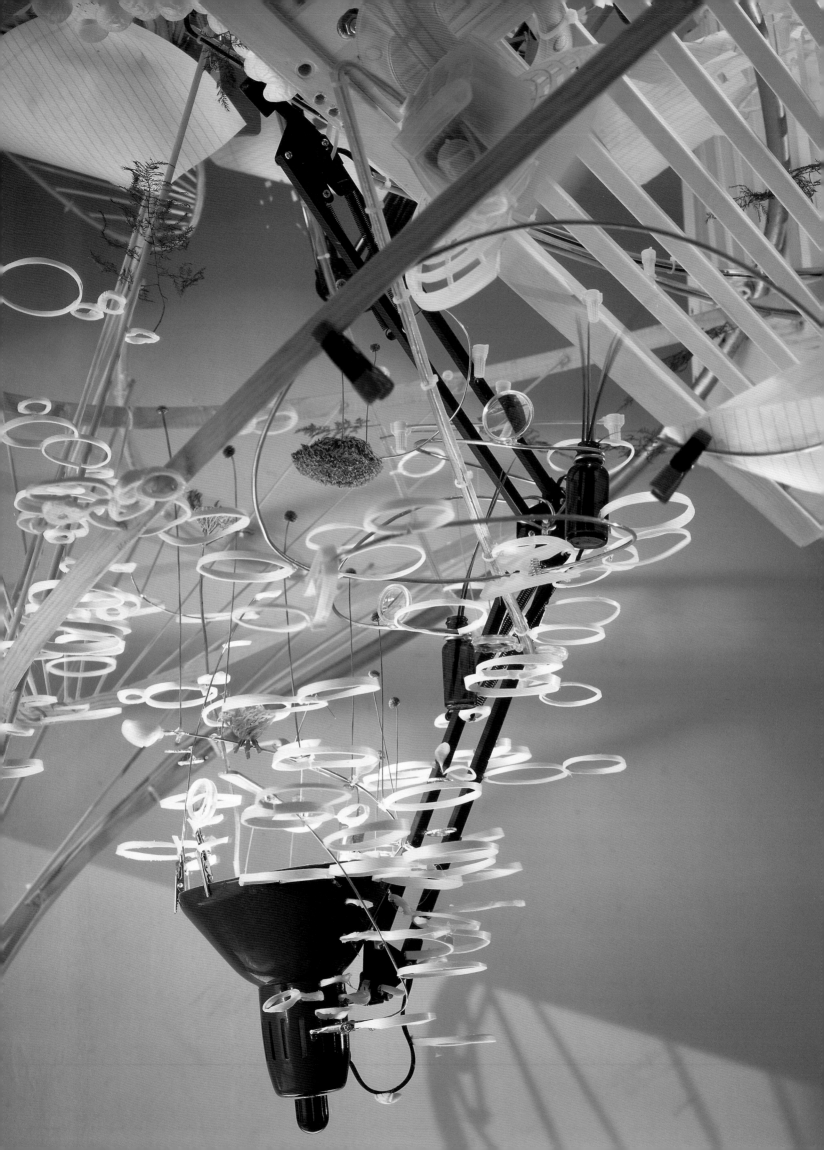

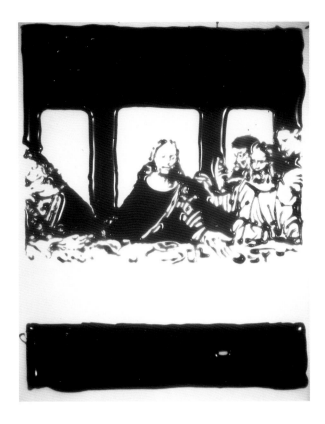

OPPOSITE: Sarah Sze, *Drawn*, 2000 (detail)

Vik Muniz, *Milan (The Last Supper) (from Pictures of Chocolate)*, 1997 (detail)

As the works in *Lateral Thinking* demonstrate, the 1990s was a diverse and dynamic decade for the visual arts. It encompassed a broad range of approaches, from the low-tech illusionism of works like Vik Muniz's *Milan (The Last Supper) (from Pictures of Chocolate)* (1997), a photographic triptych of da Vinci's famous image rendered in chocolate syrup; to the chilling seductiveness of Valeska Soares' *Untitled (from Entanglements)* (1996), two mouths in wax connected by a river of Poison perfume; to the space-claiming arabesques of Sarah Sze's *Drawn* (2000), a bed drawn, quartered, and exploded into rays of force. Will these works and the thousands collected by museums around the world survive as exemplars of their time, or will projects hatched in undiscovered artists' studios emerge to define the 1990s? Time will tell.

While this snapshot from the recent past cannot define a decade, it does provide a composite picture of its cultural life. Like omens, talismans, or trail blazes, the paintings, sculptures, photographs, and video works in the exhibition are powerful symbols and signs with which we can navigate the ever-unfolding story of the present. By illuminating, condensing, or exploding constellations of concerns central to art and life, artists attempt to make sense of our headlong rush into the future. In the process, they remind us that we belong to a continuum of thinking individuals who share and respect ideas. To embody thoughts in objects and send them into the world and history, as do the artists featured in *Lateral Thinking: Art of the 1990s*, requires commitment and courage. As long as artists take this chance, the Museum of Contemporary Art San Diego will rise to their challenges.

1. Raymond Gozzi, Jr., "The Nineties—The Downsizing Decade," *Etc.: A Review of General Semantics* 56, no. 4 (winter 1999), 458.

2. Edward de Bono, *Lateral Thinking: Creativity Step by Step* (New York: Harper & Row, 1990), 45.

3. The author is indebted to Neal Benezra and Olga M. Viso, authors of *Distemper: Dissonant Themes in the Art of the 1990s*, exh. cat. (Washington, D.C.: Hirshhorn Museum and Sculpture Garden, Smithsonian Institution, 1996), for illuminating Fukuyama's work and many of the themes in this section.

4. Francis Fukuyama, *The End of History and the Last Man* (New York: The Free Press, 1992), 45.

5. E-mail to the author from John Bancroft, Museum Specialist, National Endowment for the Arts, October 15, 2001.

6. Jan Avgikos, "The Shape of Art at the End of the Century," *Sculpture* 17, no. 4 (April 1998), 47.

7. For a statistical analysis of racial biases in New York galleries and museums and the National Endowment for the Arts, see Howardena Pindell, *The Heart of the Question: The Writings and Paintings of Howardena Pindell* (New York: Midmarch Arts Press, 1997), 19–28.

8. Dave Hickey, *The Invisible Dragon: Four Essays on Beauty* (Los Angeles: Art Issues Press, 1993), 11.

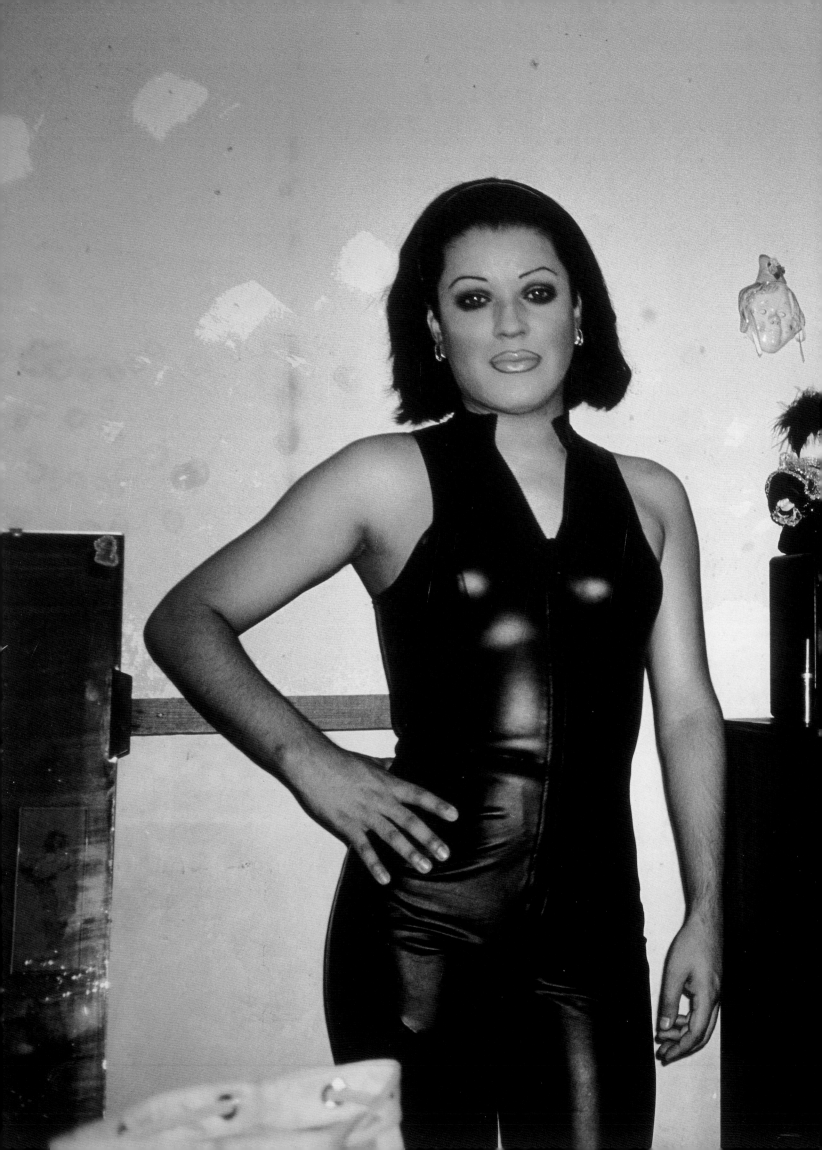

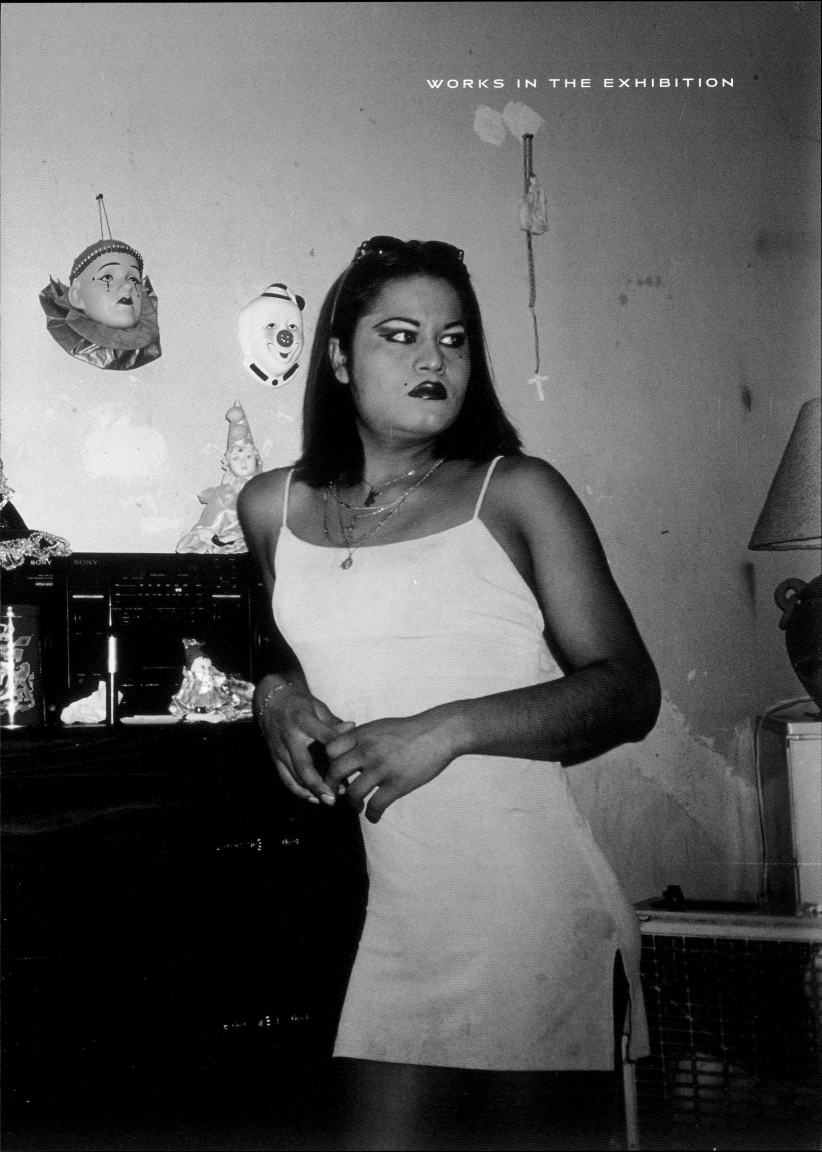

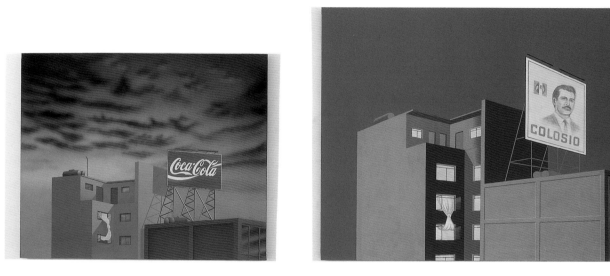

Belgian, born 1959

A Belgian living and working in Mexico City, Francis Alÿs makes images inspired by the rich visual culture of Mexico City, a site dominated by hand-painted signs, neon billboards, political banners, and Mexican flags. Alÿs' work merges the disparate issues of personal versus private, "high" versus "low," and original versus appropriated in order to challenge traditional artistic processes.

In *No Title*, Alÿs borrowed the technique and approach of traditional Mexican *rotulistas* (sign painters). Alÿs first created a small oil painting similar to the one seen here. He then commissioned sign painters Emilio Rivera and Juan Garcia to copy the painting with their materials, in this case enamel on sheet metal. Alÿs then reworked his painting to correspond to the copies, taking notice of how the *rotulistas'* versions refined and altered the original painting. Together the group of paintings become the work of art, transforming conventional methods of artistic creation to include group process and to honor the craft of tradespeople.

Alÿs, trained as an architect, intentionally left empty a large billboard on the roof of his original painting's highrise so that his collaborators could add their own imagery. A Coca-Cola ad and a campaign ad for an assassinated politician are the subjects Emilio Rivera and Juan Garcia chose. Alÿs' hybrid works raise the issue of originality and question the importance (or unimportance) of the artist's touch.

M.G.

With Emilio Rivera and Juan Garcia

No Title, 1995
oil and encaustic on canvas, enamel on sheet metal
overall dimensions variable; 3 panels: 6¼ × 8¼ in. (15.9 × 21 cm);
29⅜ × 36⅛ in. (74.6 × 91.8 cm); 36 × 47⅜ in. (91.4 × 120 cm)
Museum purchase, Contemporary Collectors Fund, 1997.15.1–3

EDGAR ARCENEAUX
American, born 1972

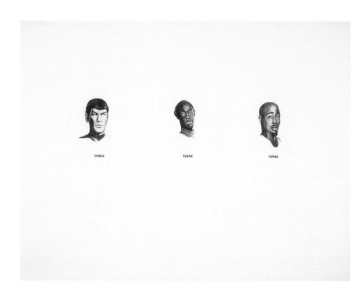

Spock, Tupac, Tuvac, 1997

graphite, gesso, marker on frosted vellum
32 × 42 in. (81.3 × 106.7 cm)
Museum purchase with funds from the Elizabeth W. Russell Foundation, 1997.27

Edgar Arceneaux's comical drawings deal with identity transformation. Culling imagery from dreams and memory, Arceneaux constructs ambiguous narratives from bits and pieces of popular culture. Superheroes, film stars, youth idols, and art stars intermingle in arrangements that blend puns, non-sequiturs, and subconscious associations. The artist explains the imprecise process of assembling meaning: "I am interested in the relationships between things . . . the connections and breaks between sound and image, linkages that are apparent and non-apparent, and the inter-connectedness between ideas, thoughts, dreams, and actual factual events. I am not in search of a meaning, because it is slippery, always moving and changing, but my interest lies in the pursuit of meaning."[1]

In *Chimpanzee, Man, Pre-Historic Man,* Arceneaux juxtaposes images of the title characters, offering a witty but pointed commentary on popular perceptions of evolution. He inserts his self-portrait in the middle of the chain, rather than placing himself as the outcome of the evolutionary process. As an ambiguous link he draws attention to the exploitation of evolutionary theories to support racist attitudes based on physical characteristics. Less overt, yet still concerned with evolutionary identity, *Spock, Tupac, Tuvac,* is a clever wordplay on fictional characters and real media personalities whose larger-than-life celebrity is the product of the entertainment industry. Typical of his work, the graphite portraits shimmer through the frosted vellum, creating an ephemeral and surreal dream world for Arceneaux's stable of characters. S.H.

1. Undated artist's statement, MCASD archives.

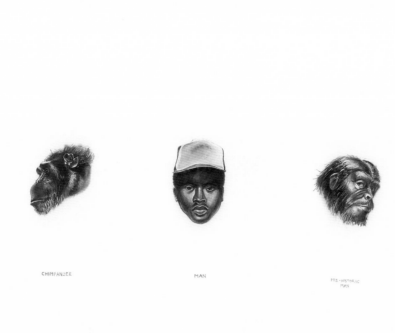

Chimpanzee, Man, Pre-Historic Man, 1997

graphite, gesso, acrylic on frosted vellum
36 × 42 in. (91.4 × 106.7 cm)
Museum purchase with funds from the Elizabeth W. Russell Foundation, 1997.28

MICHAEL ASHKIN
American, born 1955

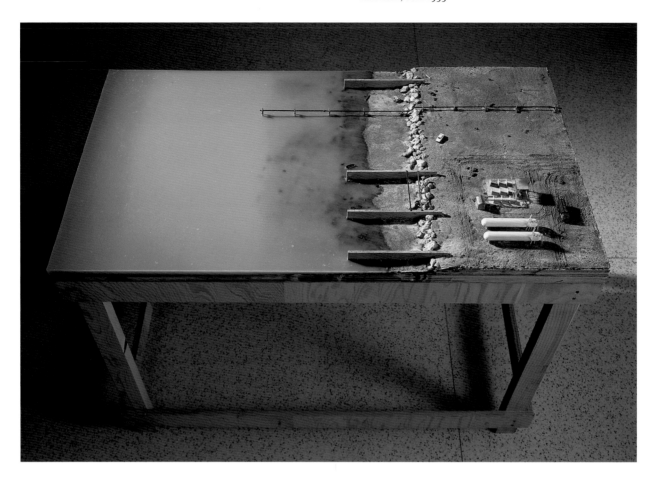

Michael Ashkin is fascinated by the polluted, abandoned, or ignored landscapes that exist on the margins of civilization— the toxic marshes of New Jersey's Meadowlands, the ghost malls dotting American highways, the desolate deserts of the Middle East. Using extremely small-scale modeling techniques, he re-creates these terrains in tabletop-scale sculptures he calls "models." No. 29, a decrepit tank farm next to a toxic-looking shoreline, featuring a parked car and truck and an ominous drainpipe, feels like the scene of a crime— either social or environmental. Filled with hauntingly precise details, Ashkin's tiny no-man's lands capture the gritty texture of real life and the relentless processes of time.

A student of the quixotic road movies of directors like Michelangelo Antonioni and Wim Wenders, Ashkin understands the ambivalent attraction of vast, unpeopled spaces, and considers them to be both romantic and nihilistic. He displays the works on low plywood tables, giving the viewer the cinematic feeling of soaring above the world, but avoids any form of dramatic action. The fact that no ripples mar the surface of his Envirotex resin water, and that the surfaces bear no traces of recent human activity, lends the sculptures a timeless universality. In this respect, they have important precedents in art. Ashkin acknowledges the Land Art projects of Robert Smithson, which investigate the effects of industrialization and entropy (the hypothesis that all systems continually lose energy and decay) on the Earth's surface. The abstract paintings of Mark Rothko, with their vestigial horizon lines, Ashkin believes, relate to his models because they both "say nothing concisely."[1] Whatever their inspirations, Ashkin's sculptures operate on two levels: their convincing illusionism lends them psychological immediacy, but their precious scale pushes them into the realm of fantasy and dreams. Connecting intimately with our individual topographical memories gleaned from car rides, airplane flights, photographs, and films, Ashkin's works are as much mental as physical spaces. T.K.

1. Author's conversation with the artist.

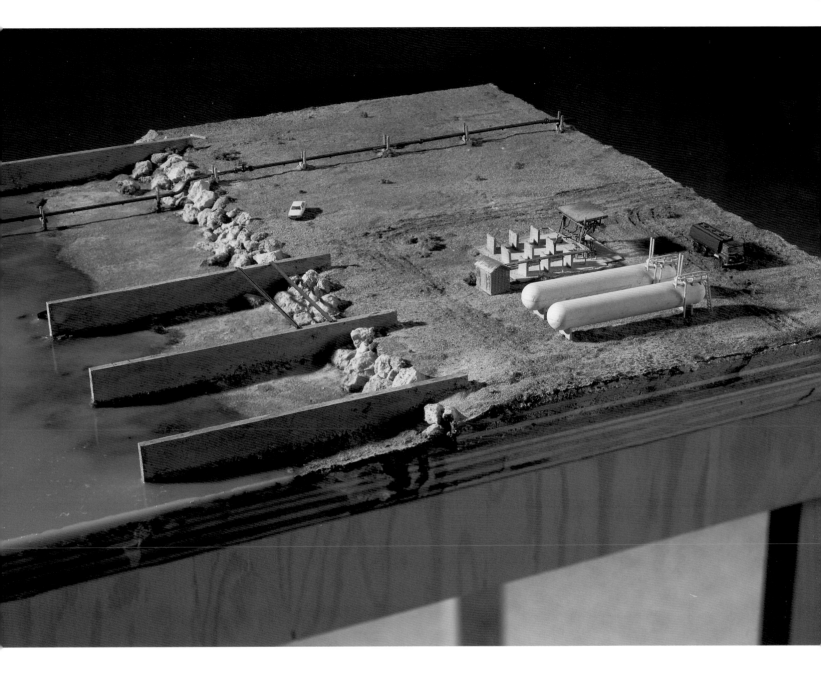

No. 29, 1996
wood, dirt, glue, n-scale models, Envirotex
36 × 48 × 27 in. (91.4 × 121.9 × 68.6 cm)
Gift of Dean Valentine and Amy Adelson, 1999.28.a–b

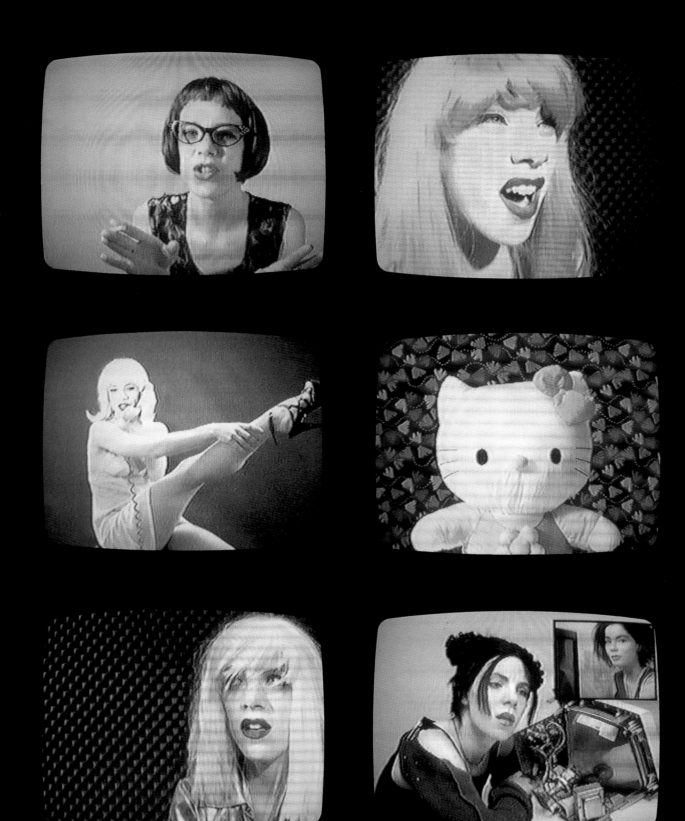

ALEX BAG
American, born 1969

Untitled (Fall '95), 1995
color videotape, 1/2 in., edition 28 of 30
57 minutes
Museum purchase, Contemporary Collectors Fund, V1999.1

Typically shot in a deliberately low-tech style, Alex Bag's video works feature the artist playing a wide variety of amusing, highly detailed characters. These personalities allow Bag to explore and question how cultural images and messages are determined and promoted. By retaining television's awkwardness, banality, static, and endearing ineptitudes, she uses the very techniques and processes of the subject she is critiquing. Her work functions as both a parody and a solution to the absurdity of phone sex advertising and the home shopping network. Through her many characters, usually introduced in a series of monologues, Bag offers a variety of slanted, yet authentic, perspectives on contemporary culture.

In *Untitled (Fall '95)* Bag assumes a broad range of characters to create a comic portrayal of the life of an art student at New York's School of Visual Arts. Scenes of the continually appearance-morphing student discussing her ideas, ambitions, and concerns at the outset of eight successive semesters are intercut with short skits inspired by late-night television that involve talking dolls, bored British shopkeepers, and the Icelandic pop singer Björk. Alternating between despair and elation, yet always maintaining a pitch-perfect portrayal of a student caught in a tangle of self-involvement, Bag's video illuminates the claustrophobic worlds of gender clashes, brutal critiques, and narcissistic professors. The viewer witnesses her transformation from inarticulate naïveté to annoying self-assuredness, the character's clothing and look changing along with her social aspirations and views of the art world. Without ever displaying a shred of self-awareness, Bag's student delivers a scathing critique of the contemporary art world. S.H.

MATTHEW BARNEY

American, born 1967

T.L: ascending HACK descending HACK, 1994
chromogenic print, self-lubricating plastic frame
39½ × 27½ × 1½ in. (100.3 × 69.8 × 3.8 cm)
Museum purchase, Contemporary Collectors Fund, 1995.4

Since the mid-1990s, Matthew Barney has made a series of elaborate, enigmatic films entitled Cremaster, after the muscle that raises and lowers the testicles. Part science fiction, part surrealist drama, and part Hollywood musical, these films describe an alternate reality inhabited by fantastic creatures and machines and touch on a wide range of themes, including athletic endurance, biological mutation, and sexual identity, through visually lush, almost hallucinatory props, makeup, and locations. Throughout the Cremaster series Barney layers diverse landscapes, characters, biography, and history to create his own mythological universe.

While making his films—for which Barney acts as director, set designer, fabricator, and performer—he also produces still photographs, sculptures, and installations featuring the actors and sets. This photograph was made during the filming of *Cremaster* 4 (1994), inspired by the annual sidecar motorcycle races on the Isle of Man off the coast of Scotland. The goal of the race is to complete a single rotation around the island. This test of control and endurance showcases such unlikely characters as androgynous orange-haired fairies, a four-horned ram, and the two racing teams shown in this work. These characters become mysterious symbols in the artist's personal myth, and Barney uses these characters and situations to test the boundaries and thresholds of the human body. Through the photograph's calculated use of color and design, the reverse-symmetrical arrangement of two customized yellow and blue racing motorcycles as seen from above captures the tenuous balance of opposing forces and may allude to the ascending and descending of the cremaster muscle. T.K.

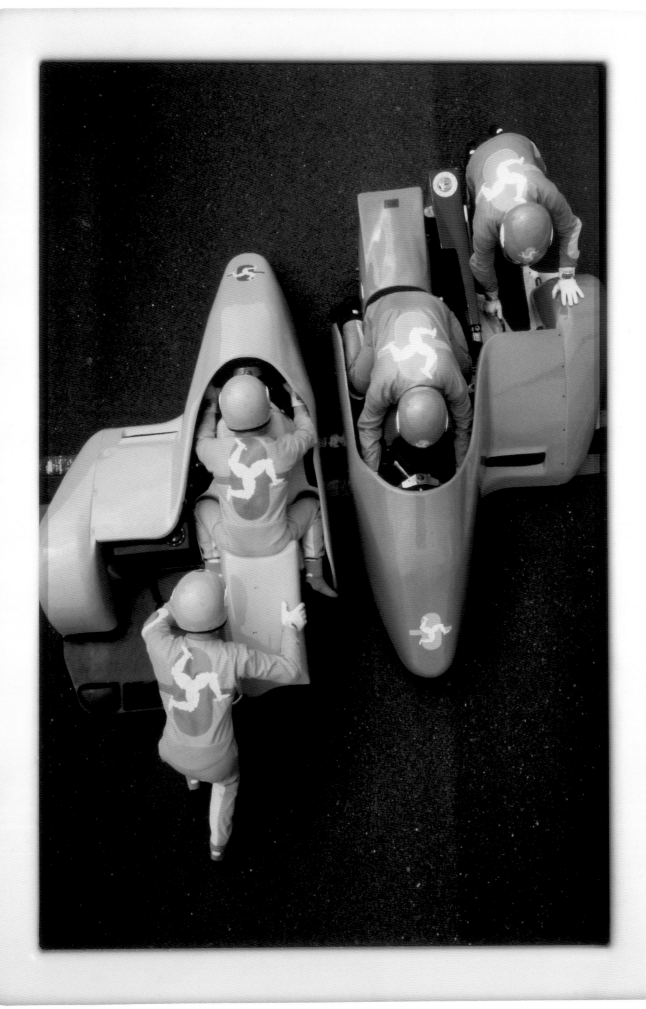

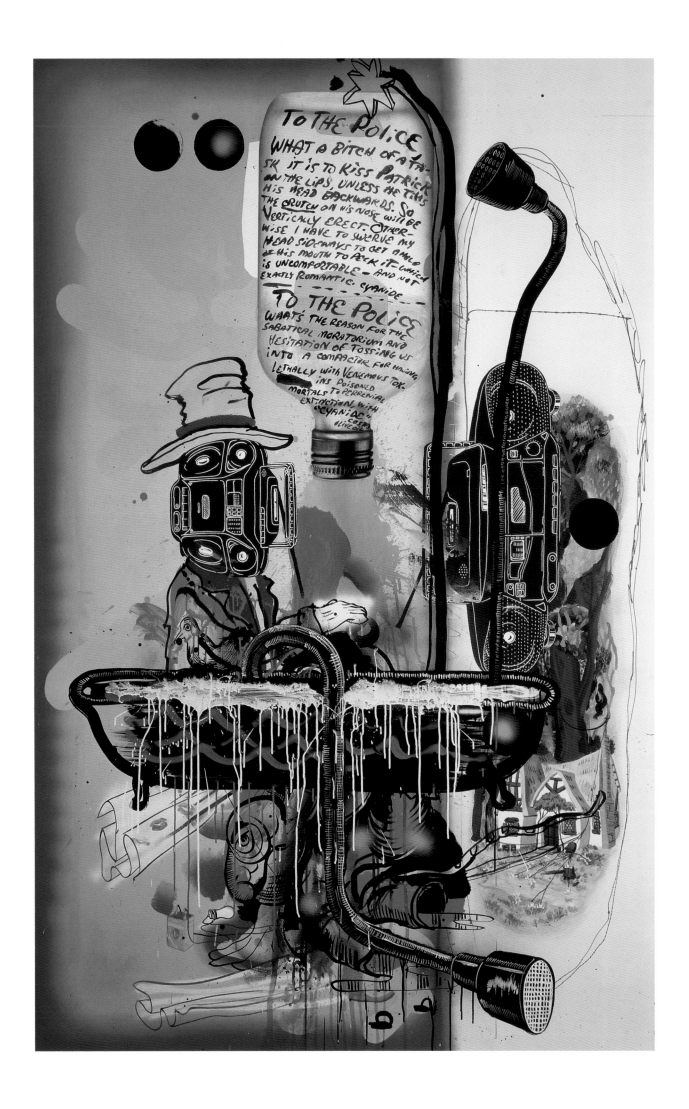

BEATTIE & DAVIDSON

Drew Beattie, American, born 1952
Daniel Davidson, American, born 1965

Artists Drew Beattie and Daniel Davidson began working as a team in 1989, after meeting at the San Francisco Art Institute. Their partnership began with a prolific mail art correspondence in which they exchanged and built on each other's drawings and ideas and quickly led to collaborative paintings made according to the same processes. Eventually, Beattie & Davidson (they no longer collaborate) moved to New York to pursue their unique approach to art making, one in which the artists subsume their own visions and personalities in the goal of sharing the same imagination. Mixing a wide range of handmade marks and mechanically reproduced images, Beattie & Davidson's rollicking paintings are often scatological and always insanely logical journeys through the corridors of fine art and popular culture.

In *To the Police*, they create a humorous, hallucinogenic vision blending abstract brushwork, boom boxes, fairy-tale cartoons, and found street poetry. The work's inspiration and title come from the ramblingly paranoid, disjointed poetic texts of an unknown author named Cyanide whose work the artists discovered on lampposts in New York's East Village. "The Cyanide notes," Davidson says, "have a fabulous rambling poetry of dispossession, a driving energy toward connecting disconnected bits of an exploded narrative that always seems to arrive at poison—oblique confessions, accusations, or protests about being accused."[1] At the top of the image, Cyanide's words are reproduced on a bottle of Calvin Klein CK One cologne. Below it, disjointed images spill through the painting with an absurd logic all their own. The radio-headed figure in the bathtub, for instance, may stem from Beattie & Davidson's belief that a tub is "a perfect carrier for a figure. It puts the figure in a floating ground."[2]

To the Police, Beattie & Davidson say, "is an intuitive fusion of narrative elements that cohere in a strange, compressed, skewed, multiple-circuit loop that picks up energy and emotion recomposing itself."[3] The painting's manifold layers, the artists feel, express the complex, perpetually shifting, and not always rational state that is consciousness for many today. T.K.

To the Police, 1997
acrylic and collage on canvas
90 × 58¼ in. (228.6 × 148 cm)
Gift of RSM Company, Charlotte, N.C., 2000.34

1. Lawrence Rinder, "Cars without Shadows: Recent Paintings by Beattie & Davidson," in *Beattie & Davidson*, exh. cat. (Santa Monica: Smart Art Press, 1998), 8.

2. David Humphrey, "Weedy Snowball: David Humphrey Talks with Beattie & Davidson, New York, November 17, 1997," in *Beattie & Davidson*, 62.

3. Daniel Georges, *In the Flow: Alternative Authoring Strategies*, http://www.franklin.furnace.org/flow.

JOSÉ BEDIA
Cuban, born 1959

¡Vamos Saliendo Ya! (Let's Leave Now!), 1994
acrylic on canvas, framed newsprint, animal horn, chain
painting: 84 × 167½ in. (213.4 × 425.5 cm); framed article: 15¾ × 12¾ in.
(40 × 32.4 cm); horn: 8 × 13 × 7 in. (20.3 × 33 × 17.8 cm)
Museum purchase, Contemporary Collectors Fund, 1996.5.1–4

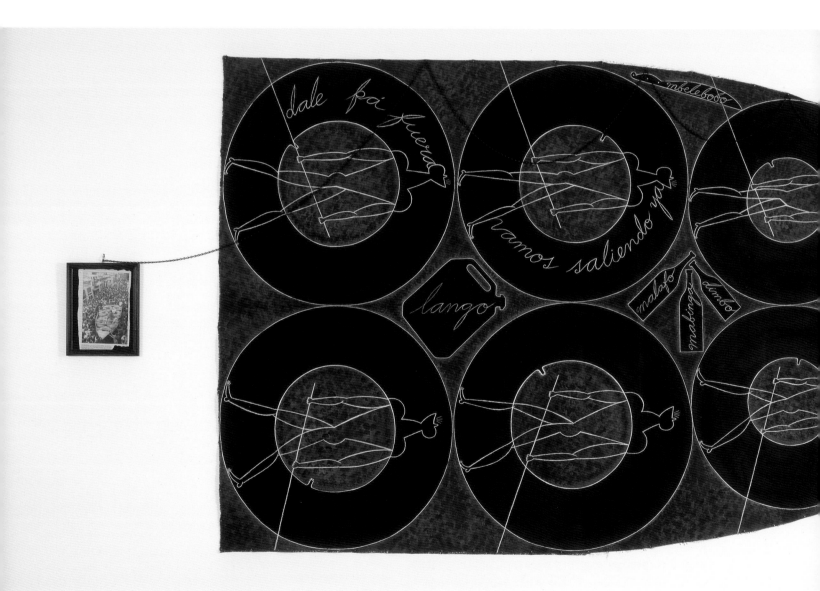

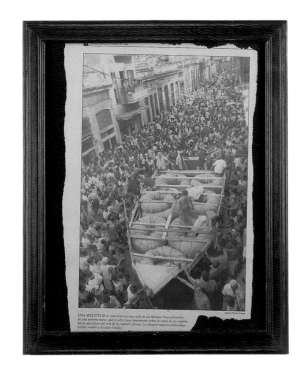

Departure, separation, and dislocation are reoccurring themes in the work of Cuban artist José Bedia. His large-scale drawings and paintings, characterized by outline, patterns, symbols, and captioning, serve as narrative vehicles to explore Cuban identity and cultural roots. Part of the first generation of artists born and educated under Castro's regime, Bedia draws from international trends in art such as Pop and Conceptual art. Yet, in the largest sense, his art is about the creation of identity in a world characterized by political and social upheavals.

Central to Bedia's art is the Palo Monte religion, a process of life-transforming ritual and spiritual belief that bridges contemporary and native cultures. Followers of Palo Monte, the oldest surviving strain of African religion in Cuba, believe in the power of a ritual object or graphic symbol to become the spirit it represents. The iconographic images of Palo Monte deities, offerings, ritual, and symbolism are consistently present in Bedia's work, and are reminders of the power of connecting with cultural origins.

In *¡Vamos Saliendo Ya! (Let's Leave Now!)*, Bedia combines sacred and secular imagery to describe contemporary events in his country. The work consists of a 1994 news photograph of Cubans carrying a handmade boat through the streets of Havana incorporated into a symbolic painting referencing the recent exodus of thousands from the island in dangerously flimsy rafts. In its schematic, silhouette form, Bedia's imagery recalls Native American pictographs as well as nineteenth-century diagrams of slave ships, which originally brought African peoples and religions to Cuba. Accompanying the written cries of "Vamos saliendo ya!" and "pá fuera," evoking a call to flee, images of sacred Palo Monte objects, including a three-legged iron *nkisi* vessel, knives, and an antelope horn, lend a spiritual aspect to the Cuban refugees' quest for freedom. In 1990, Bedia himself left Cuba and today resides in Miami. S.H.

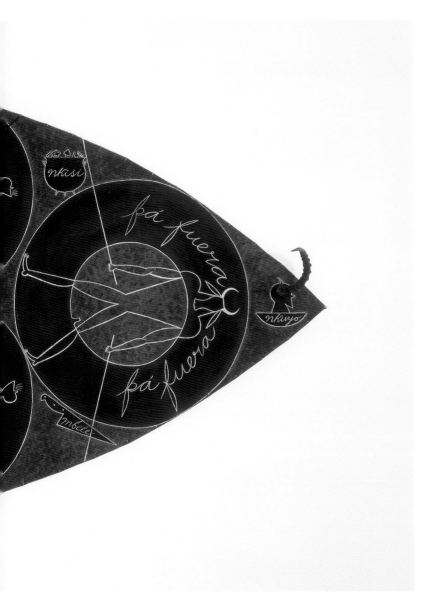

*VB 39, U.S. Navy SEALS, Museum of Contemporary Art
San Diego, 1999,* 1999
3 digital chromogenic prints, edition of 3
3 panels, overall: 96 × 120 in. (243.8 × 304.8 cm)
Gift of the artist and Deitch Projects, New York, 2000.15.a–c

On June 5, 1999, the Museum of Contemporary Art San
Diego became the site of USNAVY, a special event organized
by Italian-born, Brooklyn-based artist Vanessa Beecroft.
Working in collaboration with the Naval Special Warfare
Command on Coronado Island in San Diego, Beecroft
staged a one-time performance focusing on an elite fight-
ing force—the U.S. Navy SEALS. At exactly 4:30 P.M.,
seventeen SEALS assumed a ceremonial formation in the
museum's Farris Gallery. (Named for their deployment by
SEa, Air, and Land, the SEALS are trained in underwater
demolition and clandestine operations.) Standing nearly
stock still at attention and parade rest, in three twenty-
minute intervals over one and one-half hours, the SEALS
formed a geometrically precise human sculpture. Clad in
immaculate dress summer white uniforms, the square grid
of sailors echoed the white cube of the gallery and recalled
the classical perfection and pale colors of ancient Greek and
Roman marble sculpture. This image, taken by Todd Eberle,
is one of a series of photographic and video documents of
the performance.

Beecroft is known for performances in museums and
galleries in which she arranges and presents groups of
young women clad in wigs, underwear, high heels, or less—
unsettlingly direct portraits that she calls "visual subjects."
Beecroft describes this performance event—her first involv-
ing men—as a "representation of the intersection between
military and art aesthetics."[1] The precise work, Beecroft says,
evokes the "core values of the Navy: honor, courage, and
commitment."[2] It also highlights themes widely investigated
in contemporary art, such as gender, identity, costume, and
the gaze—the ways we all see, judge, and possess individuals
and works of art with our eyes.

Beecroft followed *U.S. Navy SEALS* with a performance
and photographic project for the 2000 Whitney Biennial
in which Navy personnel in dress blue uniforms posed in
formation on the deck of the U.S.S. *Intrepid* aircraft carrier.

T.K.

1. Author's conversation with the artist.
2. Ibid.

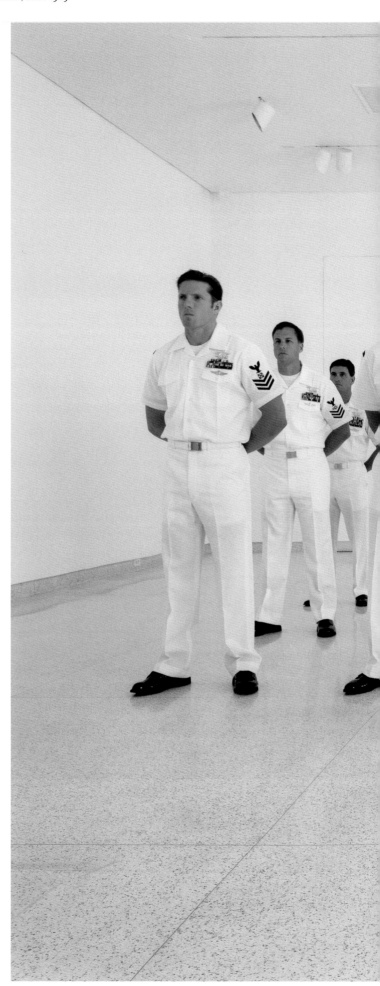

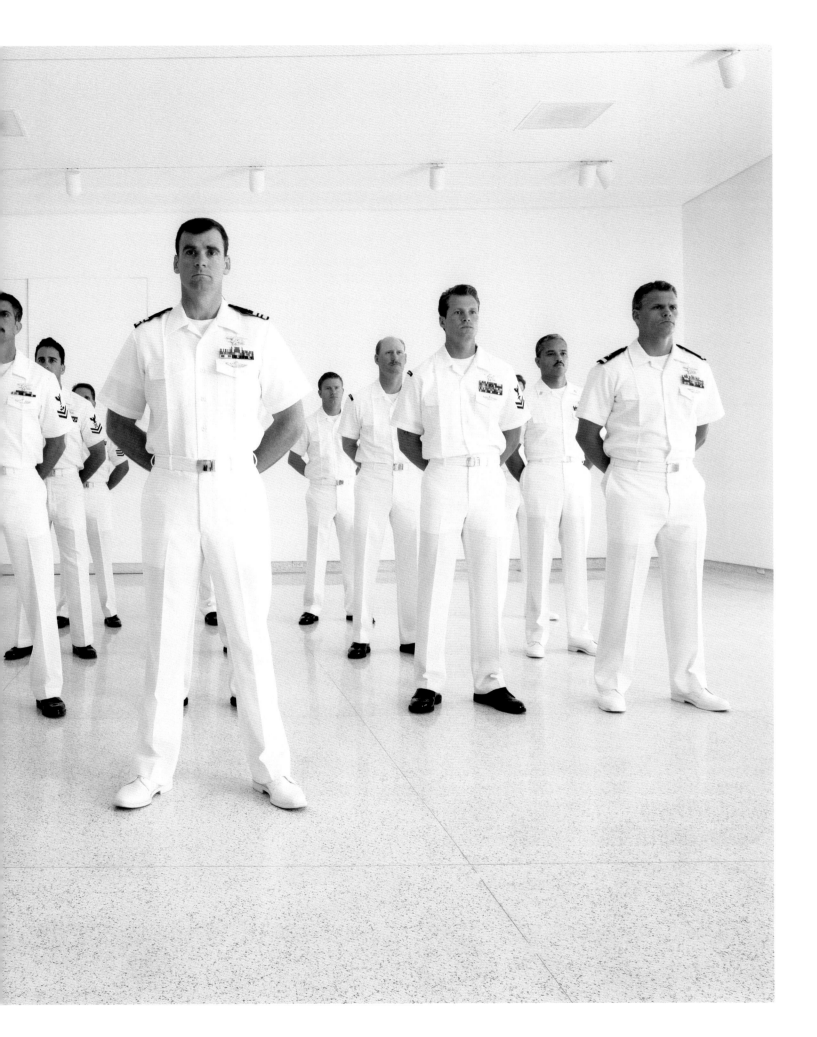

JOHN CURRIN

American, born 1962

The Hobo, 1999

oil on canvas
40 × 32 in. (101.6 × 81.3 cm)
Museum purchase, Contemporary Collectors Fund, 2000.3

Part of a new generation of artists associated with the reemergence of figurative painting in the 1990s, John Currin explores the history of painting and, in particular, the female figure in art. With technical virtuosity, Currin conjures both the elevated intent of the Old Masters and the more base appeal of cheesecake pin-up images. His subjects have included old women, middle-aged divorcees, and couples, but the works that gained him notoriety and a critical following are his depictions of large-breasted young women in provocative poses. While Currin's paintings of nude or seminude nubile women have been criticized for misogynist overtones, his subject matter reflects a satirical look at postfeminist attitudes. In *The Hobo*, the protagonist, wearing diaphanous undies, displays herself in an overtly sexual manner while at the same time projecting a strong sense of independence as she forges ahead on her journey. Completely self-aware, Currin's gamine challenges notions of female innocence and objectification. Currin effectively manipulates his subject matter to stand as an emblem of contemporary femininity, shaped by feminism yet also articulating sexuality.

Immersed in art history and passionate about Botticelli and Leonardo da Vinci, Currin draws inspiration for his figures from Mannerist and Renaissance painting. Exaggerating the female form through elongation and dramatic distortion, he creates psychologically disturbing figures. His combination of traditional techniques with contemporary interests results in a heady blending of nostalgia, desire, vulgarity, and kitsch. M.G.

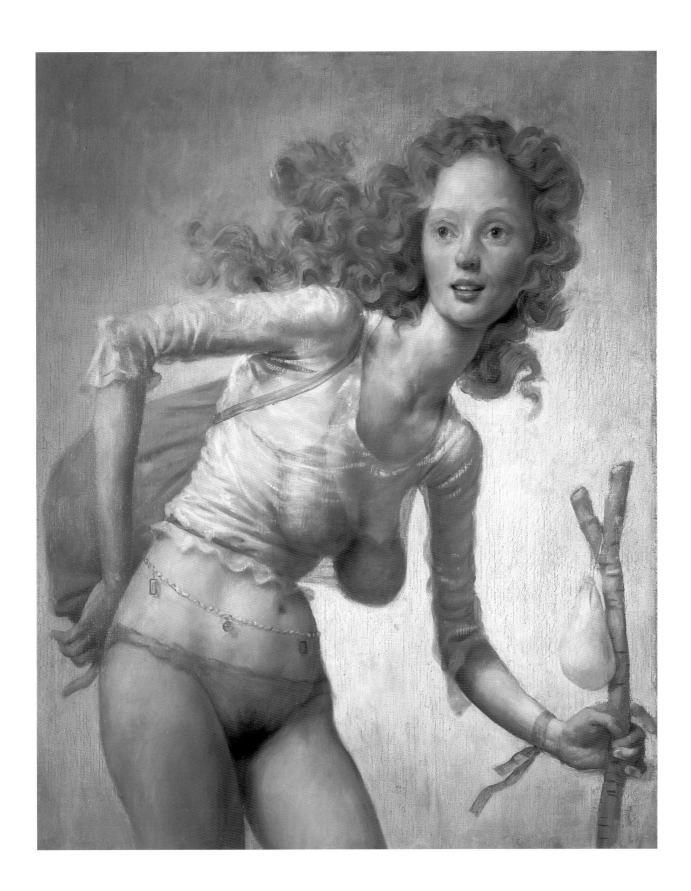

ROMAN DE SALVO
American, born 1965

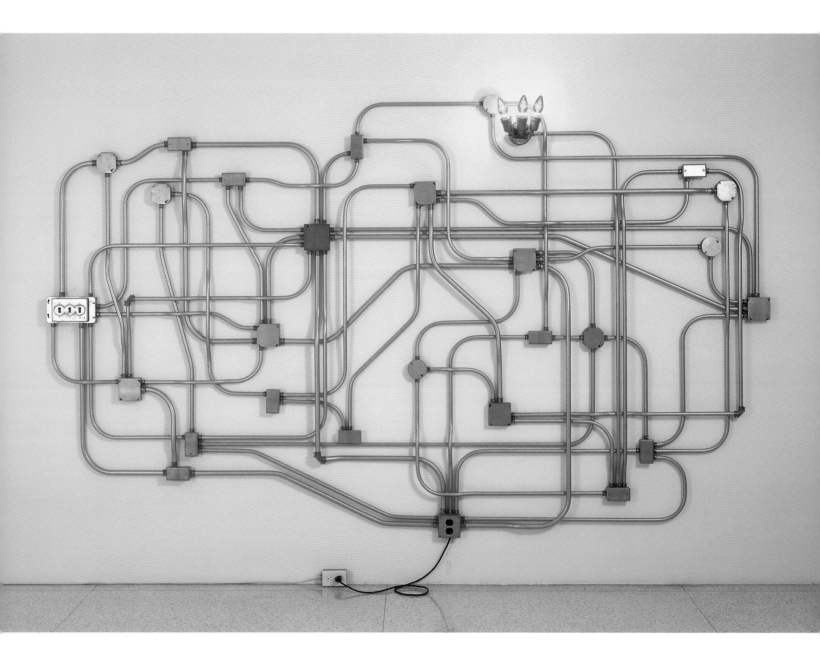

Power Maze with Sconce, 1998

electrical conduit, boxes, connectors, sockets, switches, light bulbs, wiring
79 × 132 in. (200.7 × 335.3 cm)
Museum purchase, Elizabeth W. Russell Foundation Fund, 1998.31

The San Diego–based artist Roman de Salvo reexamines and transforms everyday materials and vernacular items into playfully imaginative, unexpected objects. Through his intervention, objects cultivate new appearances and aspire beyond their means. De Salvo is intrigued by simple machines and technologies: visual puns such as his photograph of a burning fire hydrant; site-specific installations like his men's room "fountain" in which a plume of water shoots up from a floor grate when the toilet is flushed; and ironic Rube Goldberg–like contraptions such as *Liquid Ballistic*, a combination see-saw, cannon, and fountain. He subverts the original intentions for these common items to deliver clever juxtapositions of seemingly incongruous elements. The absurdist qualities of de Salvo's hybrid sculptures give his work an appealing visual wit.

Power Maze with Sconce defies the idea of efficiency and the practice of using the least amount of conduit needed to move electricity. The superfluous conduit achieves a maze-like visual density, hinting at the complexity of our contemporary lives. De Salvo states, "I see the maze as a metaphor for a kind of chaotic built environment that is difficult to navigate without some experience and practice."[1] The intricacy of the *Power Maze* can also prolong the duration of the viewing experience, as the viewer traces the conduit lines to their power sources. Details are important for the humor and irony in de Salvo's work. By juxtaposing a ridiculous amount of outdoor industrial material to power three fancy interior "flame" light bulbs, he twists the famous idiom "form follows function" into an absurdist revelation: "fun follows function"! S.H.

1. Artist's statement, 1999, MCASD archives.

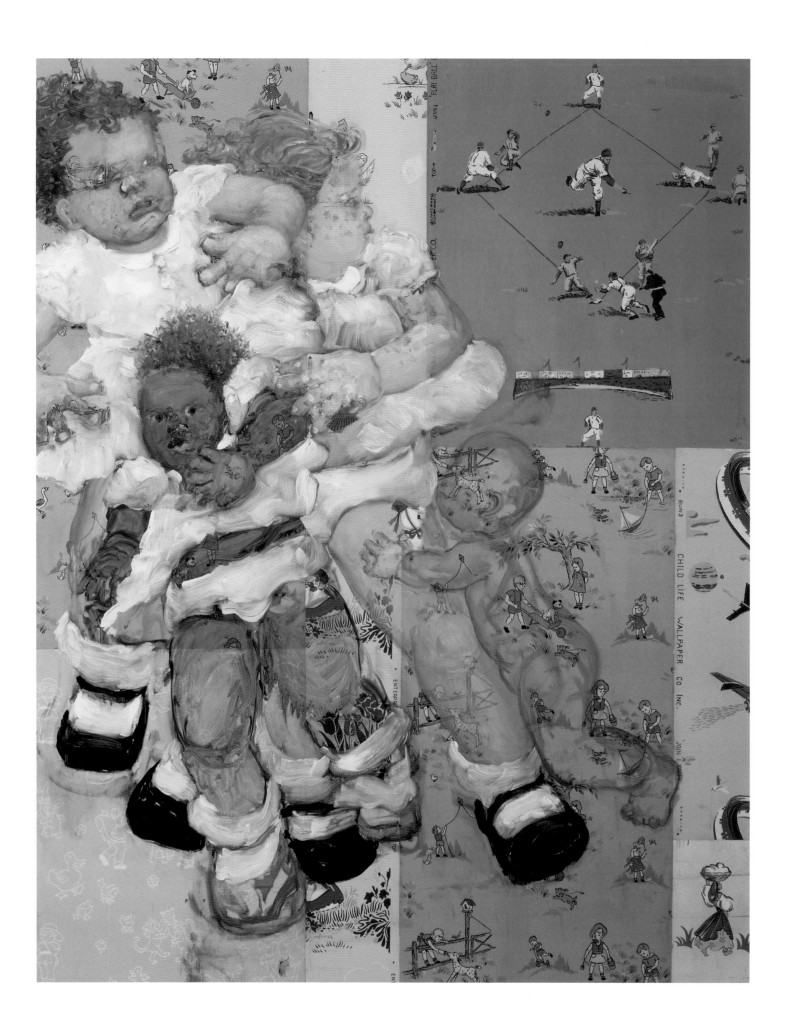

KIM DINGLE
American, born 1951

Sugar and spice and all things nice take a menacing turn in artist Kim Dingle's vision of toddlers run amok in the nursery. The girls, called "Prisses" by the artist, are painted against a collage of vintage 1950s children's wallpaper remnants depicting children in gender appropriate roles—boys involved in sports and girls playing dolls. With no parents in sight, Dingle's frilly-socked girl-gang busts out of the nursery and into the world, trashing social conventions and constraints of femininity and propriety, and mocking notions of childhood innocence. Dingle has made porcelain versions of these Priss dolls for life-size nursery installations. She has even transformed a car into a Priss Mobile complete with pink enamel, patent leather wheels, lace whitewalls, and red oil dripping onto a pink comforter.

In the early twentieth century, Surrealists blended imagery of the subconscious and the everyday to explode notions of bourgeois propriety. Dingle's work has a similar psychologically unsettling effect. She combines images and fragments of pop culture, particularly from the 1940s and 1950s, with personal memories to produce a body of work that assaults and perverts popular and historical myths and icons. A ceramic cookie jar in the form of John Wayne's head, a depiction of Ed Sullivan as a young girl, and a portrait of her mother as George Washington impersonating Queen Elizabeth are all examples of Dingle's work that not only subvert notions of identity and power, but also speak to her humorous expansiveness as an artist. K.M.

Untitled (prisspaper with blue hair), 1998

oil on wallpaper on wood
60 × 48 in. (152.4 × 121.9 cm)
Museum purchase with funds from Joyce and Ted Strauss and the Elizabeth W. Russell Foundation, 1998.41.1–2

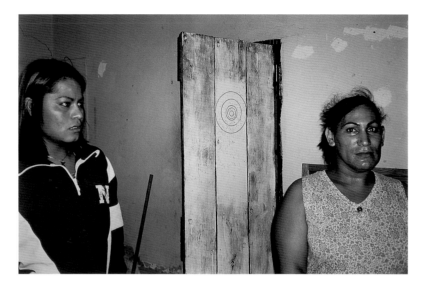

*Que Linda La Brisa / How Lovely the Breeze
(Lisa, Samantha, and Tanya),* 1999
Museum purchase with funds provided by the Joyce R. Strauss Fund, 1999.39

*Que Linda La Brisa / How Lovely the Breeze
(Tanya and Samantha),* 1999
Museum purchase with funds provided by the Joyce R. Strauss Fund, 1999.40

*Que Linda La Brisa / How Lovely the Breeze
(Samantha and Jacaranda),* 1999
Museum purchase with funds provided by Dr. Charles and Monica Cochrane,
1999.41

Que Linda La Brisa / How Lovely the Breeze (Tanya), 1999
Museum purchase with funds provided by Dr. Charles and Monica Cochrane,
1999.42

Que Linda La Brisa / How Lovely the Breeze (Lisa and Tanya), 1999
Museum purchase, 1999.43

all chromogenic prints, 1 of 3 artist's proofs
20 × 24 in. (50.8 × 61 cm) each sheet

James Drake explores geographic and emotional
borders, the ambiguous areas between affluent soci-
eties and developing countries, between hope and
desperation, freedom and incarceration, male and
female. A native Texan based in the border town
of El Paso, Drake spends years learning about and
interacting with members of fringe communities,
photographing their daily lives. In addition to
photography, Drake has worked in drawing, sculp-
ture, and installation, always focusing on Mexican-
American border culture and the political issues
inherent in the subject. His works investigate the
complex concerns found at the geographic nexus
of the border, yet go beyond that specific pressure
point to comment on the impact that extreme economic
stress and the arbitrary demarcation of nations impose
on human lives.

In *Que Linda La Brisa / How Lovely the Breeze,* Drake docu-
ments the world of a group of Mexican transvestites and
transsexual prostitutes working near the El Paso–Juárez
border. In Drake's poignantly domestic photographs of
sexual professionals getting ready for work, he subtly
unearths layers of emotional, political, and gender deceit,
employing an intimate snapshot style in presenting the
public face of private lives in a marginalized culture. The
artist came to know his subjects through his involvement
with an organization dedicated to improving the lives of
sexual professionals by preventing and treating disease
and abuse. To cross over into these subcultures, Drake
first builds a relationship of trust with his subjects, most
of whom came to America from central Mexico and work
at a bar called La Brisa, in the border town of Juárez. Their
lives seem imprisoning, regulated by difficult rou-
tines and dangerous business. The details captured
in Drake's images—an alarm clock and a picture
of Christ hung over an unkempt bed in a squalid
pink room—emphasize the hardships of their
existence. His aim is not to indulge in voyeurism,
but rather to show people shaped by the tension
of marginalized existences. S.H.

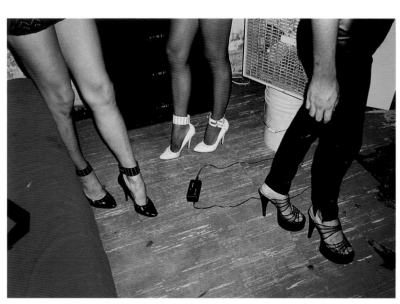

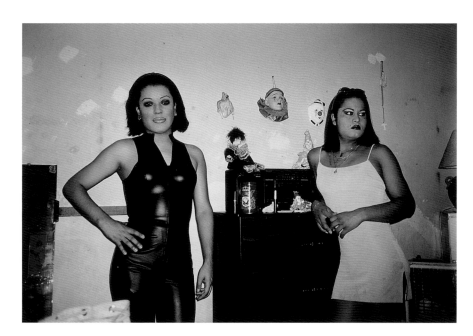

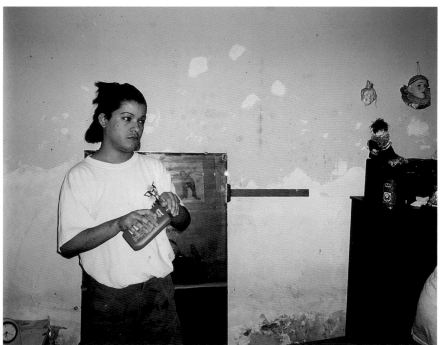

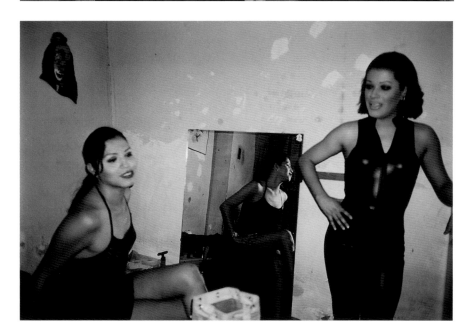

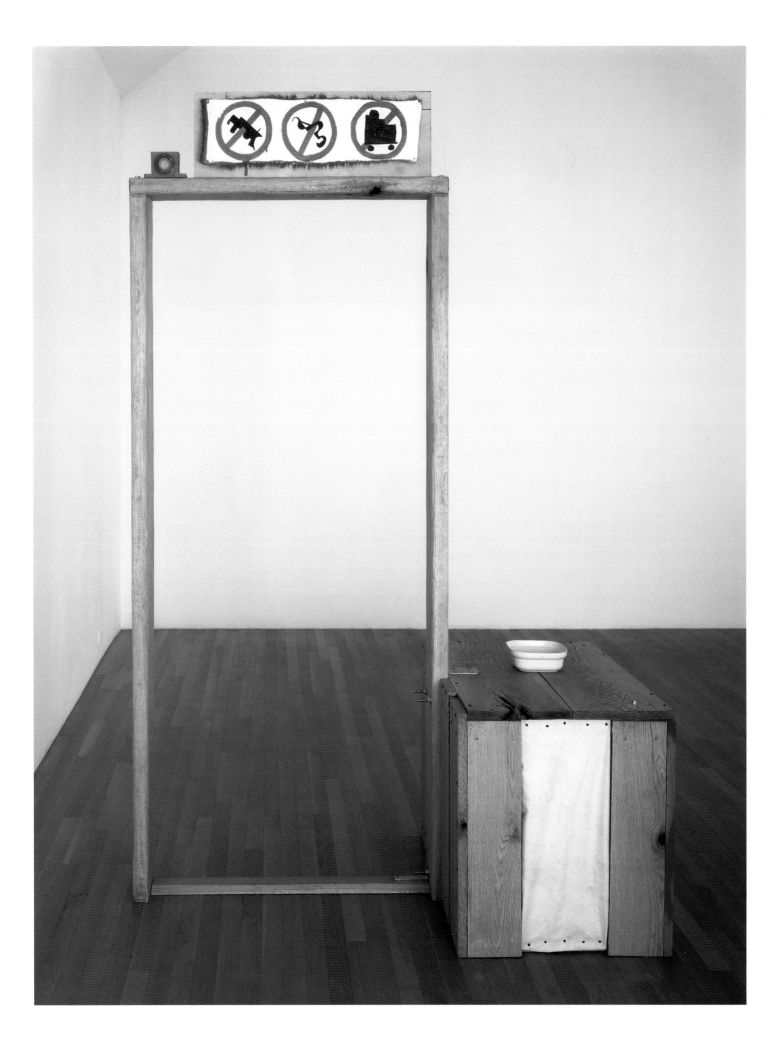

JIMMIE DURHAM
American, born 1940

A poet, writer, political activist, performance artist, and sculptor, Jimmie Durham defies stereotypes of Native American peoples and cultures in both his art and life. Born on a Cherokee reservation but not officially registered as a Cherokee, Durham lacks federal recognition of his heritage and identity, a fact that informs his artistic practice. While Durham's work remains fundamentally tied to his heritage, it never casts itself as specifically Native American. In fact, he refuses to fetishize difference, preferring to ambiguously integrate identity into his pieces. Durham describes his work as "neo-primitive, neo-conceptualism,"[1] emphasizing his juxtaposition of intellectual response and an anticraftsmanship aesthetic.

Durham's work considers incongruities in objects and experiences. In *Forbidden Things* a "metal detector" made of crudely assembled wood confronts the viewer. Durham copied the idea for *Forbidden Things* from a similar device he saw in a Mexico City bus station. All passengers passed through the detector even though its wooden structure was clearly useless. Nevertheless, the device implied authority and intimidation, and walking through it provided a sense of security. Next to Durham's wooden structure, a small bowl rests on the side table ready to hold keys or other objects that would set off an alarm. Above the gateway are three ambiguous pictograms, derived from Rorschach tests, their images canceled with the official "no" symbol. Durham is commenting on the symbolic and real roles of this device: it represents both governmental authority and intimidation, and provides a sense of security, albeit false, to travelers who pass through it. His commentary extends to the absurdity of authorities' efforts to control the traffic of people and goods, as he humorously suggests scanning for certain illegal states of mind. S.H.

Forbidden Things, 1993
oak, raw canvas, polyester resin, acrylic on untanned deerskin, plastic bowl
89 × 56¾ × 32⅜ in. (226.1 × 144.1 × 82.2 cm)
Museum purchase with funds from the Elizabeth W. Russell Foundation, 1995.8

1. Ralph Rugoff, "Laminated Warrier," *L.A. Weekly*, Sept. 10–16, 1993, 41.

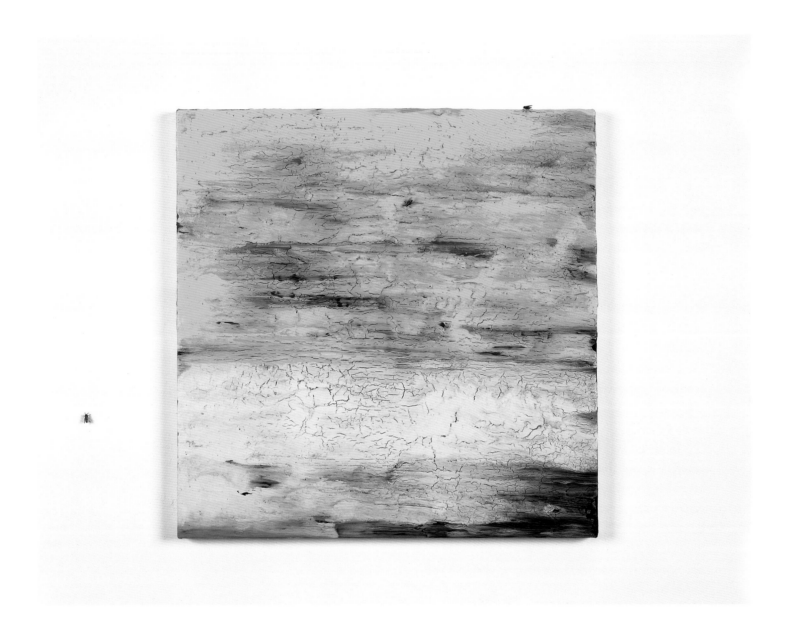

Faya, 1998
acrylic on canvas, cast epoxy, fiberglass, wire, oil paint
overall dimensions variable; canvas: 24 × 24 in. (61 × 61 cm)
Museum purchase with funds from the Ansley I. Graham Trust,
Los Angeles, 1998.34.1–5

VERNON FISHER

American, born 1943

Texas artist Vernon Fisher makes paintings, drawings, sculptures, photographs, and installations that take a humorous, often absurdist approach to illuminating the mysteries of nature and culture. For his images he looks to scientific illustrations, historic photographs, and found objects like dental casts and bathroom sinks. Like Zen *koans*, paradoxical riddles that challenge us to embrace the illogic of life, Fisher's work mixes painting, text, and three-dimensional objects to spin out multiple, open-ended narratives.

Faya consists of a richly weathered abstract painting, done in acrylic cut with alcohol to produce a cracked surface, combined with four meticulously detailed handmade flies made from plastic and wire and painted with oil. Randomly named for a small oasis city in Chad, the work is a tongue-in-cheek meditation of the Latin saying *ars longa,* *vita brevis,* or "art is long, life is short." Throughout the twentieth century, critics have argued whether painting is dead—whether it is possible to paint new and relevant images after artists have experimented with every conceivable version of realism and abstraction. Part of a series called Zombies (a reference to painting's survival after its purported demise) *Faya* positions timeless "high" art in the world of death and decay. In seventeenth- and eighteenth-century European still lifes featuring food or flowers, flies are often depicted as memento mori symbols. The flies, two of which rest on the painting, Fisher points out, are undiscriminating critics: "they will land on anything."[1] While making an ironic commentary on the state of the medium, Fisher demonstrates the potential still residing in painting by creating a compelling hybrid of realism and abstraction. T.K.

1. Author's conversation with the artist.

LLYN FOULKES

American, born 1934

Art is Love is God, 1991
mixed media
60 × 60 in. (152.4 × 152.4 cm)
Gift of Kati Breckenridge, 1999.57

Los Angeles–based artist, musician, and performer Llyn Foulkes is a highly individualistic artist whose surreal assemblages and collages confront the viewer with comic and ironic images. A member of the community of 1960s Southern California artists associated with the Ferus Gallery in Los Angeles, Foulkes has rooted his painting in a critique of power in the modern world. He employs instantly recognizable imagery and trompe l'oeil effects to convey a dark vision of American culture in trouble, and has taken on American corruption as a personal burden. For Foulkes, mass-marketed, Disneyesque culture signals the emptiness of American society and the soullessness of our nation that is epitomized in the Disney corporation's squeaky clean symbol, Mickey Mouse.

Although he earned his reputation for his 1960s Pop paintings that recall large-scale postcards of desert land-scapes, Foulkes repudiated the Pop movement in 1969 and continues to rail against its flat, thin images, preferring to use painting to question social systems of power. *Art is Love is God* conflates the visual narrative structure of cartoon imagery, consisting of separate panels of simple line drawings and color, with Foulkes' personal rhetoric: "If God is good why does he kill?"; "Maybe G-O-D is money."; "Why of course it's a free country!" These panels are framed by letters whose texts and doodles are barely decipherable. His imagery includes a tiny Superman, the epitome of a diminished and powerless superhero spouting platitudes. He uses collaged elements and familiar icons to hook viewers into an alternative point of view from preprogrammed corporate imagery. Foulkes' inflammatory text questions clichés regarding freedom, religion, and political control, as he continues the struggle to affect his audience.

S.H.

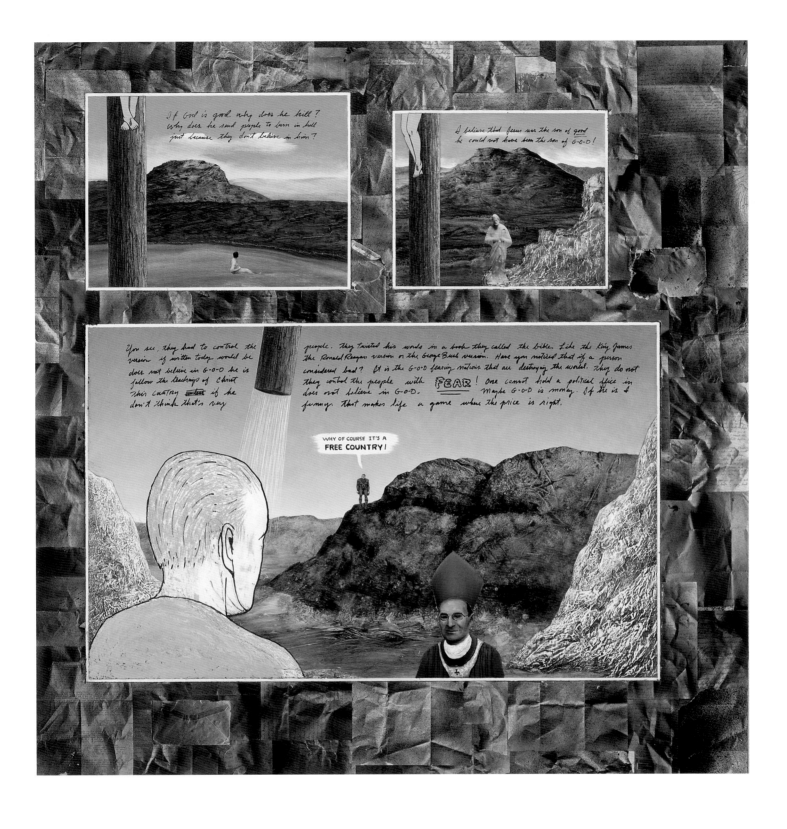

Silvia Gruner utilizes the disciplines of anthropology, archaeology, and architecture to question how objects and customs produce national and cultural identities. Throughout the 1990s, Gruner worked with photography, video, performance, and site-specific installations to create multilayered works that explore personal and collective concerns of assimilation and the continuum of history. While developing El Nacimento de Venus (The Birth of Venus) in Mexico City, the artist found a Swedish soap-making machine marked with a swastika. That discovery was the catalyst for a meditation of her family's traumatic passage from Europe to Mexico. In 1945 Gruner's grandmother and mother were rescued from a Nazi concentration camp and a year later arrived in their adopted homeland of Mexico.

Gruner subsequently used a video of the soap machine in her installation along with a group of objects—four videos featuring the words and hands of her mother and grand-mother, and the soap-making machine grinding; wall texts by the artist; crates of boxed soap; and an industrial scale weighing a batch of soap. The installation provides a non-linear narrative with multiple voices of tragedy and survival recounted by the generations of women in her family. The combined weight of the soap figurines on the scale repre-sents the exact body weight of the artist, and the figurines also evoke the stories of Jews being made into soap by the Nazis and the issue of ethnic cleansing. The soap is shaped into Mexican pre-Columbian figures, and on their backs are stamped serial numbers, recalling the numbers tattooed onto concentration camp victims. The silver spoon serves as a symbol of memory, representing the only family item to survive from that period. These shifting modes of inter-pretation change according to the personal experiences of each viewer, thus allowing the artist to circumvent official and institutional histories. Like all of Gruner's work, this installation explores the ways in which subjective notions of memory and history are created and conveyed.

M.G.

El Nacimento de Venus (The Birth of Venus), 1995
mixed-media installation
dimensions variable
Museum purchase with funds from Dr. Charles C. and Sue K. Edwards
and the Elizabeth W. Russell Foundation, 1998.30.1–20

Learning Curve (still point), 1993
single-channel video installation, 5-inch black-and-white monitor,
plywood
54 × 32⅝ × 225¾ in. (137.2 × 83 × 573.4 cm)
Museum purchase, Contemporary Collectors Fund, 1998.13.1–16

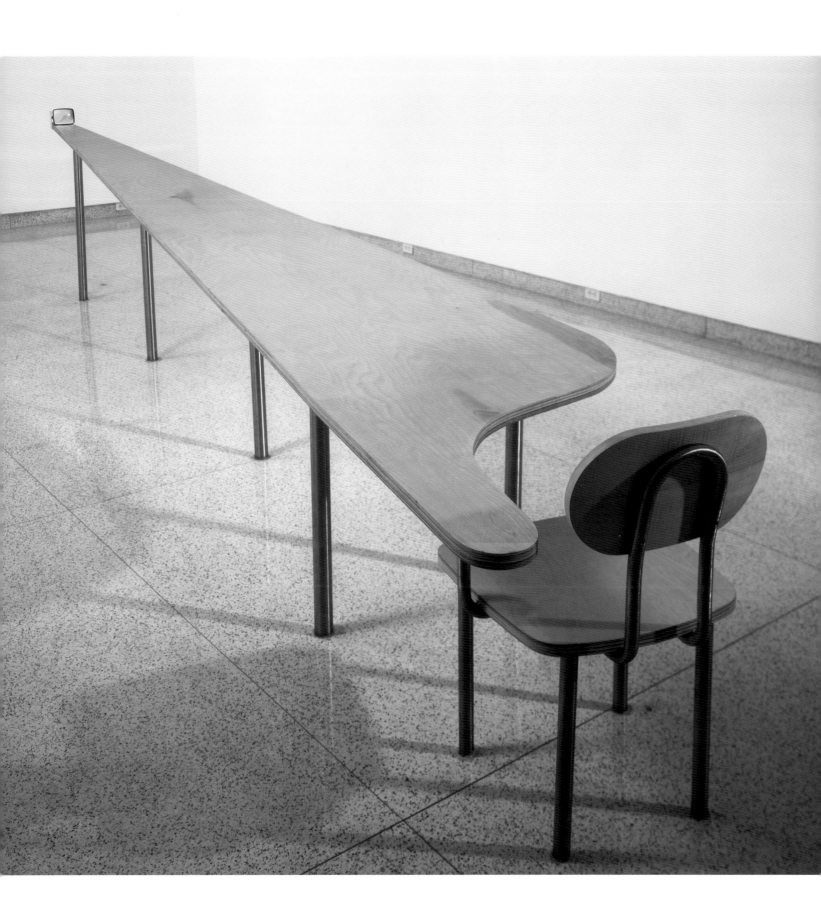

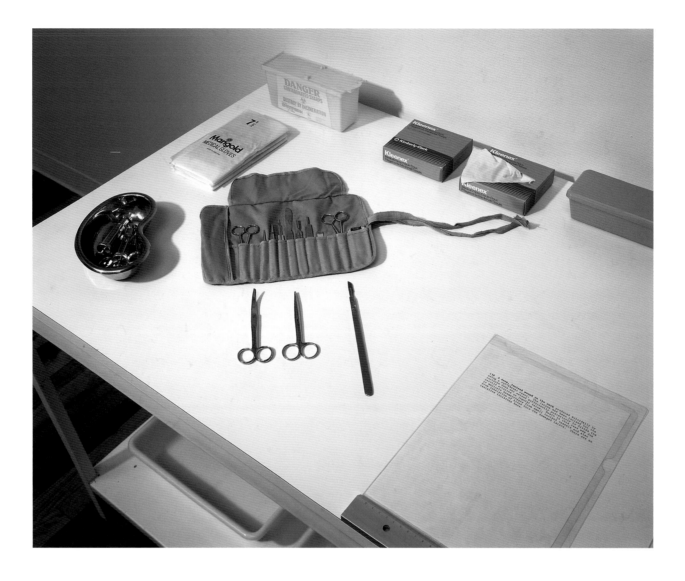

A key figure in the vibrant London art scene of the 1990s, Damien Hirst earned an international reputation for sensationalistic, often shocking work. Hirst came to the forefront of contemporary art in the late 1980s when he organized the exhibition *Freeze*, featuring a group of young and often controversial artists, which signaled a new, entrepreneurial, and irreverent phase in British art. Hirst's work covers a diverse range of forms; infamous displays of bisected animals in formaldehyde, banal machine-made "spin-art" paintings, and pharmaceutical supplies.

Mortality is a prominent theme in Hirst's work, and the artist's fascination with death and the human body's losing struggle against disease and decay directs the content of many of his pieces. He often works with real objects and real situations, conflating science and art as a means to draw attention to society's unquestioning willingness to accept the edicts of modern science, while at the same time viewing contemporary art with a large degree of skepticism. *When Logics Die* presents the viewer with two versions of death—one an accident, the other a suicide. The sterile lab table and autopsy instruments objectify the deaths, which are each described by a written narrative and graphic photograph. Yet, this clinical presentation cannot protect the viewer from the visceral shock of the display. The medical table and equipment lend a chilling physicality to the work's two grisly photographs. From this forensic evidence and descriptive texts, the viewer is left to construct the victims' stories. Hirst presents life through the examination of death. The ambiguous, philosophical title, *When Logics Die*, suggests both the randomness of death—whether by choice or fate—and the powerlessness of science (or art) to comprehend what it may be like. T.K.

DAMIEN HIRST

British, born 1965

When Logics Die, 1991

painted Formica and metal table, assorted medical supplies, color
photographs
table: 30 × 84 × 30 in. (76.2 × 213.4 × 76.2 cm); 2 photographs: 16 × 32 in.
(40.6 × 55.9 cm) each
Museum purchase, Contemporary Collectors Fund, 1994.2

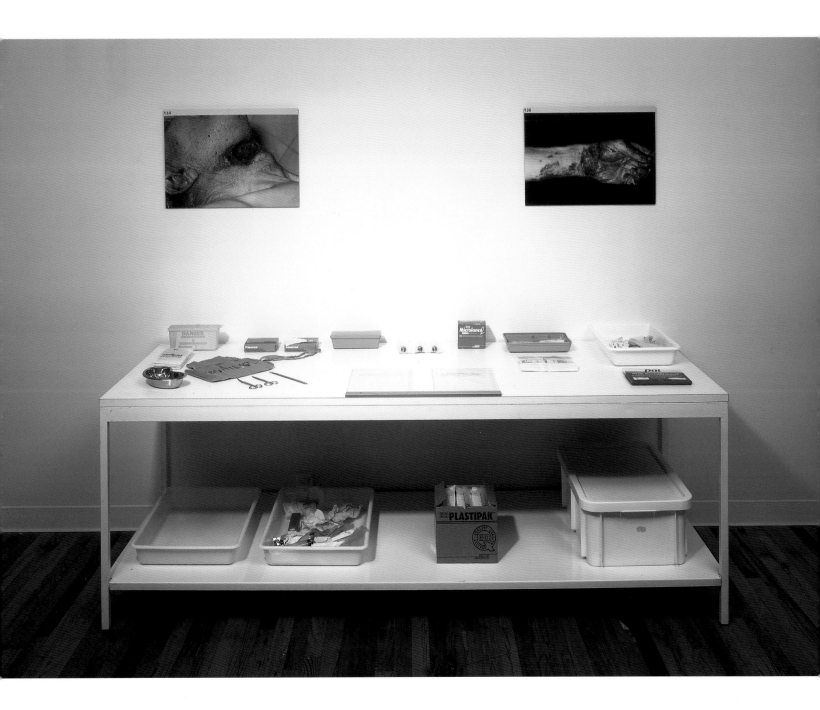

ZHANG HUAN
Chinese, born 1965

 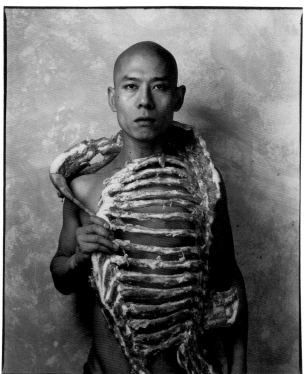

1/2 (Meat #1) (Text), 1998, edition 3 of 15

1/2 (Meat #2) (Meat), 1998, edition 1 of 15

1/2 (Meat #3) (Meat and Text), 1998, edition 6 of 15

chromogenic prints on Fuji archival paper
37 × 31 in. (94 × 78.7 cm) each
Extended loan and promised gifts of anonymous donor, EL.1999.1.1–3

Zhang Huan was trained as a painter in a traditional European academic realist style. At age twenty-seven, he abandoned painting in favor of more socially engaged forms of art—performances, sculptures, and photographs that reflect the often grim conditions of his life and the lives of many of his fellow Chinese. While his paintings celebrate beauty and technical perfection, Zhang Huan's new work emphasizes violence, masochism, and marginalization. Projects such as *12 Square Meters,* in which the artist covered himself in honey and fish oil and sat for hours in a fly-infested public latrine, and *To Raise the Water Level in a Fish Pond,* in which the artist and a group of disenfranchised workers used their bodies to displace water in a fish pond, illuminate social problems in post-Maoist China. In the 1/2 series, Zhang Huan photographs his own body three times: once draped in the rib cage of a freshly butchered pig, once covered in Chinese calligraphy, and once wearing the writing and the bones. The melding of flesh and language (the writing on the artist spells out such phrases as "Buddha," "concept," "accurate and wrong," and "rich and poor") may suggest that the human condition is one half ideas and transcendence and one half meat and death. T.B.

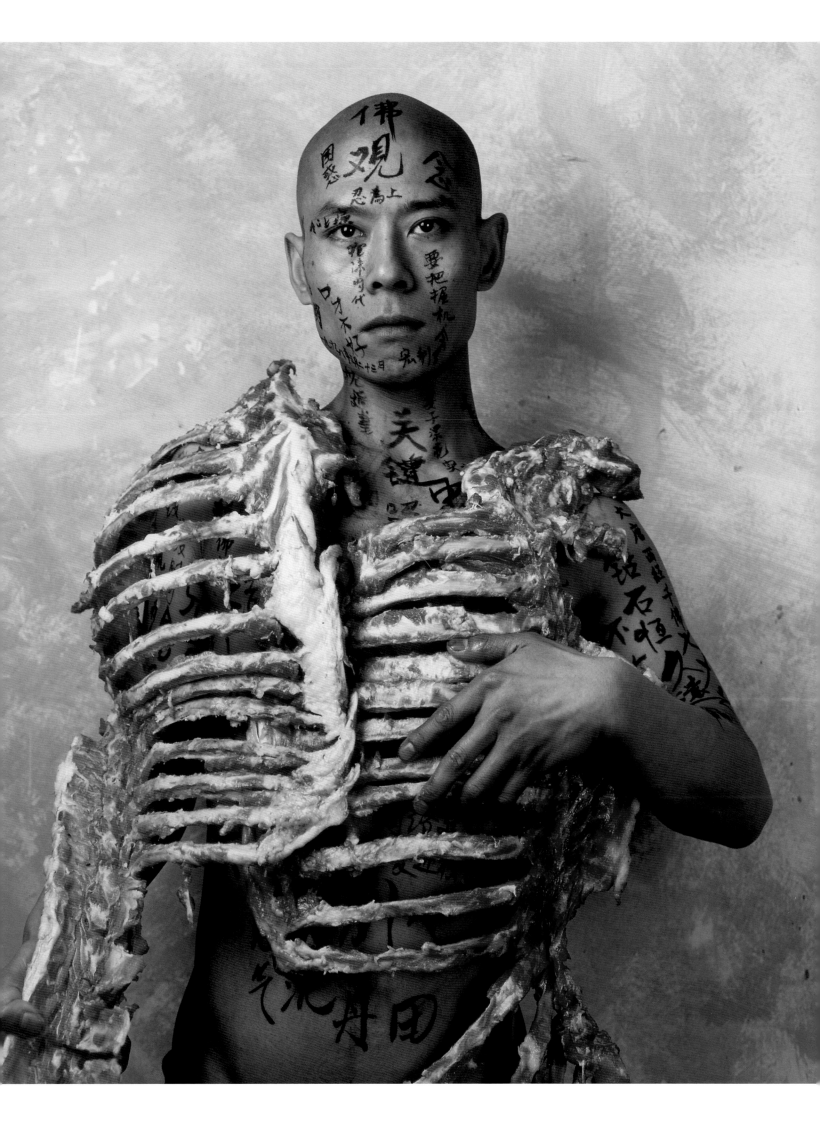

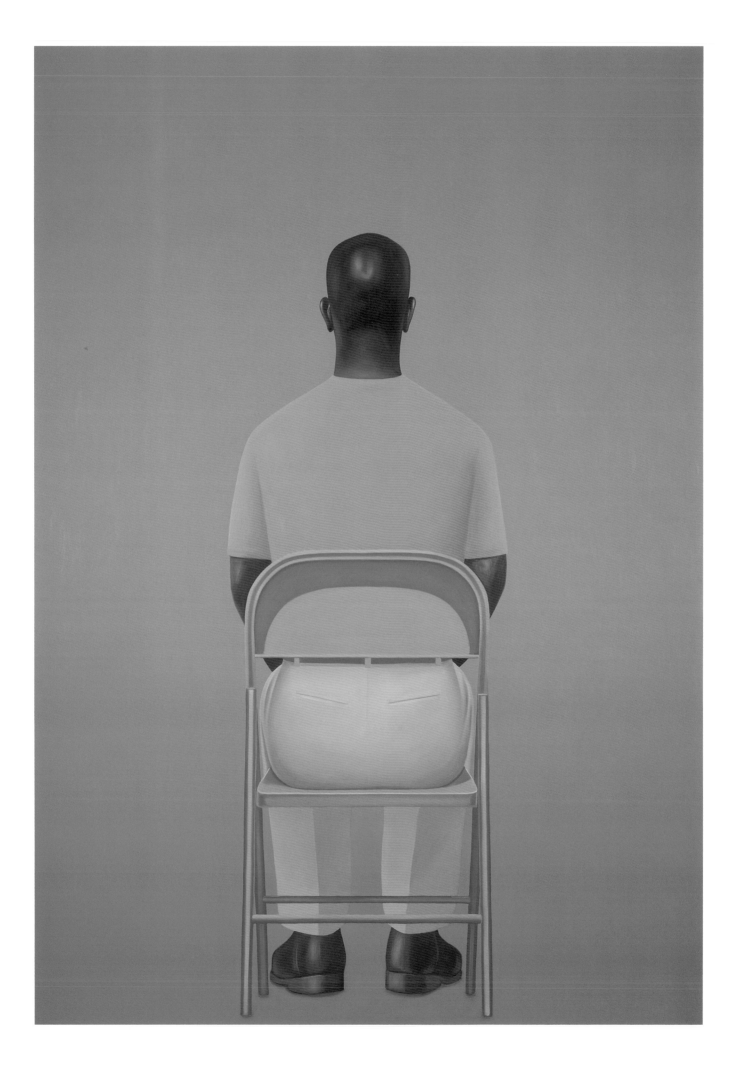

SALOMÓN HUERTA

American, born Mexico, 1965

Untitled Figure, 2000

oil on canvas on panel
68 × 48 in. (172.7 × 121.9 cm)
Museum purchase, Contemporary Collectors Fund, 2001.9

Salomón Huerta challenges the conventions of portraiture in a series of rear views of men's heads and bodies. Historically, portraits relied upon detailed renderings of facial expressions to commemorate the sitter's character. Huerta, on the other hand, offers a generic male type with a shaved head and nondescript clothing. Even the title of the work promotes anonymity. But Huerta lavishes attention on the few visual details he allows into the paintings. The ears and folds of skin are painted with the precision of a Renaissance master. Like his images of the facades of unadorned homes in South Central Los Angeles, Huerta's quiet and careful surfaces suggest complicated interior lives.

In the same way that Huerta subverts traditional expectations of portraiture, he also questions how we perceive identity. The detailed skulls that appear throughout the series reference the nineteenth-century practice of phrenology that used the shape of the skull to assess mental facility, moral character, and racial affiliation. Skin color is the only identifying characteristic that Huerta conveys in the work, which at the same time shows a distinct absence of stereotypical racial characteristics. The luminous tones of his palette celebrate the beauty of skin color and the ethnic and racial identities that accompany it. R.T.

WILLIAM KENTRIDGE
South African, born 1955

Untitled from WEIGHING . . . and WANTING, 1997–1998
mixed-media installation composed of 2 drawings and a video projection,
charcoal, pastel, gouache on paper (film transferred to video disc)
dimensions variable, suggested room dimensions: 14½ × 19 ft. (442 × 579.1 cm)
Museum purchase with funds from the MCASD Board of Trustees, 1997–1998,
in honor of Hugh M. Davies, 1998.15.1–5

William Kentridge's 1998 film *WEIGHING . . . and WANTING*
is the seventh in a series begun in 1989 chronicling the life
of fictional character Soho Eckstein, a wealthy white South
African industrialist. The title of the work comes from the
biblical tale of the Babylonian king Belshazzar to whom
mysterious handwriting appeared on a wall: "You have been
weighed in the balance and found wanting, for you have not
humbled your heart before God, so your kingdom has come
to an end." Throughout the film, Eckstein moves between
inner and outer landscapes—between his home and his
memories, and the ghostly remnants of his industrial empire
outside. Picking up a rock that slowly morphs into an MRI
brain scan, then into a shattered image of his wife and later
a mine shaft, Eckstein literally and metaphorically weighs
the psychic and physical import of his personal and cultural
identity as husband, businessman, and white South African.

Elliptical and suggestive rather than linear and narrative,
Kentridge's films have a raw, hand-wrought quality. Unlike
stop-frame animation, in which thousands of individual
images create a seamless moving sequence, Kentridge uses
perhaps only twenty drawings per film—adding, erasing,
and adjusting aspects of one image many times over. Each
alteration is photographed to become a single frame of an
animated sequence, resulting in dreamlike images merging
from one into another, with traces of previous forms and
configurations lingering in the background. Kentridge's
drawings are not direct depictions of apartheid and its dis-
mantling. However, his subjects and technique are unmis-
takably informed by the complex historical, social, and
political contexts of his homeland. His technique metaphori-
cally parallels the acts of effacement and remembrance that
characterize South Africa's postapartheid state—a nation
erasing, drafting, and redrawing itself. K.M.

Drawings from *Untitled from WEIGHING . . . and WANTING*, 1997,
charcoal and pastel on paper, 22 × 30 in. (55.9 × 76.2 cm) each

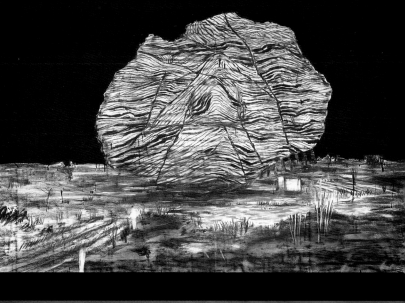

IN WHOSE LAP

DO I LIE

'DOO ID

MARTIN KERSELS

American, born 1960

Twist, 1993

gear motor, motor speed control, bridge rectifier, wood, metal, rubber bands, prosthetic leg, sock, shoe
dimensions variable: approx. 120 in. (304.8 cm) high
Museum purchase, Contemporary Collectors Fund, 2001.10

Martin Kersels began his career as a performance artist, working alone and as a member of the Los Angeles–based dance-and-performance collaborative Shrimps. Realizing that the opportunities for performance art were limited, he decided to make works of visual art that would translate the concerns of performance—movement, timing, sound, staging, and the audience's empathy—into three-dimensional objects. Calling his work "performative objects," Kersels makes animated sculptures that enact simple, often comical activities—part backyard science experiments and part popular culture inspired tantrums.

Among his creations are a crude simulation of a microwave oven using a pool speaker and the artist's yells to raise the temperature of a container of water an infinitesimal amount; a "flame speaker" that plays the Eagles classic 1970s rock hit "Hotel California"; and a piano that winches itself across a gallery, amplifying the sounds of its own destruction. Kersels has stated, "Through the use of simple mechanics, I tried to animate these pieces so that they had their own personalities. . . . I wanted to make work that came off the wall and took over a space."[1]

Twist consists of a prosthetic leg attached to a motor via a tangled rope made of more than 10,000 rubber bands. As the motor twists, the rubber bands coil tightly until the leg breaks free of the wall and starts to flail wildly. The fleshlike rubber bands, the poignant details of the worn shoe and sock, and the spasmodic jerking of the leg lend the work a disarming physicality. Watching this disembodied limb kicking away at the gallery wall, viewers must decide whether they are watching slapstick comedy or something more sinister and tragic. T.K.

1. "Interview with Martin Kersels by Toby Kamps, January 1997, Madison, Wisconsin," in *Commotion: Martin Kersels*, exh. cat. (Madison: Madison Art Center, 1997), 4.

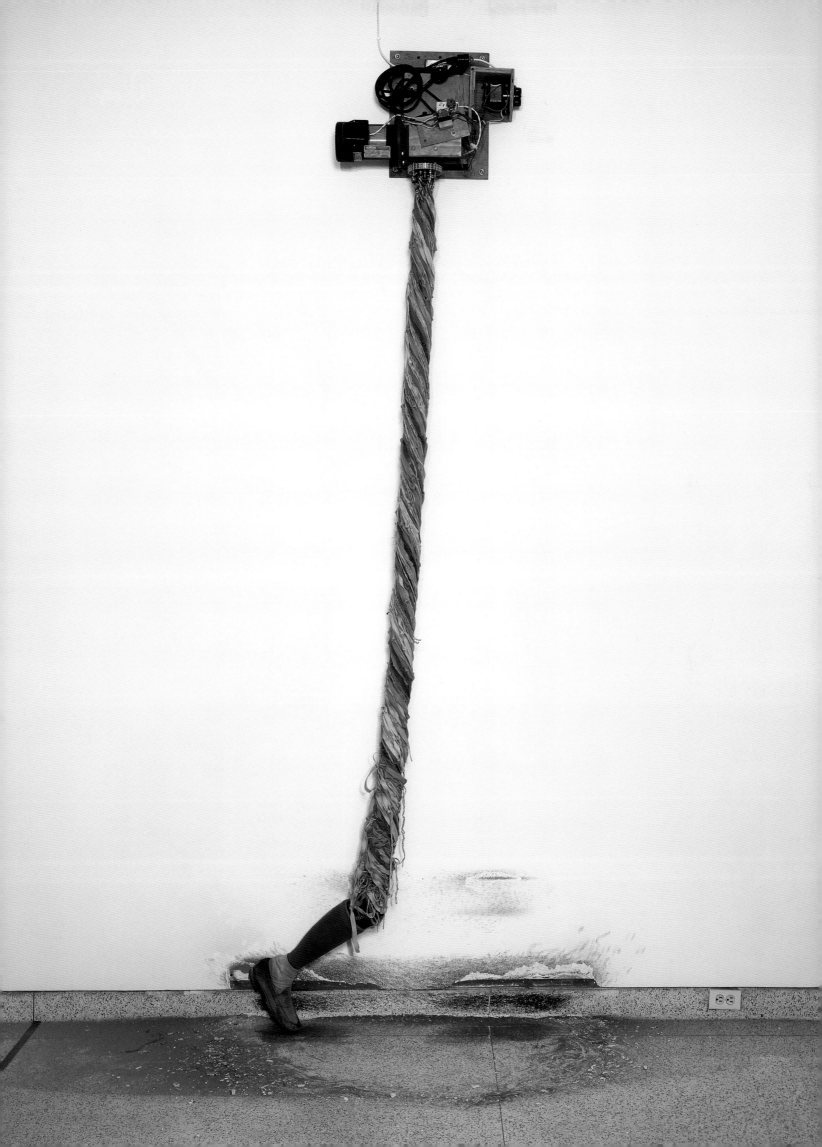

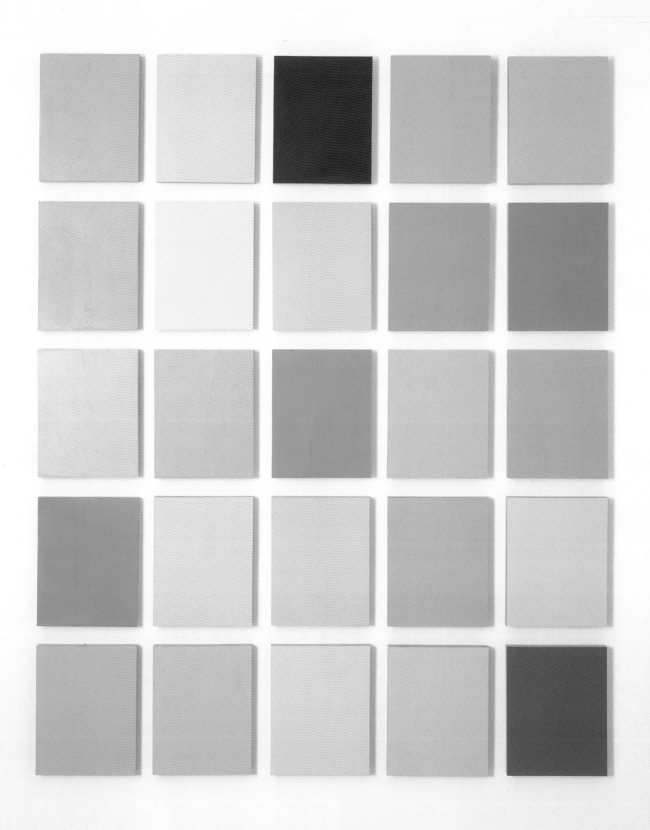

American, born 1961

Synecdoche: Barbara Arledge, C. W. Kim, Carol C. Wallace, Carolyn P. Farris, Carolyn Yorston, Charles G. Cochrane, Christine Forester, Christopher C. Calkins, Colette Carson Royston, David Guss, Edgar J. Marston, Jr., Heather Metcalf, Joseph J. Lipper, Kathleen Connor, L. J. Cella, Mason Phelps, Matthew C. Strauss, Murray A. Gribin, Neal R. Drews, Patrick Ledden, Pauline Foster, Robert J. Nugent, Robert L. Shapiro, Sue K. Edwards, Victor Vilaplana (left to right, top to bottom), 1994

oil and wax medium on panel
25 panels: 10 × 8 in. (25.4 × 20.3 cm) each
Museum purchase, Contemporary Collectors Fund, 1994.15.1–25

Byron Kim investigates the relationships between the body, cultural diversity, and formalist concerns. Using grids of color panels, Kim combines his interest in abstract painting with the broader social and political implications of skin color. At first glance *Synecdoche*, part of a larger, ongoing investigation, appears to be a study of formal relationships between subtle shades. On closer inspection the work is revealed to be a portrait of MCASD's Board of Trustees, comprised of twenty-five panels arranged alphabetically according to the sitter's first name. The work's title, *Synecdoche,* is a rhetorical term referring to a figure of speech in which a fragment represents a whole, much as the individual panels each represent a different sitter. Color variations taken from the sitters' forearms become a palette of subtle fleshtones, metaphors for the individual as well as a cultural profile for the group.

Working in the tradition of monochromatic painting, Kim challenges the well-established canons of abstract painting by creating works reminiscent of the reductive, geometric images of painters like Ad Reinhardt but that, paradoxically, are also portraits. As he states: "I am making an abstract painting, but their subject matter is so concrete. In a sense these paintings are representations, even figurative."[1] Kim gives a new twist to the role of portraitist—cognizant of external factors in the perception of a person rather than focusing on internal personality. Preoccupied with the modernist fascination with the flatness of the picture plane and the surface of paint, Kim plays off the fact that this surface is commonly referred to by art historians and critics as the "skin" of the painting. M.G.

1. *1993 Biennial Exhibition*, exh. cat. (New York: Whitney Museum of American Art, 1993), 28.

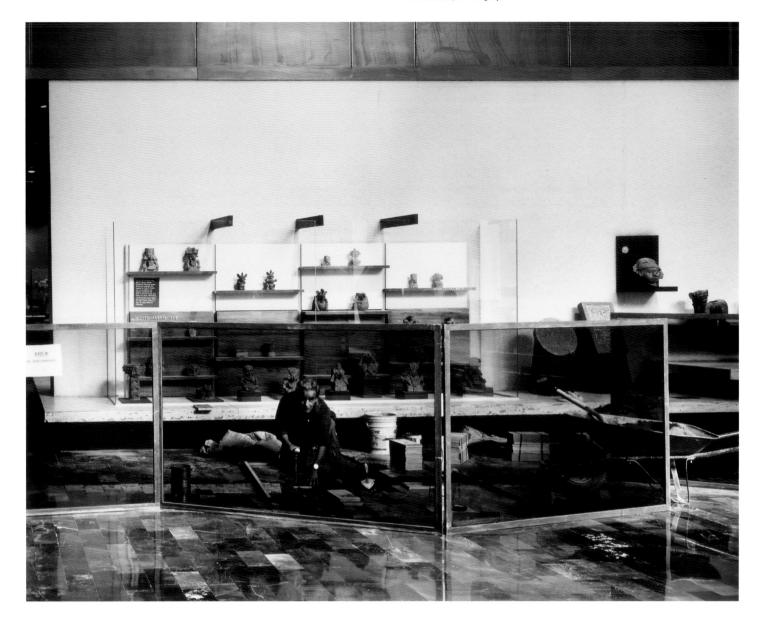

*Enrique Nava Enedina: Oaxacan Exhibit Hall, National Museum
of Anthropology, Mexico City, 1999*

chromogenic prints, edition 1 of 6
3 prints: 49 × 61½ × 2¼ in. (124.5 × 156.2 × 5.7 cm) each framed
Museum purchase, Contemporary Collectors Fund, 1999.19.a–c

Sharon Lockhart makes photographs and films that examine representations of the individual, the group, and culture in general. Inspired by anthropological studies, advertising strategies, Northern European painting, and the hypnotic, minimal action of dance and experimental film of the 1970s, Lockhart carefully stages her scenes to create philosophically charged, enigmatic atmospheres and open-ended narratives. Traveling the world in search of compelling themes and settings, she evokes the private minidramas we all construct while observing others. Often enlarged to the size of small movie screens, Lockhart's pictures toy with many of the same issues, problems, and goals commonly associated with film.

In the triptych *Enrique Nava Enedina: Oaxacan Exhibit Hall, National Museum of Anthropology, Mexico City*, Lockhart captures a worker as he repairs a stone floor in front of a display of pre-Columbian sculpture. By emphasizing the play of reflections on the polished floor, the Plexiglas barricade around the worksite, and the glass display cases, and calling attention to Enrique Nava Enedina's gaze back at us, Lockhart invites speculation on the complex processes of looking and interpreting that occur in museums and in most human encounters. To convey the singularity of an instant, she dwells on the minutiae of the particular settings her figures inhabit. The transparent barricade, for instance, effectively places Enedina on display, like an art work or ethnographic specimen. Enedina essentially becomes a living artifact among indigenous relics. The viewer is forced to contemplate larger issues of cultural heritage, colonialism, and identity.

At first glance Lockhart's images appear to be spontaneously candid, but they are in fact methodically styled and completely contrived. Working in the new photographic tradition associated with artists such as Jeff Wall, Lockhart acts as director of her photographs. She casts her subjects like actors, scouts for locations, sets props and lights each scene, frames the picture through the camera lens, discusses the shot with assistants, and then steps back while a professional camera operator takes the picture. And yet, for all the control that goes into their making, Lockhart's images ultimately take on a candid reality of their own, as if the artist happened upon the scene. S.H.

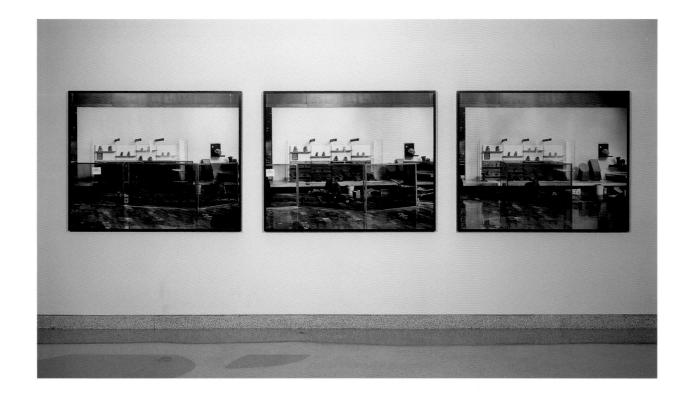

CHARLES LONG
American, born 1958

Fred, 1999

rubber, brass, edition 1 of 3
32 × 42 × 20 in. (81.3 × 106.7 × 50.8 cm)
Museum purchase, Contemporary Collectors Fund, 1999.20

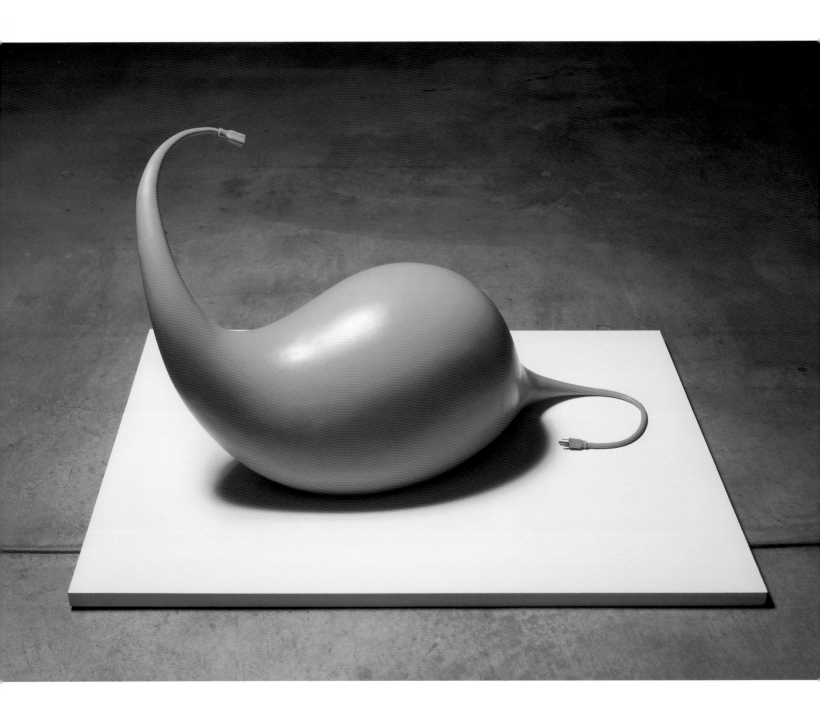

Charles Long creates playfully cartoonish, anthropomorphic abstract sculptures made with unusual materials including rubber, paper pulp, and coffee grounds. While some of his biomorphic shapes recall Surrealist sculptures, Long's ingenious post-Pop imagery is influenced by such diverse topics as electronic music, Chinese scholar rocks, Rococo furniture, and 1960s science fiction. Such a sensibility has led him to cast popcorn kernels in bronze and to collaborate with the British electro-lounge band Stereolab to create sculptural multiple-user listening stations.

Long's anthropomorphic forms blur the distinctions between animate and inanimate. With an electrical outlet for a head, and a plug for a tail, *Fred*'s combination of organic form and electrical components playfully suggests a being whose energy is self-produced and self-sufficient. By titling the work *Fred*, Long implies a kind of portrait, and bestows a gender on an inanimate object that has the mechanisms of both female and male. About his works, he has stated: "I use my role as a sculptor to bring out latent physicality in a culture on the edge of the information age, to remind people that at the end of every wire is a flesh-and-blood body."[1] In addition to the humor of his works, Long rigorously deals with the sculptural questions of volume, space, texture, and color to create psychologically charged forms. Bright orange and smooth-surfaced, with the seamless appearance of a mass-manufactured consumer item, *Fred* references the heightened prominence of industrial design in today's commercial products. S.H.

1. Raphael Rubinstein, "Shapes of Things to Come," *Art in America* (November 1995), 100.

JEAN LOWE
American, born 1960

Living with Nature, 1996–1997
wood, papier-mâché, enamel, resin, brass clock with glass dome
overall: 91½ × 56 × 19½ in. (232.4 × 142.2 × 49.5 cm)
Extended loan and promised gift of Dr. Fred and Erika Torri, EL.1998.1.1–15

San Diego artist Jean Lowe creates a sense of false comfort with her decorative carpets, furniture, and wall coverings. What is at first familiar and domestic becomes, upon further inspection, strange and subversive. The objects' immediate decorative impact overshadows the caustic imagery. Only after inspection of her lavish spaces do we notice small recurring motifs that expose the conceit: images of suburban tract housing and empty parking lots, and scarred landscapes devoid of foliage.

A significant portion of Lowe's work attempts to illuminate the impact of humans on the natural environment, and to explore the continuum of degradation that is eroding our natural ecosystems. Her landscape paintings—with their dammed-off rivers and encroaching subdevelopments—are subtle reminders of the ever-fragile relationship between humans and the natural world. The Rococo-style, salonlike domestic interiors of Lowe's installations—featuring decorative images of nature in their ornamental details—suggest a long tradition of idealizing the landscape and aestheticizing reality.

The central focus of *Living with Nature* is a mock sculptural clock in the form of the ancient Greek sculpture Laocoön. The writhing mythological hero struggles to conquer and control an enormous snake. Man's drive to control nature and culture is a central theme of Lowe's work, and details gradually reveal the artist's vision of the impact of human beings on nature. The landscape painting features nature overrun by the spread of encroaching urban environments. Incorporating humorous visual puns and double entendres, the titles on the books in the ornate bookcase ironically refer to sexual and material greed, for example, *How to Be a Bon Vivant, Living with Nature,* and *Origins of Syphilis.* Lowe views her installations as a means by which to orchestrate her messages. Through this unfamiliar juxtaposition of opulence and politics, she forces her audience to rethink what they take for granted, while lessening the sting of her message through humor. S.H.

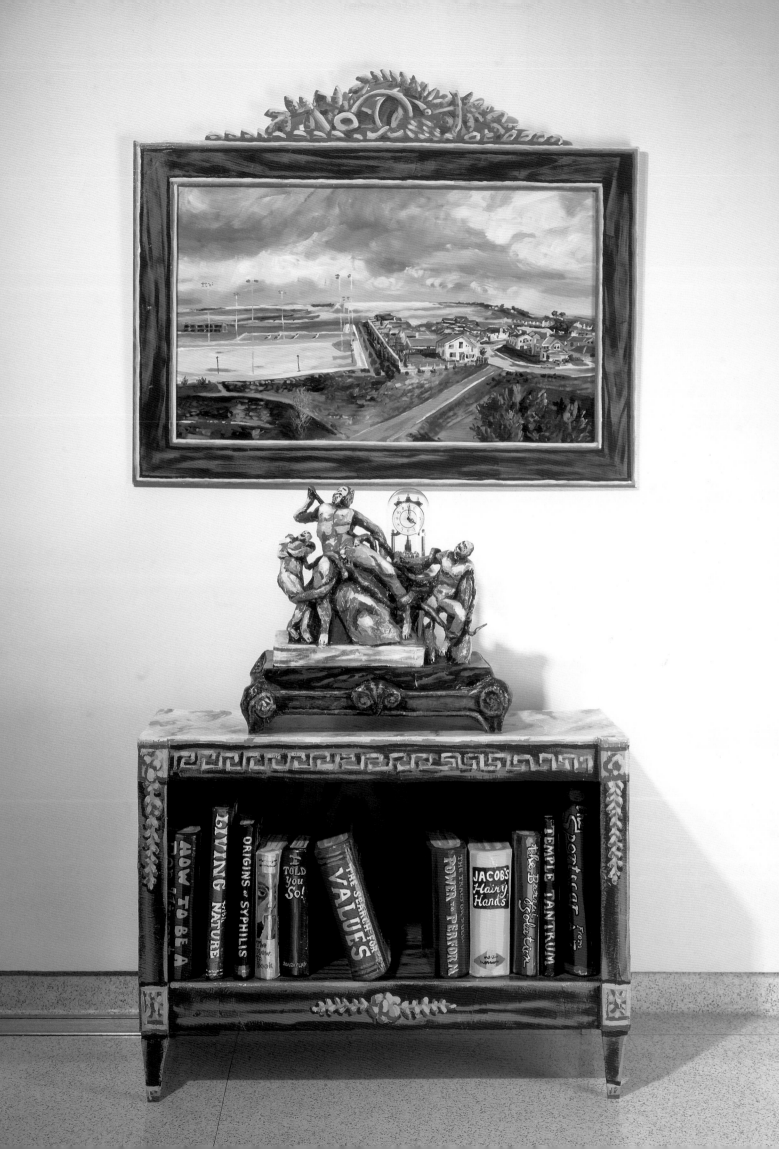

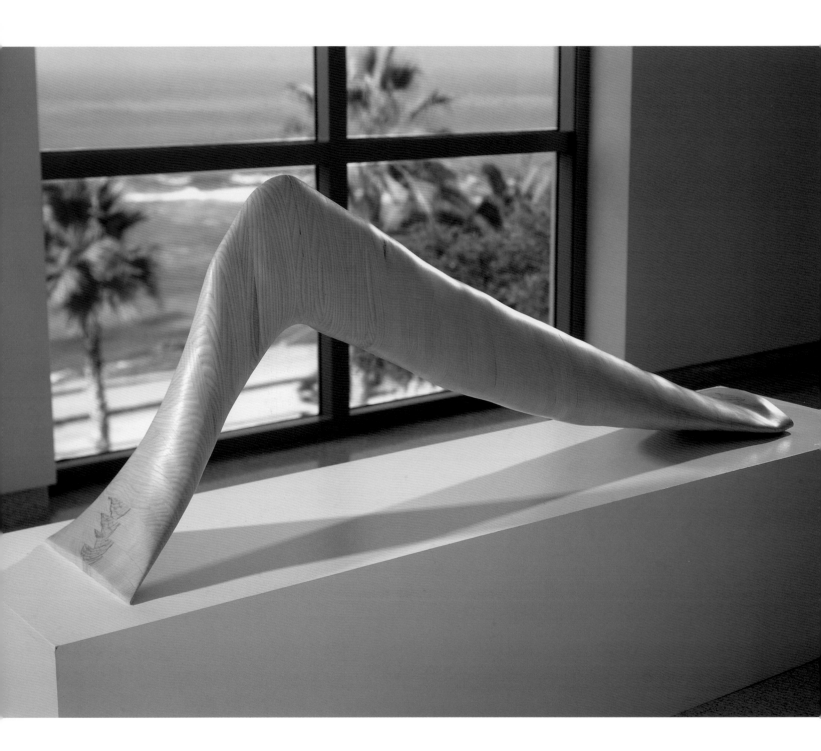

American, born 1944

2nd Corpse, 2000

laminated and carved ash
30 × 75 × 16 in. (76.2 × 190.5 × 40.6 cm)
Gift of the Betlach Family Foundation and Nancy B. Tieken,
through the N.B.T. Foundation, 2001.13.a–c

New York–based artist Loren Madsen makes sculptures whose shapes derive from statistical data. Although they seem like playfully abstract organic forms, Madsen's works are multidimensional graphs plotting complex historical trends such as cost-of-living indexes, public opinion polls, and homicide and execution rates. He has created visual analogs for public opinion about many of society's most pressing issues. Through his work, Madsen hopes to establish structures by which viewers can reorient themselves in a world undergoing permanent cultural, social, technological, and economic revolutions.

The inchworm-shaped sculpture *2nd Corpse* is a three-dimensional representation of a set of national homicide statistics. In this elegant, corpselike form born of ugly circumstances, Madsen analyzes murder rates by graphing the number of people killed by guns and other means as well as the number of shooters from ages one to ninety, the range for which the government keeps statistics. The length of *2nd Corpse* is divided into ninety equal parts of laminated and carved wood, each representing a year of age, moving from the thin horizontal to the thick vertical end. The width of each section is determined by the average number of non-shooting homicides per year (from 1976 to 1998) for people at that age. The number of shooting homicides sets the vertical dimension, while the number of shooters in that age bracket determines the height of the arch under the sculpture. By giving concrete form to the information we are accustomed to receiving as dry numbers, Madsen prods a fresh visualization and understanding of emotionally charged social developments. S.H.

*The Controversy Surrounding the "Veronese" Vase
(From the office of Luigi Zecchin)*, 1996

blown glass, metal shelving, bulletin board, drawings, text
overall: shelves with vases: 84 × 35½ × 12 in. (213.4 × 90.2 × 30.5 cm);
bulletin board: 37¼ × 25¼ in. (94.6 × 64.1 cm)
Museum purchase, 1997.20.1–50

A master glassblower, Josiah McElheny aims to erase the customary distinctions between the fine and the decorative arts while also toying with the viewer's sense of fact versus fiction. He conducts meticulous research to make glass objects based on traditional styles and techniques that date from ancient Rome. These "period pieces" are then framed within a tableau that resembles museum displays, complete with documentation.

In *The Controversy Surrounding the "Veronese" Vase (From the office of Luigi Zecchin)*, McElheny relates the story of Luigi Zecchin, a professor of mathematics, who in 1920 drew versions of a glass vase depicted in a painting of the Annunciation by the Renaissance artist Paolo Veronese. Zecchin commissioned the Venini glass company in Murano, Italy, to reproduce the vase. On the surface, this work presents a didactic display of the products of Zecchin's quest for the perfect three-dimensional version of the vase depicted in the painting, including detailed notations describing how each vessel was copied. The vases and the presentation, however, are all fabricated by McElheny. The work illustrates how our relationship to objects is dictated by our perception of them as originals, and questions the authoritative nature of museum displays. M.G.

VIK MUNIZ
Brazilian, born 1961

 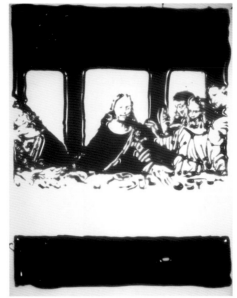

Milan (The Last Supper) (from Pictures of Chocolate), 1997
cibachrome prints
3 parts: 38 × 28 in. (96.5 × 71.1 cm) each unframed
Museum purchase, Contemporary Collectors Fund, 1999.21.a–c

Vik Muniz has said, "Things look like things, they are embedded in the transience of each other's meaning: a thing looks like a thing, which looks like another thing, or another."[1] Muniz creates photographic illusions. He begins with an image, replicates it in a common material—tomato sauce, granulated sugar, thread, dust, soil, and most recently skywriting—and photographs the result. In *Milan (The Last Supper)*, Muniz re-creates Leonardo's famous fresco in chocolate syrup. These photographs question society's use of images. "I have done some pictures after better known works," Muniz has explained, "but I tried to play down their iconographic value by emphasizing their perceptual output. I did Leonardo's *Last Supper*, for example, but I wasn't thinking of Leonardo. I was thinking of perspective and the idea of the Eucharist as an early form of broadcasting."[2]

According to Muniz: "There are two things that are constant in my work, I'm always portraying things that represent other things. And I'm always representing things that exist for a limited amount of time."[3] After Muniz creates the drawings, the images survive only in their photographic documentation. In the case of *Milan (The Last Supper)*, the artist licked up all traces of the chocolate immediately after photographing the work. This emphasis on the ephemerality of images is a commentary on the history of photography. Photography's inventors (which included scientists in Brazil, the artist's homeland) confronted the essential challenge of how to "fix" ghostly images caught on paper. Muniz's work captures the experimental spirit as well as the magical nature of early photographs. R.T.

1. Mark Alice Durant, "When the Duck's Beak Becomes the Rabbit's Ears: Vik Muniz and the Alphabet of Likeness," in *Vik Muniz: Seeing Is Believing* (Santa Fe, N.M.: Arena Editions, 1998), 141.

2. Charles Ashley Stainback, "Vik Muniz and Charles Ashley Stainback: A Dialogue," in *Vik Muniz*, 37.

3. Debra Solomon, "The Way We Live Now: 2-11-01: Process; Ars Brevis," *New York Times Magazine* (February 11, 2001), sec. 6, 32, col. 3.

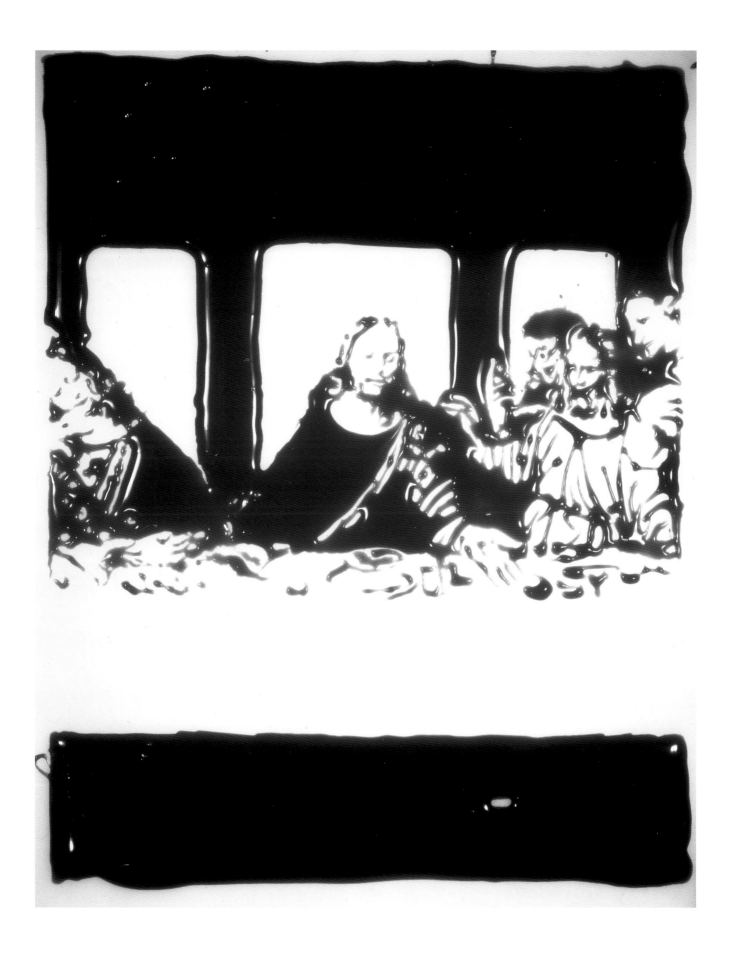

GABRIEL OROZCO
Mexican, born 1962

Rio de basura (River of Trash), 1990
cibachrome, print edition of 5
12½ × 18¾ in. (31.8 × 47.6 cm)
Gift of Marian Goodman Gallery, New York, 1996.19

Gabriel Orozco uses the world as his studio. Traveling widely and living and working in the United States, Europe, and his native Mexico, Orozco makes art inspired by chance encounters, by engaging the minor, corner-of-the-eye visual experiences that make up everyday life. Rejecting a signature style or medium, he responds to the artistic potential in the objects and events he encounters in his journeys, either recording what he sees or gently intervening to create compelling new forms. He makes photographs and video works that document simple, real-world aesthetic events, such as breath on a piano; creates sculptures out of disposable materials, like a wall relief composed of clear yogurt container lids; transforms everyday objects, for instance, by removing a 62-centimeter-wide section from the length of a shapely French Citroen DS sedan; and creates variations on familiar games with their own open-ended logic, such as *Ping-Pond Table*, a four-sided ping-pong table with a lily pad pool in its center. In all his work, Orozco transforms familiar forms into compelling works of art that deftly call attention to the beauty and poetry in the common things that fill the world. Orozco says, "I'm trying to change the scale in terms of gesture. For me, the breath on the piano is as important as the DS, and I think if they are both important, good or whatever, then they have the same power to transform. One is a big important historical car, more expensive to make, and the other is just breath on a piano. The two have the same power to change something. Does this make sense?"[1]

Orozco's photographs, such as *En la fábrica de algodon, Paleta derretida, Colchón sin hogar,* and *Rio de basura,* explore the web of connections between people and the objects around them. Whether collecting images of humble yet aesthetically charged objects like melted popsicles, old futons, and a trash-filled riverbed, or creating impromptu works by the simple, playful gesture of tucking wads of cotton under the racks of bicycles, Orozco creates daydreams. His visual haiku call to mind the multiple layers of consciousness underlying the intentional or accidental structures of material reality and the often magical results of chance happenings. T.K.

1. Robert Storr, "Gabriel Orozco: The Power to Transform—Interview with Robert Storr," *Art Press*, no. 225 (June 1997), 27.

En la fábrica de algodon (At the Cotton Factory), 1993

cibachrome print, edition of 5
12¼ × 18½ in. (31.1 × 47 cm)
Museum purchase with funds from Joyce and Ted Strauss,
1996.13

Paleta derretida (Melted Popsicle), 1993

cibachrome print, edition of 5
18¾ × 12½ in. (47.6 × 31.8 cm)
Museum purchase with funds from Joyce and Ted Strauss,
1996.14

Colchón sin hogar (Futon Homeless), 1992

cibachrome print, edition of 2
12½ × 18¾ in. (31.8 × 47.6 cm)
Museum purchase with funds from Joyce and Ted Strauss,
1996.15

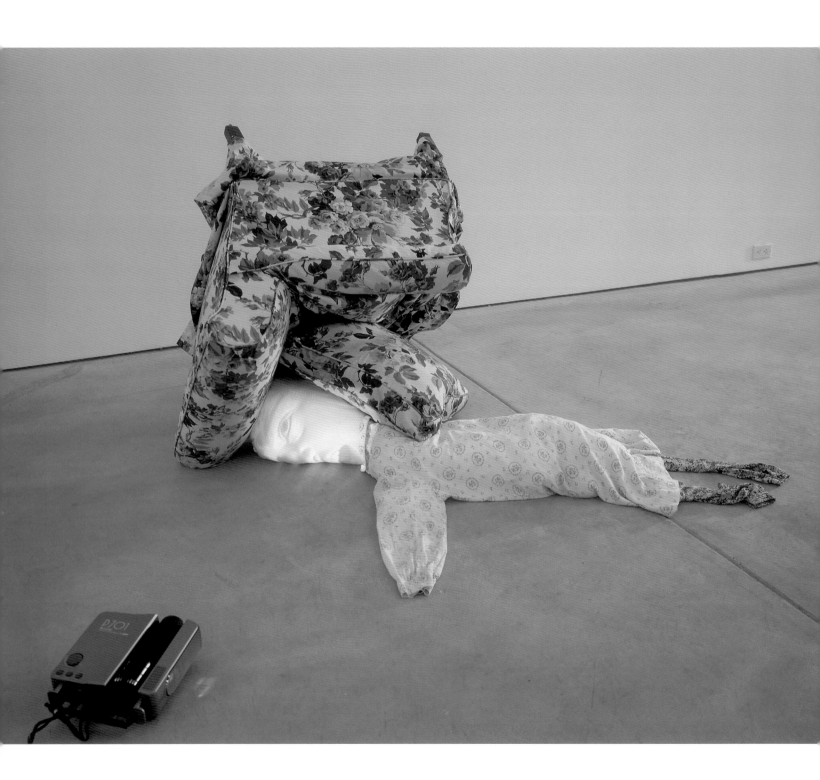

American, born 1957

Don't Look at Me, 1994

701 video projector, VCR, videotape, armchair with cushion, cloth figure
dimensions variable
Museum purchase, Contemporary Collectors Fund, 1995.1.1–10

For Tony Oursler, "video is like water, this completely ethereal art form that's been boxed for forty years in television."[1] Oursler's work has stretched the potential of video art by releasing the image from the confines of a box. He started making videos while a student at the California Institute for the Arts. At the time, "it seemed like a natural direction to go from a square of the canvas to the box of the television, but there was always the problem of having a giant box of the television set to deal with."[2] In the early 1990s, when small projectors became commercially available, Oursler began to animate canvases, bouquets, jarred specimens, cloudlike wads of cotton, and heads with live-action video. *Don't Look at Me* is one of Oursler's "video effigies"—deflated, hand-stitched dolls with blank faces onto which he projects video images. By situating the doll under a cushion of an over-turned armchair, Oursler created an oddly homespun fusion of installation, video, and performance art.

In *Don't Look at Me* the face of performance artist Tracey Leipold is projected onto the head of a female doll wearing a flannel nightgown. The flowered upholstery and clothing appear unthreatening, until the doll cries out: "Don't look at me!" "Get away from me!" "You're making me sick!" Her shouts and darting eyes engage and repel viewers. This curious coupling of opposites—passive and aggressive, inside and out—is a central theme of the work. Oursler has explained that the attraction and repulsion these dolls embody are a critical reflection upon the insidious role of the media in American culture: "People are alienated and siphoned off from any real cultural experience by movies and TV."[3] According to Oursler, the media satisfies a deep human need for images, but it concomitantly shakes our grasp on reality. Oursler sees the woman in *Don't Look at Me* as "infected" by visual media. She is his attempt to dis-comfit the viewer and provoke interaction with someone else's reality. "I was interested in viewer empathy, and the way people can feel someone else's joy or pain, and the dolls were experiments in that. I think the struggle that we have in postmodern art is to reconnect with the audience."[4]

R.T.

1. Matthew Ritchie, "Tony Oursler: Technology as an Instinct Amplifier," *Flash Art* (January–February 1996), 78.

2. Ibid.

3. Ibid.

4. Jo Ann Lewis, "At the Hirshhorn, Dolls with Attitude," *Washington Post* (July 5, 1998), Sunday Arts, G1.

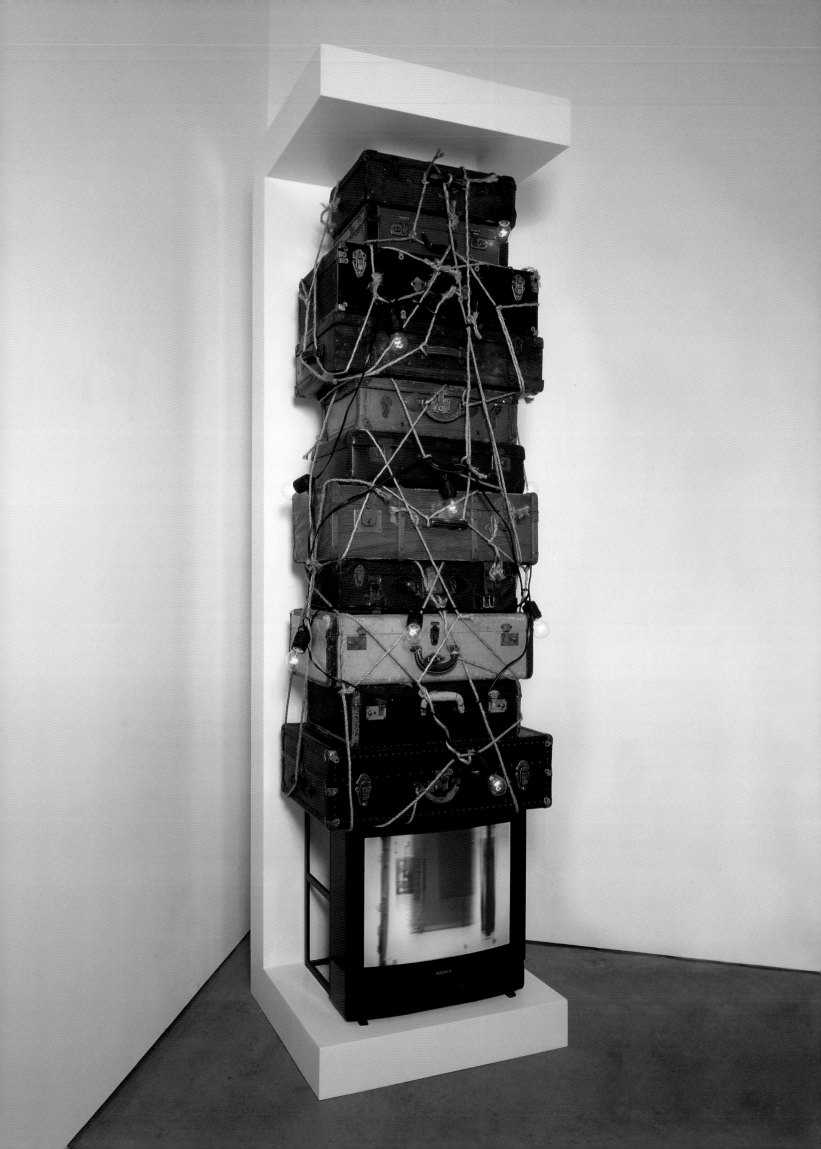

FABRIZIO PLESSI
Italian, born 1940

La Cariatide dei poveri (The Caryatid of Poverty), 1998
single-channel video installation, television monitor, 12 suitcases,
rope, electrical cord, lightbulbs
118 × 40½ × 24 in. (299.7 × 102.9 × 61 cm)
Museum purchase, Contemporary Collectors Fund, 1999.22

Italian artist Fabrizio Plessi has earned an international
reputation for his video sculptures, which combine sound
and video images with raw materials like marble, steel, glass,
wood, and water to create spectacular, large-scale sensory
environments. Plessi is inspired by the *arte povera* ("poor art")
movement, which emerged in Italy in the 1960s. *Arte povera*
employs commonplace materials to address nature, history,
and everyday life, but what sets Plessi apart from Mario
Merz, Michaelangelo Pistoletto, and other practitioners
is the fact that he integrates electronic imagery into his
simple, elegant sculptural forms. Plessi creates what he
calls a "clash . . . between the poverty of primary materials
and the transforming richness of technology."[1]

Named for a caryatid (a supporting column in human
form seen in ancient Greek architecture), this work is in-
spired by the plight of refugees from the wars in Yugoslavia.
Plessi says, "The *Caryatids of the Poor* were born precisely
from the thought of the migrations, the displacements,
the painful political and social instability of those people.
Former Yugoslavia, the Balkans, Poland, Russia, Eastern
Europe are nothing but enormous containers of caryatids."[2]
The battered suitcases, bare lightbulbs, and video images
of X-rayed luggage—trappings of airports, harbors, and
train and bus stations—suggest the hardships and expo-
sure faced by refugees and migrant workers. These indi-
viduals, who literally carry their lives with them, Plessi
suggests, bear the weight of the world. The video footage
was recorded at an airport in Cologne, where Plessi taught
courses in the "humanization of technology" at the city's
Academy of Media Arts. T.K.

1. *Fabrizio Plessi*, exh. cat. (New York: Guggenheim Museum Soho, June 17–
September 13, 1998), n.p.

2. Fabrizio Plessi in conversation with Evelyn Weiss, cited in *Fabrizio Plessi*, exh.
cat. (Mainz and Munich: Chorus-Verlag für Kunst und Wissenschaft, 1998), 335.

KENNETH PRICE

American, born 1935

Yang, 2000

acrylic on fired ceramic
27 × 22½ × 17½ in. (68.6 × 57.2 × 44.5 cm)
Museum purchase, Contemporary Collectors Fund, 2001.11

Ken Price's amorphous ceramic sculptures invite a multitude of associations while remaining resolutely abstract. The bumps, curves, and swells of *Yang* allude to themes as diverse as Darwinian evolution and human sexuality. With its iridescent textured surface, the work resembles a giant, undulating tongue covered in multicolored taste buds. To create *Yang* Price used an unorthodox method of slowly firing his clay and then coating it with layers of paint. He then sanded the bumps to reveal the layers of color underneath. These bumps spread across bulges that seem to morph subtly as you move around the sculpture. From one vantage the sculpture suggests aquatic creatures—mantas, turtles, prehistoric cephalopods—emerging from a primordial sea. Viewed from a different angle the work's swelling becomes frankly sexual. Yang, the masculine principle of Chinese cosmology, is constantly in search of yin to achieve harmonious balance.

Price has produced important work since the 1960s, when he was known as Peter Voulkos' star student. Voulkos was one of the first artists to challenge the traditional understanding of ceramics as wheel-thrown or slab-built vessels. Like his mentor, Price was inspired by Abstract Expressionist painting and experimented with intuitive methods, organic shapes, and rough textures to create ceramic objects that did not have an obvious function. *Yang*, one of Price's most recent sculptures, is testimony to the artist's long and inventive career. R.T.

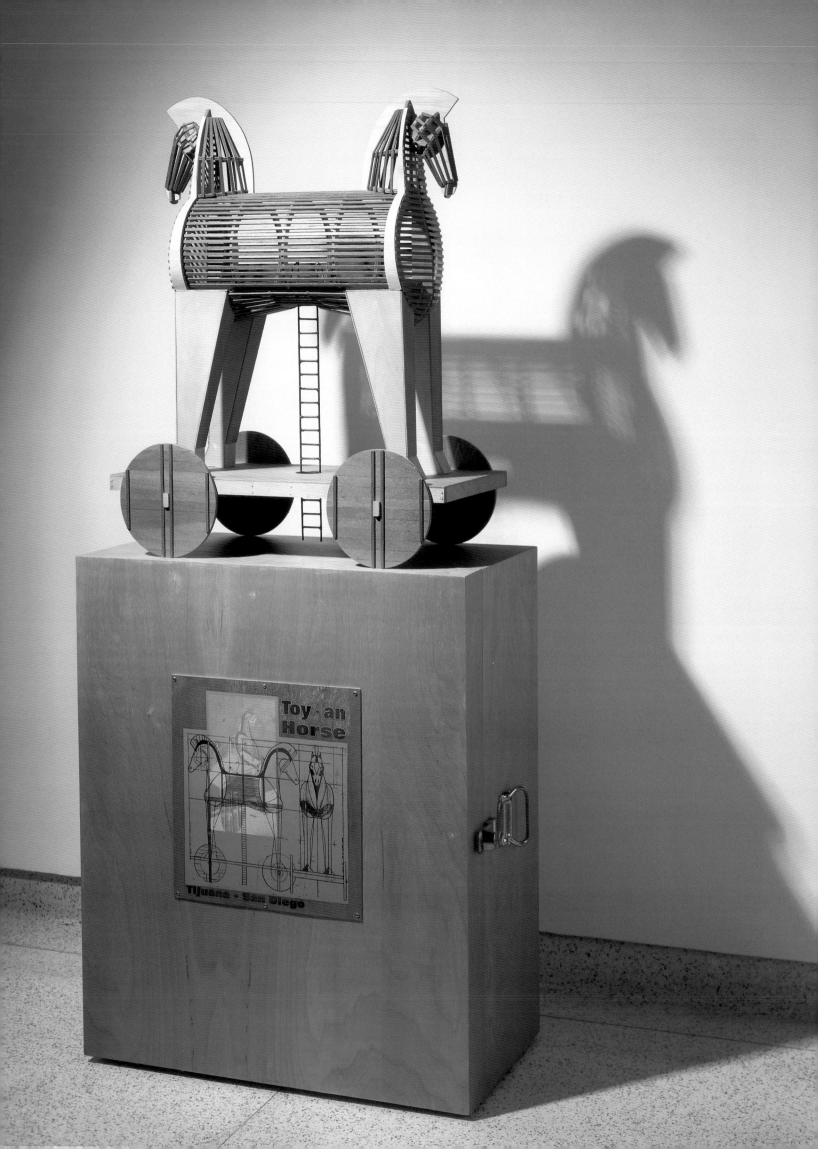

Mexican, born 1961

Marcos Ramírez, also known as ERRE, from the Spanish pronunciation of the first letter in his surname, creates large-scale public installations informed by a political and social consciousness. Often his sculptures describe his vantage point as an artist working on both sides of the border. In his widely acclaimed outdoor, site-specific works at the international public art exhibitions staged in San Diego and Tijuana, inSITE 94 and inSITE 97, he addressed the dynamics of the border between the United States and Mexico. While the placement of his works may be specific, Ramírez wants his work to be broader: "I may speak of local issues, but they are universal issues. The work I make has to do with cultural frontiers."[1]

Toy an Horse is a small-scale version of a large, 33-foot-high outdoor sculpture commissioned for inSITE 97 that occupied a traffic island at a border crossing site, straddling the boundary line between the United States and Mexico. The double-headed toy horse—one head oriented toward Mexico, the other toward the United States—is a powerful reminder of the interdependence of the two cultures. By locating his work at the country's most heavily trafficked border crossing, Ramírez focuses on the conundrum of illegal immigration and cultural imperialism. The sculpture references the legendary Trojan horse of Virgil's *Aeneid*, but in Ramírez's version the work's lattice strips of wood allow the viewer to see into and through the horse's body. Any concealed soldiers are no longer hidden. In its contemporary context, a two-headed Trojan horse raises questions about who is invading whom, and whether we see the interchange between our cultures as a kind of invasion. S.H.

1. Lorenza Munoz, "Sculptor Holds a Mirror Up to His Mexico," *Los Angeles Times* (May 20, 2000), F1.

Toy an Horse, 1997, installed at inSITE 97

Toy an Horse, 1998

wood, metal, hardware, edition 1 of 10
overall: 69 × 31 × 14¾ in. (175.3 × 78.7 × 37.5 cm)
Museum purchase and gift of Mrs. Bayard M. Bailey, Mrs. McPherson Holt in memory of her husband, Catherine Oglesby, Mrs. Irving T. Tyler and Mr. and Mrs. Scott Youmans by exchange, 1999.11.a–b

DAVID REED
American, born 1946

#312–3 (for Ellen Browning Scripps), 1992–1996–1998

oil and alkyd on linen
30 × 166 in. (76.2 × 294.6 cm)
Museum purchase in honor of Elizabeth Armstrong, 1999.24

David Reed celebrates painting's sensuality and illusionism by rendering marks that appear three-dimensional but are actually flat. Lacking real texture, the monumental, swirling forms evoke the Abstract Expressionist notion of the signature gesture of the artist's hand, yet their flatness negates any heroic associations and points to earlier representational traditions. A great admirer of Baroque and Mannerist art, Reed has likened the markings in his work to the billowing cloaks that cover the figures in Baroque painting. A native San Diegan, Reed has had a longstanding relationship with the Museum of Contemporary Art, having taken art classes at the museum as a boy. *#312–3 (for Ellen Browning Scripps)* pays homage to the

original owner of the home that is now the location for the museum's galleries.

Sensuous in its folding ribbons of brushstrokes and lurid colors, the smooth surface of *#312–3* shows no trace of the artist's touch; it instead provides a visual experience akin to viewing projections of art work. The smooth, glossy surfaces of Reed's paintings, with their artificial Cibachrome or Technicolor hues, look photographic. Films have greatly affected the way Reed sees the world, and subsequently, informs how he paints. The undulating forms within his canvases have been compared to ribbons of film, and the relationship between film strips and Reed's preference for long, horizontal canvas is strong. Reed has engaged in a

dialogue with technology. He traverses the borders of media by incorporating visual aspects of computer graphics, video, and film into his paintings and sometimes digitally inserting images of his paintings into films such as Hitchcock's *Vertigo*. In Reed's most recent work, he has further intertwined his interest in photography and film in installations that place his paintings directly next to videos, films, and photographs. Reed's paintings express his critical awareness of technology and the ways in which contemporary media have altered how we see and understand our world. These diverse interests, and the uniquely complex way in which he filters them in his work, have placed Reed at the forefront of contemporary abstract painting. M.G.

American, born 1960

Los Angeles artist Ross Rudel combines the clean lines of Minimalism and the tradition of African wood carving into seductive, abstract forms. The sensuous shapes and skin-like surfaces of Rudel's works draw on our desire for tactile gratification. Erotic, yet elegant in their understated simplicity, Rudel's gorgeously crafted works reveal an almost fetish-istic attention to detail. His gently curving forms of carefully composed negative and positive spaces, protrusions and orifices, are understated, intimate, and suggestive of parts of the human body. While his work appears to draw upon the cornerstones of Modernism in their formal innovation, Rudel incorporates a Postmodern and humanistic conscious-ness of the body.

In *Untitled No. 193* the beautifully rendered, tactile sur-faces invite closer inspection. The shimmering surface re-sembling snakeskin is actually lace set in resin. This delicate, translucent covering envelops the bleached wood, emphasiz-ing the form's precisely curved sensuality. Although modest in physical size, the work commands a generous space, changing depending on whether it is viewed from a distance or upon closer inspection. S.H.

Untitled No. 193, 1995–1996
bleached wood, lace, resin
8 × 16 × 15 in. (20.3 × 40.6 × 38.1 cm)
Museum purchase with funds from the Elizabeth W. Russell Foundation, 1996.20

EDWARD RUSCHA
American, born 1937

"Do As I Say Or", 1997
bleach on rayon on board
20 × 16 in. (50.8 × 40.6 cm)
Museum purchase, Contemporary Collectors Fund, 1998.12

Better Get Your Ass Some Protection, 1997
acrylic on rayon on board
16 × 20 in. (40.6 × 50.8 cm)
Museum purchase with funds from the Elizabeth W. Russell
Foundation, 1998.11

Edward Ruscha is widely regarded as the artist most in tune with the spirit of his adopted home, Los Angeles. Since the early 1960s, Ruscha has shaped his own distinctively West Coast versions of Pop and Conceptual art, producing works that embrace urban and commercial culture and resonate with a cool, systematic approach. Ruscha mines his cinematic city—its cultural, architectural, and automotive icons—to create deadpan, wisecracking, and always studiously laconic photographs, paintings, prints, and films, many of which feature written words as central elements.

Better Get Your Ass Some Protection and *"Do As I Say Or"* are small paintings on rayon (the quintessential Southern California fabric) from the series Cityscapes. They continue a practice Ruscha developed in the early 1980s: blotting out text with horizontal bars. Both works present censored passages of tough-guy texts the artist says are inspired by "ransom notes, threats, and revenges" pieced together from letters in newspapers and magazines as well as the overpainted graffiti on the walls near his Venice studio. The works' titles, whose words and punctuation marks would fit exactly in the empty marks on the paintings, seem taken straight from the noirish L.A. detective stories of Dashiell Hammett and Raymond Chandler. In both works, the medium is appropriate to the message. In *"Do As I Say Or"*, the artist uses bleach to "rub out" a threat, and in *Better Get Your Ass Some Protection* acrylic paint to "cover up" a dubious admonishment. Although they obscure the paintings' language, these dynamic arrangements of rectangles emphasize the staccato rhythms and illicit nature of their communication.

T.K.

Cindy Sherman has spent her career casting and photographing herself as different female characters—everything from Hollywood B-movie stars to housewives. Sherman, along with many other female artists in the 1970s who were influenced by the women's movement, questioned photographic representation, in particular the representation of gender, in their work. Sherman has imitated and confronted an assortment of stereotypes, investigating the ways in which women have been represented throughout history by the mass media, art history, and popular culture.

Sherman created a series of large-scale photographs depicting what she calls West Coast types. Using various prostheses such as wigs, artificial breasts, and noses, the artist creates comical and satiric portraits of women one might expect to find in a typical California setting. In *Untitled* Sherman poses as a middle-aged fitness-obsessed, tanning bed worshiping, collagen-injection pouting, bleached blonde. Her character, dressed in a tracksuit and wearing a tiara, embodies the California Barbie doll stereotype of superficiality and obsession with physical fitness. Sherman makes herself up as these characters to expose the typecasting of women that saturates media and contemporary consciousness. She invites the viewer to consider the ways we all shape our outward appearances and identities. M.G.

Untitled, 2000
color photograph, edition 2 of 6
image: 36 × 24 in. (91.4 × 61 cm)
Museum purchase, Contemporary Collectors Fund, 2001.12

ROBERT THERRIEN
American, born 1947

No Title, 1992 (blue cloud)

enamel on steel, mixed media
63 × 106 × 12 in. (160 × 269.2 × 30.5 cm)
Contemporary Collectors Fund and Museum purchase in honor of
Lynda Forsha, 1993.2

Robert Therrien works with a vocabulary of simple but suggestive forms derived from childhood memories such as coffins, steeples, snowmen, and clouds. Throughout his career he has repeated these basic shapes with slight changes in scale, material, and technique. His objects have a powerful capacity to refer to familiar physical things and evoke multiple symbolic associations. The artist wants his forms to be open-ended and purposefully names them "no title." In the last decade, Therrien's work has become larger, more three-dimensional, and less abstract. This change was precipitated by what the artist sees as a maturing that has allowed him to think through an idea over an extended period.

In this sculpture Therrien returns once again to the blue cloud that he has previously rendered in paint on paper, mahogany, and bronze. For the first time large faucets punctuate the cloud's surface, playfully suggesting a movie-set kind of deluge precipitated by a turn of the faucet. At the same time, the rusting drips allude to erosion and the role of irrigation in Southern California where the artist lives and works. In the Central Valley faucets replace clouds at the cost of a plumbing infrastructure that is slowly defiling the beauty and potential of the natural landscape.

R.T.

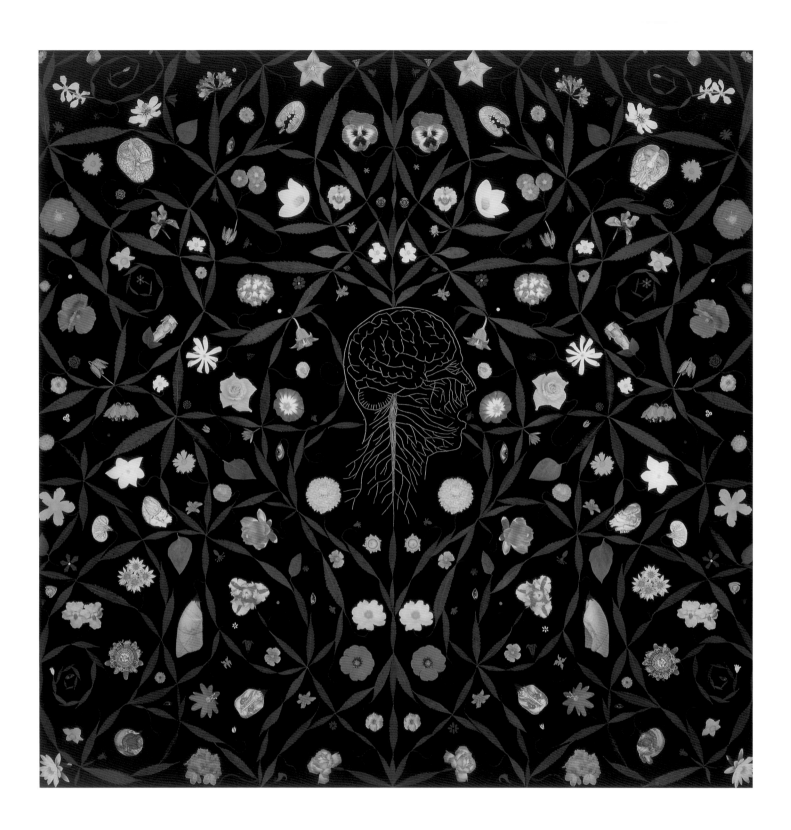

American, born 1956

In his paintings, Fred Tomaselli compares the chemical effects of drugs with the ecstatic possibilities of art as a window into another reality. A native Californian, Tomaselli emerged from the underground punk-rock scene in Los Angeles of the late 1970s and early 1980s. Using unorthodox materials, including pharmaceutical and contraband substances, his work offers the viewer a psychedelic vision combining illusionistic imagery and three-dimensional objects. Tomaselli's paintings encapsulate a diverse variety of stylistic influences, from landscape painting, to abstraction, to Indian miniatures, and the Southern California sources of "fetish-finish" cars and surfboards.

In *Head with Flowers*, Tomaselli sets plant parts, photos from field guides, and medical illustrations in transparent, plastic resin. The resulting depiction outlines a human head and brain surrounded by substances capable of stimulating it chemically or optically. Real hemp and datura leaves, both of which have psychoactive properties, along with brightly colored images of flowers intertwined with swirling vines, suggest the transporting effects of hallucinogenic drugs and perhaps even art itself. Illicit in nature, Tomaselli's works are invitations to be visually stimulated, to experience with one's eyes the psychedelics of powerful drugs or art. M.G.

Head with Flowers, 1996

paper collage, daytura, ephedra, hemp, resin on wood
60 × 60 in. (152.4 × 152.4 cm)
Museum purchase, Contemporary Collectors Fund, 1997.14

LISA YUSKAVAGE

American, born 1962

Manifest Destiny, 1997–1998
oil on linen
110 × 55 in. (279.4 × 139.7 cm)
Museum purchase, Contemporary Collectors Fund, 1999.23

Lisa Yuskavage paints images of exaggerated, clichéd, and disconcertingly sexualized female figures. Alluding to pornographic imagery, Yuskavage's women satirize contemporary depictions of male fantasy and also constructions of female sexuality. In *Manifest Destiny*, for example, a Kewpie doll–like blond bathed in pale pink and baby blue hues stands before an exaggeratedly tall, absurdly phallic white column. As she often does in her work, Yuskavage juxtaposes hyperbolic emblems of male and female sexuality. It is difficult, however, to discern why or how the artist employs these overblown stereotypes. Does this painting lampoon the whimsicality of male sexual fantasy or reveal women's body-obsessed self-deprecation? Furthermore, what does it mean for a woman to paint such sexualized images of women?

In this painting, the title suggests a provisional interpretation of Manifest Destiny, the nineteenth-century political doctrine that regarded the expansion of U.S. territory as inevitable and just, regardless of the fate of indigenous peoples. The monolithic column, a stand-in for male sexuality and a common means of commemorating war heroes, suggests that Yuskavage is exploring this imperialist attitude as it is expressed in a battle between the sexes. Conversely, she has hinted that the columnar figure represents her psychologist, included in many of her paintings. Perhaps, then, the image of the bouquet-wielding nymphet is a self-portrait and this painting is an exploration of Yuskavage's own destiny— manifest and otherwise. R.T.

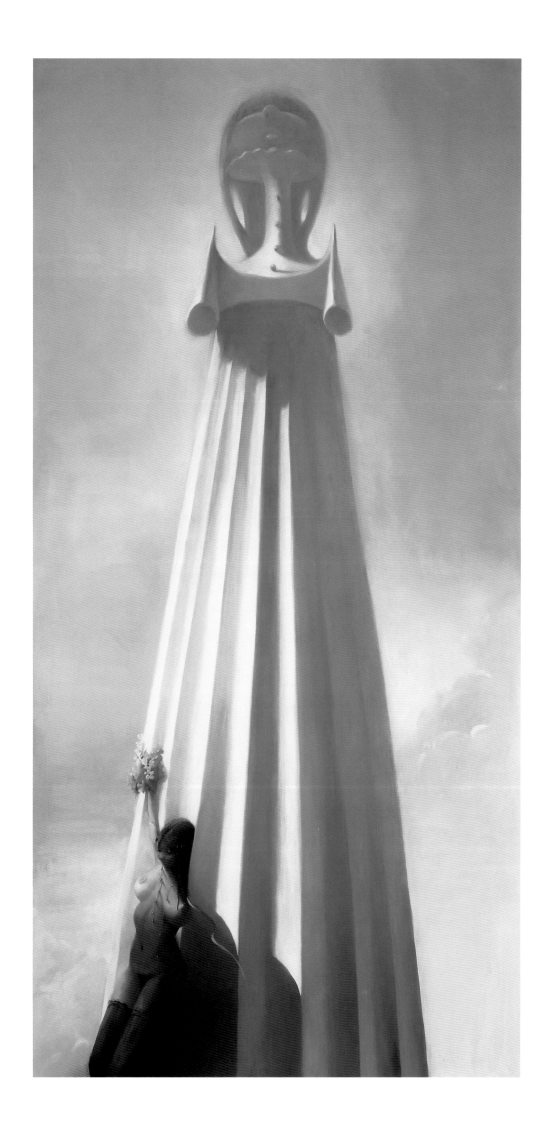

RELATED WORKS

Additional 1990s works in the collection of
the Museum of Contemporary Art San Diego
(not in the exhibition)

FELIPE ALMADA
Mexican, 1944–1993

Felipe Almada's *The Altar of Live News* is a testament to the sacred and profane representations that litter the streets of Tijuana. Altars, common in Mexican culture, provide a space for remembrance and typically consist of a rich collection of religious and secular objects. Almada's sculpture is part shrine and part cabinet of border curiosities. The niches are cluttered with images and trinkets, such as Bart Simpson figurines, that are mass produced as souvenirs of the border. For Almada, this is an altar of living news; recent newspaper clippings that skirt the base of the sculpture engage the viewer with the daily realities of the border region.

The Altar of Live News, 1992

mixed-media installation
overall: 95¼ × 63½ × 24½ in. (241.9 × 161.3 × 62.2 cm)
Gift of Maria Gloria and Baraciel Almada, 1997.1.1–51

JOHN BALDESSARI
American, born 1931

Combining text and imagery borrowed from movies, advertising, and commercial art, John Baldessari's paintings and photomontages use gentle humor to expose the ways we are indoctrinated into a culture of images. *Wrong (Version #2)* is a reconstruction of a similar painting made between 1967 and 1968. Inspired by handbooks for amateur photographers, the first *Wrong* shows the artist standing outside his house in National City, a suburb of San Diego. The image is "wrong" because the artist is standing in front of a palm tree, which appears to sprout from the top of his head. *Wrong (Version #2)* presents the same scene twenty-nine years later. Although his house has been remodeled and the tree and the artist's hair and beard have grown dramatically, Baldessari is still—stubbornly—"wrong."

Wrong (Version #2), 1996

photo emulsion on canvas
59 × 45 in. (149.9 × 114.3 cm)
Museum purchase, 1996.7

ROGER BALLEN
American, born 1950

A New York native living in South Africa, Roger Ballen captures the faces of a nation in transition. In black-and-white photographs reminiscent of the Depression-era photodocumentary images of Walker Evans and the psychologically charged portraits of Diane Arbus, Ballen commemorates the vast numbers of people whose lives have been changed by the dismantling of the racist policies of apartheid. His images capture the circumstances of people living in newly integrated public housing projects and whose fortunes have been altered—for better or worse—by South Africa's struggles for equality.

Labourers, 1997
selenium-toned photograph on Illford multigrade paper, edition 6 of 35
image: 14 × 14¼ in. (35.6 × 36.2 cm)
Museum purchase, Joyce R. Strauss Fund, 2001.4

Sergeant F. de Bruin, Department of Prison Employee, Orange Free State, South Africa, 1992
selenium-toned photograph on Illford multigrade paper, edition 10 of 35
image: 14 × 14¼ in. (35.6 × 36.2 cm)
Museum purchase, Joyce R. Strauss Fund, 2001.3

Dora and cousin Attie, 1998–2000
selenium-toned photograph on Illford multigrade paper, edition 7 of 35
image: 14 × 14¼ in. (35.6 × 36.2 cm)
Museum purchase, Joyce R. Strauss Fund, 2001.5

MARÍA FERNANDA CARDOSO
Colombian, born 1963

María Fernanda Cardoso's sculptural work, conceptual and performative, speaks a personal language that references conditions in her native Colombia. *Cementerio/Vertical Garden* is a large installation of groups of plastic lilies arranged in rhythmic patterns on the gallery wall. Drawn lightly in pencil on the wall are arched openings that suggest the stacked tombs of a mausoleum. Referencing the countless victims of her country's drug wars, the work is a gentle memorial and a reminder of the beauty of life.

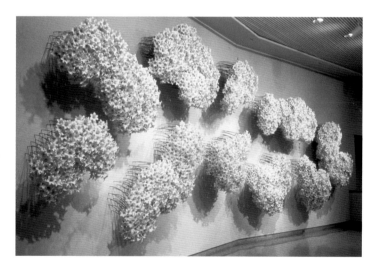

Cementerio/Vertical Garden, 1992
artificial flowers, pencil on wall
dimensions variable
Museum purchase with funds from Charles C. and Sue K. Edwards, 2000.9

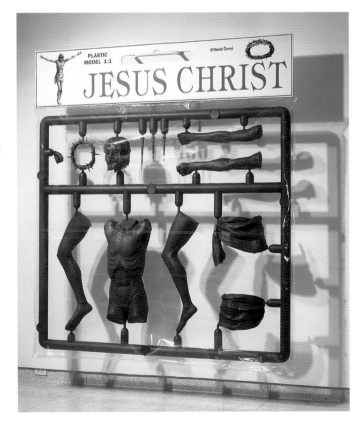

Untitled (Spiral Shaped Oven), 2001

watercolor on paper
29½ × 41½ in. (74.9 × 105.4 cm)
Museum purchase with funds from the Bloom Family Foundation, 2001.27

LOS CARPINTEROS

Alexandre Jesús Arrechea Zambrano, Cuban, born 1970
Dagoberto Rodriguez Sanchez, Cuban, born 1969
Marco Antonio Castillo Valdéz, Cuban, born 1971

Los Carpinteros is the name of a collaborative of three Cuban artists whose art ranges from elaborate drawings and sculptures to wooden objects created with the hand tools often used by carpenters—hence their name. Los Carpinteros use sculpture and drawings to analyze the structures of everyday life, pointing out the humor, beauty, and symbolism in commonplace buildings and consumer products.

Jesus Christ, 1993

fiberglass, metal, plastic, Masonite
89 × 85 × 11 in. (226.1 × 215.9 × 27.9 cm)
Museum purchase with funds from Dr. Charles C. and Sue K. Edwards and the Elizabeth W. Russell Foundation, 1996.21

DAVID ČERNÝ

Czech, born 1967

Born in Prague, David Černý grew up in Czechoslovakia during a period of state-enforced atheism. After the country's "velvet revolution" of 1989 and during its subsequent separation into the Czech Republic and Slovakia in 1993, religion was no longer taboo. In fact, there was an explosive influx of religions of all forms, from traditional Catholicism to Hare Krishna to American evangelical television ministries, each of which espoused its own vision of God and the road to salvation. *Jesus Christ* is a satiric commentary on the redefinition of religion and the church during the birth of the Czech Republic.

Černý depicts Christ as a do-it-yourself plastic model kit—wrapped in plastic, labeled for sale, and hung from a hook. Like the various religions promoting themselves in his country, Černý's *Jesus Christ* is ready for mass consumption. Complete in all details, including his genitals and the spikes used to nail him to the cross, this Christ is ready to be assembled according to the needs and desires of a people newly rediscovering Christianity.

SANDRA CINTO
Brazilian, born 1968

Working in both two- and three-dimensional formats, Sandra Cinto creates dreamlike images and objects expressing varied states of fragmentation, separation, and isolation. Cinto's drawings are embodied by networks of sinuous lines and symbolic imagery that reveal a mystical, celestial, and spiritual space. For this untitled work, the artist adopted the act of tattooing as her drawing method. Appropriating the tribal use of tattoos as a means to simulate and assimilate one's surroundings, she inscribed a drawing on her arm as well as onto the wall behind it, producing a seamless melding of body, architecture, and art.

Untitled, 1998
photograph, edition 5 of 5
28¾ × 51 in. (73 × 129.5 cm) framed
Museum purchase, Contemporary Collectors Fund, 1999.18

ROBERT COLESCOTT
American, born 1925

In a satirical narrative style, Robert Colescott critiques Western art history and culture, often playing on racial and sexual taboos and stereotypes. In his paintings he employs facetious captions and titles to create subversive effects. "I pull the viewer in with humor," says Colescott, "but when they begin to understand what they have to deal with in the paintings they don't know whether to love them or hate them."[1] In *The Bilingual Cop* Colescott's exaggerated, humorous, and perverse characters accentuate the absurdity of stereotypes. A bilingual border patrol officer hurls profanities at an African American and a Mexican American vagrant in English and Spanish. The scene shatters the preconception that the ability to speak in more than one language makes you fluent in cultural sensitivity.

The Bilingual Cop, 1995
liquitex gesso, paint, gel medium on canvas
90 × 114 in. (228.6 × 289.6 cm)
Museum purchase, Contemporary Collectors Fund, 1997.11

1. *Robert Colescott Recent Paintings*, exh. Queens Museum, April 22, 1997–October 4, 1998, http://www.queensmuse.org/exhibitions/colescott.html.

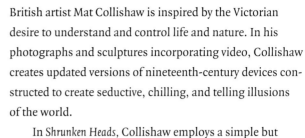

MAT COLLISHAW
British, born 1966

British artist Mat Collishaw is inspired by the Victorian desire to understand and control life and nature. In his photographs and sculptures incorporating video, Collishaw creates updated versions of nineteenth-century devices constructed to create seductive, chilling, and telling illusions of the world.

In *Shrunken Heads*, Collishaw employs a simple but effective form of projected video to create a diorama with a built-in narrative. On a low, card-table-sized platform, he constructs a detailed replica of a quaint North England village square, complete with a brick church, a thatch-roof pub, and an illuminated fountain (made from a plastic champagne glass). At one end of the model, a pane of Plexiglas stands upright inches away from a television monitor on which moving images of hoodlums are presented against a black screen so that their shimmering reflections seem to move about in the space of the model.

Shrunken Heads, 1998
mixed media, laserdisc, color monitor
59 × 89 × 62 in. (149.9 × 226.1 × 157.5 cm)
Museum purchase, Contemporary Collectors Fund, 2000.2

Slippers Place Estate, 1992
oil on canvas, painted wood, glass
26 × 16 × 2¼ in. (66 × 40.6 × 5.7 cm)
Museum purchase, Contemporary Collectors Fund, 1995.3

KEITH COVENTRY
British, born 1958

Keith Coventry skews the stark vocabulary of modernist abstract painting towards representation. In *Slippers Place Estate*, Coventry carefully renders his canvas in the manner of Constructivist paintings: rectangular bars seem randomly scattered across a creamy white field. Yet the scheme laid out in this work is actually a floor plan of an English public housing project—Slippers Place Estate. Coventry wryly challenges modernism's idealistic goals for art and urban planning, while calling attention to the claims and failures of both. In his De Stijl–like diagram, Coventry uses the very language of the thing critiqued, implying that the nonreferential "purity" of abstract painting and utopian ideals of public housing projects have exhausted themselves. Coventry revitalizes and politicizes the language of abstraction by introducing specific subject matter into seemingly nonobjective compositions.

PETAH COYNE
American, born 1953

Primarily an installation artist, Petah Coyne makes work that evokes nature and its processes. Incorporating a wide range of materials in her pieces—in this case car parts, chicken wire, sand, and black pigment—Coyne makes anthropomorphic forms that produce an ambiguous but visceral experience. Evoking the despoilment of the natural world, her works convey both the fragility of living things and the power of destructive forces, melded together in a darkly mysterious form. Coyne's hanging accumulation of organic and inorganic materials was inspired in part by the exaggerated architecture of European Gothic churches.

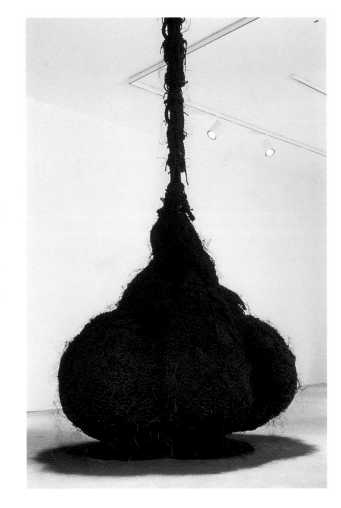

Untitled 676-676k, 1990

mixed media
approx. 175 × 63 × 50 in. (444.5 × 160 × 127 cm)
Museum purchase, Contemporary Collectors Fund, 1992.1.1–3

MATTHEW CUSICK
American, born 1971

Matthew Cusick's glossy, sofa-sized paintings depicting ultramodern home interiors are visually arresting and conceptually provocative. Using masking tape, knives, and enamel paint, Cusick renders every detail of a painting as a flat, sharp-edged shape. His mosaic pictures resemble 1960s illustrations from *Playboy* magazine. In subject and title, *Diamonds are Forever* refers to the James Bond thriller of the same name, which features a six-minute sequence of the Elrod residence, a luxurious Palm Springs home designed by Albert Frey and built in 1968 to suit the needs of an extravagant bachelor.

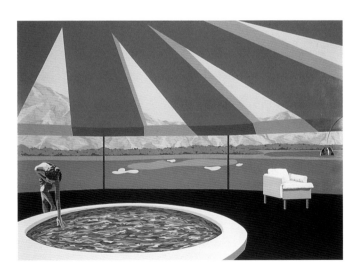

Diamonds are Forever, 1998

enamel on wood
48 × 67 in. (121.9 × 170.2 cm)
Museum purchase with funds from the Ansley I. Graham Trust,
Los Angeles, 1999.13

EINAR DE LA TORRE
JAMEX DE LA TORRE

Einar de la Torre, Mexican, born 1963
Jamex de la Torre, Mexican, born 1960

Born in Guadalajara, Mexico, brothers Jamex and Einar de la Torre moved to Southern California in their teens and have since created art that celebrates culture shock. Using irony, over-the-top embellishment, and double entendres, the artists invite the spectator to reconsider their preconceptions of "authentic" Mexican art and culture and to reexamine the increasingly blurred lines between the United States and Mexico. The blown foam in *El Fix* resembles a small intestine twisting in and around to form a map of Mexico. In the upper left-hand corner of this visceral sculpture, roughly corresponding to the location of Tijuana, a crucifix-like hypodermic needle punctures the intestine. The iconography leaves the interpretation open-ended and could refer to the injection of religion into Mexico or the reference to illegal drug trafficking in this part of the country. An image of the infant Jesus, combining elements of popular milagro trinkets and pornographic illustrations, dominates the region of central Mexico.

El Fix (The Fix), 1997
blown glass and mixed media
30 × 72 × 4 in. (76.2 × 182.9 × 10.2 cm)
Museum purchase with funds from an anonymous donor, 1999.27.a–b

NIKI DE SAINT PHALLE
French, born 1930, died 2002

Working in performance, painting, sculpture, and public art, Niki de Saint Phalle creates images and objects infused with bright colors and fantastic narratives. Located in the museum's Sculpture Garden, de Saint Phalle's *Big Ganesh* depicts the popular Indian deity Ganesh, the god of good luck, wisdom, and prosperity. In traditional Hindu art, Ganesh is typically represented painting or carving and riding the back of a rat. De Saint Phalle has constructed a more whimsical rendering of Ganesh and his companion.

Big Ganesh, 1998
steel, polystyrene foam, polyurethane, automotive paint, electronic component, light bulbs, iron base
elephant: 128 × 62 × 58 in. (325.1 × 157.5 × 147.3 cm); mouse: 26 × 28 × 15 in. (66 × 71.1 × 38.1 cm)
Gift of Ron and Mary Taylor to honor Martha Longenecker, Founder, Mingei International Museum of Folk Art, 1998.29.1–2

JACCI DEN HARTOG

American, born 1962

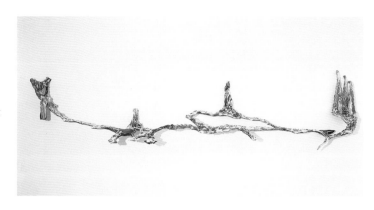

Los Angeles–based artist Jacci Den Hartog creates objects that merge aspects of reality and artifice. Her large-scale work *Passing a Pleasant Summer III* consists of a three-dimensional relief made of polyurethane, plastic, and pigment depicting a river that appears to flow from the wall. The sculpture evokes a flowing mountain stream as it cascades over boulders, shoots through crevasses, and collects in pools. Although inspired by the ancient tradition of Chinese landscape painting, Den Hartog's works also evoke the kind of commercial décor—faux waterfalls, Buddha sculptures, plastic rocks, and Zen minigardens—found in restaurants, shops, and bars throughout the Chinatown district of Los Angeles.

Passing a Pleasant Summer III, 1998
polyurethane, steel
29 × 137 × 17 in. (73.7 × 348 × 43.2 cm)
Gift of the Alberta duPont Bonsal Foundation, 2000.16

MARK DION

American, born 1961

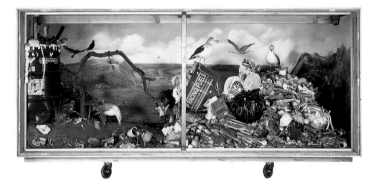

Mark Dion is a student of the history of environmental science—the ways humans have tried to analyze, categorize, and understand the creatures and the landscapes around them. In his work, he assumes the roles of scientist, adventurer, and historian to research ecologies—social and natural.

 Landfill, a life-size and lifelike habitat group, complete with painted backdrop, taxidermied animals, and simulated terrain, is inspired by research trips to municipal landfills in Tijuana and San Diego. Packaged in a shipping crate as if hauled out from the vaults of a natural history museum, the work features a taxidermied dog, rats, seagulls, sparrows, and starlings scavenging in a landscape filled with garbage and potentially toxic waste. Upon closer examination, it becomes clear that nearly all the refuse in the work is either made from or somehow related to the animal kingdom. Illustrating our dietary, economic, and sentimental attachments to animals, *Landfill* exposes the consequences of humankind's position as apex predators.

Landfill, 1999–2000
mixed media
71½ × 147½ × 64 in. (181.6 × 374.7 × 162.6 cm)
Museum purchase, Contemporary Collectors Fund, 2000.4

Riding Crop, 1993

oil on canvas and riding crop
painting: 81 × 113¼ in. (204.5 × 287.7 cm); riding crop 36 × 3½ × 2 in.
(91.4 × 8.9 × 5.1 cm)
Museum purchase, Contemporary Collectors Fund, 1994.1.1–2

TOMÁS ESSON
Cuban, born 1963

Tomás Esson's paintings combine aggression, humor, and vulgarity. In *Riding Crop,* a pink bull form glides through a sea of green paint, seemingly propelled by its own flatulence. The painting bears the marks of a violent lashing by a riding crop, which hangs next to the canvas. Esson, a native of Cuba, has lived in Miami since 1991, and some have interpreted *Riding Crop* as a satiric map of the artist's home island.

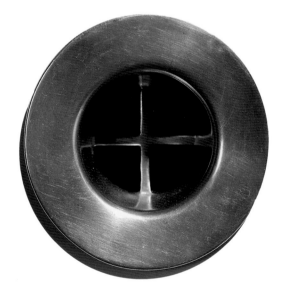

Drains, 1990

cast pewter, edition 4 of 8
3¾ in. diam. × 1¾ in. (9.5 × 4.4 cm)
Gift of Peter Norton Family Foundation, 1992.7

ROBERT GOBER
American, born 1954

With a characteristically delicate touch, sculptor Robert Gober points out the omnipresence of the unknown in *Drains,* a cast pewter replica of a household drain inlet. By the simple act of dislocating this common orifice from its customary location in a sink or tub and placing it on a white gallery wall, Gober calls attention to vast, usually unseen structures underlying daily life (where does our bathwater go when we pull the plug?), and gently reminds us that we all share an ultimate destination. Part of a generation of gay men affected by the AIDS epidemic, the artist also obliquely references a new uneasiness about the body.

RAÚL GUERRERO

American, born 1945

San Diego–based artist Raúl Guerrero employs a wide range of representational styles to address themes of history, place, and travel. In *Peru: Francisco Pizarro, 1524–1533*, Guerrero appropriates the seventeenth-century Spanish painter Diego Velasquez's famous image of Venus contemplating her image in a mirror to comment on the impact of colonialism on the New World. Using the female body as a metaphor for the conquered landscape, the artist superimposes maps and images from Pizarro's journey through Peru. Guerrero transforms this famous vanitas image into an emblem of the narcissism of one nation's drive to transform a continent in its own image.

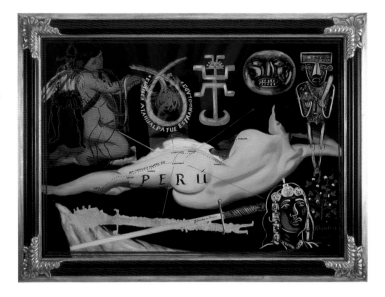

Peru: Francisco Pizarro, 1524–1533, 1995

oil on linen
34⅛ × 48¼ in. (86.7 × 122.6 cm)
Museum purchase with funds from the Elizabeth W.
Russell Foundation

HANS HAACKE

German, born 1936

In his work, Hans Haacke concentrates on exposing the covert relationships between art, business, and power. *Helmsboro Country (Unfolded)* takes on Senator Jesse Helms, a staunch supporter of the tobacco industry in his home state of North Carolina, and an adamant voice for the end of government-subsidized support of the visual arts, particularly the National Endowment for the Arts. Haacke highlights the relationship between Helms and the tobacco, alcohol, and food conglomerate Philip Morris, which funded both Helms' campaign and many art exhibitions around the world. With this juxtaposition he demonstrates the problematic connections between government, censorship, and corporate support of the arts.

Helmsboro Country (Unfolded), 1990

silkscreen on paper with cibachrome, edition 5 of 36
2 panels: 48 × 25⅛ in. (121.9 × 63.8 cm) each
Museum purchase with funds from the Elizabeth W. Russell
Foundation, 2000.14.a–b

ANN HAMILTON
American, born 1956

linings, 1990
felt boot liners, woolen blankets, grass, glass, ink on paper, monitor
with video loop
4-sided structure: 120 × 150 × 294 in. (304.8 × 381 × 746.8 cm)
Museum purchase with funds from the Elizabeth W. Russell
Foundation, 1990.23

Ann Hamilton creates all-encompassing environments that
envelop viewers by stimulating their senses of sight, touch,
sound, and smell. The function and material of Hamilton's
felt boot liners are associated with insulation and protection,
while the quantity of boots presented suggests many journeys
taken. The texture of the quilted woolen English hospital
blankets outside the room contrasts with the interior of the
room, whose walls and floor of native grass are covered with
panes of glass. The walls are also covered with hundreds of
small panes of specimen glass through which horizontal
bands of handwritten text by naturalist John Muir are visible.
In the room a nine-inch video monitor continuously plays a
slow-motion image of a woman's mouth being filled until it
overflows with water. Hamilton created linings as a personal
response to the national debate on censorship in the visual
arts, and the "linings" to which she refers are the borders
between realms: the meeting points between individuals
and culture.

STEPHEN HANNOCK
American, born 1951

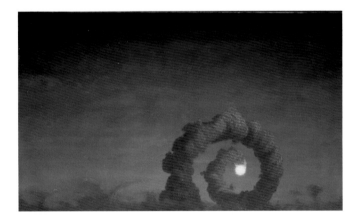

Vortex at Dawn, 1990
oil on canvas
40 × 50 in. (101.6 × 127 cm)
Museum purchase, 1990.24

Stephen Hannock uses elaborate oil painting techniques
to create his luminous landscapes. Among the sources he
cites are the dreamlike subjects of nineteenth-century French
Symbolist painters Gustave Moreau and Odilon Redon, the
romanticized landscapes of the American Luminists such as
Sanford Robinson Gifford—as well as the glowing images
of television and the movies. In Vortex at Dawn, he achieves
a glowing atmosphere by slowly building up layers of paint,
and then sanding and polishing the surface. The imagery
combines his childhood memories of setting off rockets
above the Connecticut River with an image he had seen of
the thick downward coil of smoke made by the Trident II
missile as it self-destructed in Florida. Vortex at Dawn is
at once an elegy to natural beauty and an omen of human
intervention.

LYLE ASHTON HARRIS
THOMAS ALLEN HARRIS

Lyle Ashton Harris, American, born 1965
Thomas Allen Harris, American, born 1962

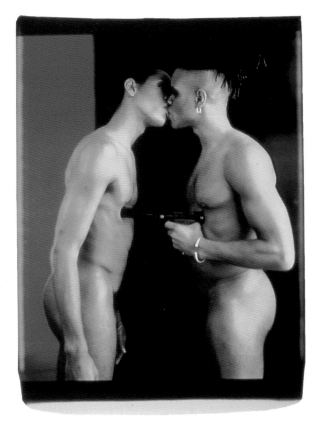

Since the late 1980s, Lyle Ashton Harris has been making photographs that employ beauty as a "subversive strategy"— a way of exploring his identity as a gay black male. Including himself in his work, he often deals with the violence committed against those who choose alternate lifestyles. In this work, Harris collaborated with his brother, the filmmaker Thomas Allen Harris, to make an image that, in the artist's words, "speaks to the ambivalence around desire, envy, compassion and death."[1] Influenced by a nightmare of being "fag-bashed," these collaborative images reveal the artist's struggle with fears regarding his body and violence.

1. "Lyle Ashton Harris," Art in America 82, no. 6 (June 1994), 63.

Brotherhood Crossroads and Etcetera #2, 1994
duraflex print, edition 2 of 3
60 × 48 in. (152.4 × 121.92 cm)
Museum purchase with partial funds from Joyce and Ted Strauss, 1995.5

REBECCA HORN

German, born 1944

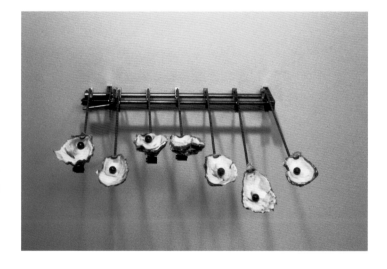

Since the 1960s Rebecca Horn has worked in performance, film, verse, and elaborately constructed sculptures and installations. *Oyster's Piano* is akin to Horn's larger-scale objects and installations comprising devices that are surreal surrogates for the human body. Moving in a gentle rhythmic pattern on fingerlike armatures, the oyster shells evoke the artist's central concern of transforming lifeless objects into "living" forms. Horn's anthropomorphized machines embody and personify this transformative process with romance and humor.

Oyster's Piano, 1992
motor, oyster shells, lead pearls, edition 5 of 10
14¾ × 17 in. (37.5 × 43.2 cm)
Museum purchase, Contemporary Collectors Fund, 1995.2

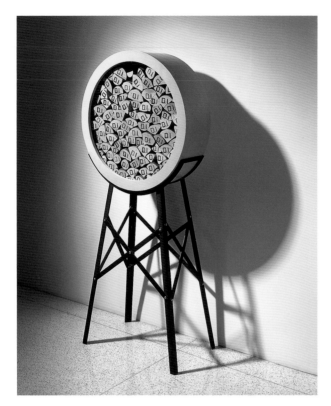

DAVID IRELAND
American, born 1930

San Francisco conceptual artist David Ireland works within the artistic heritage of the ready-made, or found object, particularly anonymous building supplies and furniture. *Other Ego* exemplifies the quiet simplicity and playfulness of Ireland's built forms, with its plain, sturdy, and highly finished design enclosing pieces of rough-hewn wood. In a Duchampian display of irony, Ireland's initials serve as a subtle wordplay—turned upside-down they become I.D., not only "identification," but also the "id" or ego referenced in the work's title.

Other Ego, 1992
metal, wood, glass, paint
63¼ × 27½ × 16 in. (160.7 × 69.9 × 40.6 cm)
Gift of Paule Anglim, 2000.33

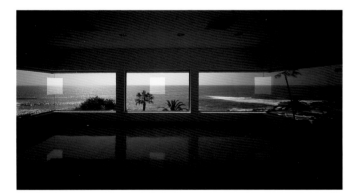

ROBERT IRWIN
American, born 1928

1°2°3°4°, 1997
apertures cut into existing windows
apertures: left, 24 × 30 in. (61 × 76.2 cm); center, 24 × 26 in. (61 × 66 cm); right, 24 × 30 in. (61 × 76.2 cm); overall room dimensions: 115 × 320 × 221 in. (292.1 × 812.8 × 561.3 cm)
Museum purchase in honor of Ruth Gribin with funds from Ruth and Murray Gribin and Ansley I. Graham Trust, Los Angeles, 1997.18.1–5

Robert Irwin's art explores illusion, perception, and experiential effects. His early transformative pieces helped to define the aesthetic of the West Coast Light and Space movement in the late 1960s by exploring how phenomena are perceived and altered by consciousness. Pronounced "first dimension, second dimension, third dimension, fourth dimension," *1°2°3°4°* is a site-specific installation located in the museum's Krichman Gallery, a space often referred to as the "glass gallery" because of the windows that overlook the Pacific Ocean. For the commission, Irwin removed three rectangles from the windows, thereby directly connecting the interior and exterior spaces. Elements of the outside environment—sound, smells, and other physical sensations—comingle with the white planar surfaces and controlled space of the museum. Time—the fourth dimension of the work's title—becomes an integral element of the piece, determining climate, light, and even color as the sun moves across the perimeter of the gallery and sets beyond the Pacific. The tactile presence of nature—felt as well as seen—heightens a physical and perceptual awareness that is integral to Irwin's work.

WENDY JACOB
American, born 1958

Wall, Museum of Contemporary Art Downtown was built as an integral part of the second-floor galleries at the museum's downtown location. In this work Wendy Jacob animates a white museum wall. Looking at the wall sideways, one sees that it breathes, expanding and contracting at regular intervals. Concealed within the white latex-painted rubber wall are a vinyl airbag, two blowers, a vacuum, and a timing mechanism, which enable the expansion and contraction of the flexible wall. The minimalist object blends with its architectural framework, giving life and presence where least expected.

Wall, Museum of Contemporary Art Downtown, 1993
rubber, vinyl, wood, plaster, blowers, timing mechanism
167 × 71½ × 22½ in. (28 in. or 71.1 cm fully extended) (424.2 × 181.6 × 57.2 cm)
Museum purchase, 1993.3

RONALD JONES
American, born 1952

Ronald Jones is a socially and politically oriented artist who uses sensuous forms to seduce and surprise the viewer. *Untitled (These four upturned "collapse boards" . . .)* appropriates the form of collapse boards, devices that were employed to transport faint-hearted prisoners to the gallows at the Walla Walla State prison in Washington, to create an abstract sculpture. Combining elegant geometries and chilling associations, Jones deftly points out the fact that creation and destruction are part of everyday life.

Untitled (These four upturned "collapse boards" . . .), 1990
ebonized wood, varnished poplar, paint on wood, and patinized bronze, edition 1 of 3
84⅛ × 48 × 50 in. (213.7 × 121.9 × 127 cm)
Museum purchase, 1993.2.1–3

ANISH KAPOOR
British, born India, 1954

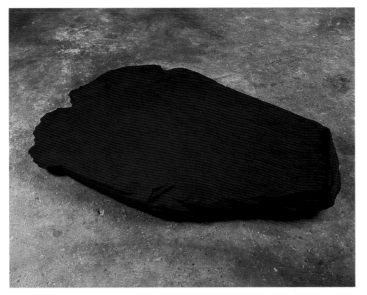

Anish Kapoor's sculptures engage deep-rooted metaphysical polarities: presence and absence, solidity and intangibility, being and nonbeing. *Angel* consists of a large piece of slate covered in vibrant blue pigment, a combination that produces a paradoxical sensation of extreme lightness and heaviness, ethereality and solidity.

Angel, 1990
slate, pigment
9 × 87 × 64 in. (22.9 × 221 × 162.6 cm)
Gift of the artist and Lisson Gallery, London, 1992.15

SOL LEWITT
American, born 1928

A pioneer of Conceptual art in the 1960s, Sol LeWitt makes wall drawings that challenge established categories of painting, sculpture, and drawing. Emphasizing the idea of the work of art over its execution or existence as an object, LeWitt produces the directions and dimensions for a work, which are in turn carried out by assistants. Since these works are executed directly on the wall, they are a temporary installation to be painted over when the exhibition ends.

Wall Drawing #774, 1994
color ink washes
dimensions variable
Gift of Nicholas and Kathleen Connor, 2000.28

DONALD LIPSKI
American, born 1947

Donald Lipski's work explores the poetic potential of found objects by presenting them in new contexts. *Waterlilies #35* is one of a series of sculptures made of glass forms shaped like life preservers filled with water and plant elements. In this case, the plant is dune grass, which appears to be a scientific specimen preserved for eternity. But the grass steadily decays as the water evaporates over time. Resembling both a life preserver and a ship's wheel, the glass tubing is fitted with wooden handles that invite the viewer to take the helm and steer the destiny of the planet's fragile ecology.

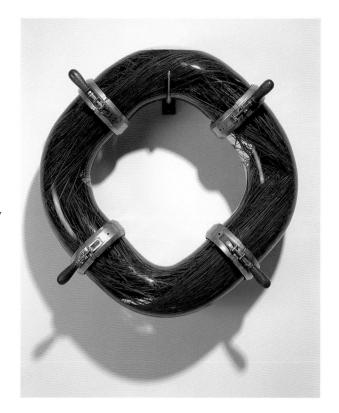

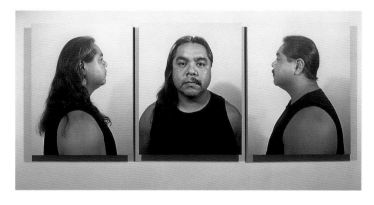

Waterlilies #35, 1990
glass, dune grass, water, hardware
32 × 32 × 9 in. (81.3 × 81.3 × 22.9 cm)
Museum purchase, Contemporary Collectors Fund, 1990.29

JAMES LUNA
American, born 1950

In his performances and photographs, James Luna, an American Indian living on the La Jolla Reservation in northern San Diego County, employs humor, satire, and cultural anthropology to address myth and reality in Native American culture. In the photographic triptych *Half Indian/Half Mexican*, Luna, whose father is Mexican and mother is a Luiseño/Diegueño Indian, creates an image of his dual heritages. The work presents three mugshots of the artist: two profiles—one with long hair, clean-shaven face, and an earring, and another with short, slicked-back hair, and a moustache—and a full-face shot with long hair on one side and half a moustache on the other. By modifying his appearance to correspond to stereotypical images of the long-haired Native American and the mustachioed Hispanic American, Luna illustrates the ongoing mixing of cultures in the Americas as well as the hybrid identities such mixing produces.

Half Indian/Half Mexican, 1991
three black-and-white photographs
photographer: Richard A. Lou
30 × 24 in. (76.2 × 61 cm) each
Gift of the Peter Norton Family Foundation, 1992.6.1–3

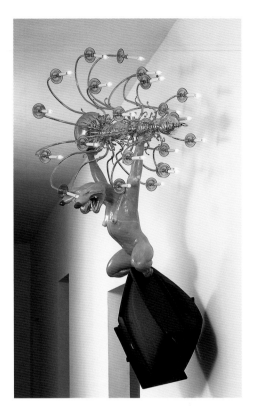

Untitled (Gargoyle), 1991
chandelier, television, fiberglass, paint
98 × 55 × 48 in. (248.9 × 139.7 × 121.9 cm)
Museum purchase, Contemporary Collectors Fund, 1992.2.1–3

DAVID MACH
British, born Scotland, 1956

Like other British sculptors working in the 1980s, such as Tony Cragg and Bill Woodrow, Mach comments on overproduction and overconsumption in Western society. Here, a two-headed, hermaphroditic beast crouches atop a static-playing television set. The snarling gargoyle appears on the verge of hurling a decadent gold chandelier upon an unexpecting victim. Lashing out against opulence and technology, the naked creature becomes a stand-in for human beings transformed and overwhelmed by their own conveniences.

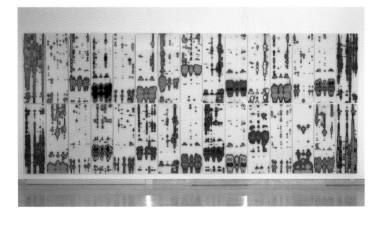

Paternity Test (Museum of Contemporary Art San Diego), 2000
chromogenic prints of DNA analysis
30 prints: 60 × 19½ in. (152.4 × 49.5 cm) each
Museum purchase with partial funds from Cathy and Ron Busick,
Diane and Christopher Calkins, Sue K. and Dr. Charles C. Edwards,
Murray A. Gribin, Dr. Peter C. Farrell, 2000.24.a–d

IÑIGO MANGLANO·OVALLE
American, born 1961

Iñigo Manglano-Ovalle is an interdisciplinary artist who draws on a variety of media and new technologies. Many of Manglano-Ovalle's works reflect the artist's interest in scientific research and the connections between medical technologies and social debate. Paternity Test (Museum of Contemporary Art San Diego) consists of human-scaled panels of digital DNA portraits of the museum's board members made from cells collected from the trustees' mouths. On the surface, the rich chromatic abstractions recall the luminous qualities of color field painting. The DNA charts also, however, raise questions about the social, political, and cultural ramifications of categorizing identity. Derived from computer-generated images executed by a genetics laboratory, the DNA "fingerprint" identifies individuals and has numerous uses and repercussions, particularly in legal and ethical contexts. Getting beneath skin color as a means of categorization, Manglano-Ovalle's DNA portraits present the individual characteristics not normally visible on the surface.

RITA MCBRIDE

American, born 1960

Rita McBride re-creates familiar forms in her sculpture—
cars, architecture, roadways—with dramatic shifts in scale
and material. *Toyota*, a Celica sedan made of hand-bent
rattan, blends high-tech and handicrafts and First and Third
Worlds. Made by artisans in the Philippines, a developing
nation, the work uses low-cost, traditional materials to
reproduce the form of an expensive consumer product
from Japan, a highly industrialized nation.

Toyota, 1990
rattan
48 × 180 × 84 in. (121.9 × 457.2 × 213.4 cm)
Gift of Brenda and Michael Sandler, 1995.22

LIA MENNA BARRETO

Brazilian, born 1959

Lia Menna Barreto explores social and psychological aspects
of beauty, innocence, and destruction. The artist transforms
children's trinkets into unsettling artworks. In *Bonecas derre-
tidas com flores* Menna Barreto has fused exquisite flowing
silk, bought in the markets of her hometown, Porto Alegre,
Brazil, with plastic toys and flowers using a hot, heavy
iron. She engages in a violent, mutilating act that forces
the confrontation of beauty with danger and playfulness
with brutality.

Bonecas derretidas com flores (Melted Dolls with Flowers), 1999
silk and plastic
118⅛ × 55⅛ in. (300 × 140 cm)
Museum purchase, Contemporary Collectors Fund, 1999.17

GABRIEL OROZCO
Mexican, born 1962

In *Long Yellow Hose*, a sculpture consisting of 1,200 feet of standard yellow plastic watering hose conceived for MCASD's oceanfront Edwards Garden, Orozco creates an elegant, looping arabesque that provides a vibrant contrast to the garden's terraced green lawn. At the same time, the work elegantly points out the artificiality of this verdant landscape, which is dependent on armies of gardeners and an elaborate irrigation system to keep it healthy in an environment that would otherwise be a coastal desert.

Long Yellow Hose, 1996
plastic watering hose
1,200 feet of hose
Museum purchase, 1997.7.1

RUBÉN ORTIZ TORRES
Mexican, born 1964

Pointed in its humor and criticism, Rubén Ortiz Torres' art focuses on the borderlands of Mexico and the United States, articulating a web of images, references, and sources that are directly pertinent to binational cultures. Ortiz Torres relies on puns that may be evident or cryptic: the viewer must navigate two languages—English and Spanish—as well as vernacular variations from border regions and from different social classes. His series of altered baseball caps evoke urban youth's fascination with sports attire, and weave in events of cross-cultural political and historical significance. For example, *L.A. Rodney Kings* conflates the logo of the city's hockey team with a reference to racially charged police brutality that sparked riots in Los Angeles.

Malcolm Mex Cap (La X en la frente), 1991
ironed lettering on baseball cap

1492 Indians vs. Dukes, 1993
stitched lettering and airbrushed inks on baseball caps

L.A. Rodney Kings (2nd version), 1993
stitched lettering and design on baseball cap
7½ × 11 × 5 in. (19.1 × 27.9 × 12.7 cm) each
Gifts of Mr. and Mrs. Scott Youmans, by exchange, 2001.6–8

MAURIZIO PELLEGRIN

Italian, born 1956

The title *Your eyes desert me* is taken from a poem written by Maurizio Pellegrin, which is inscribed on the wall as part of the installation. Knowledge is the theme of the work that consists of several hundred black books, each individually numbered and bound, which carpet the gallery floor. The artist chose books as a sculptural material because of the information they contain. Yet the titles of the books remain a mystery. For Pellegrin, the stamped numbers express the amount of energy contained within each book, hinting at the vitality of the knowledge contained within.

Your eyes desert me, 1993
tempera, books, fabric, rope, and graphite
dimensions variable
Gift of the artist and John Gibson Gallery, New York, 1994.3.1–222

ARMANDO RASCÓN

American, born 1956

Latina Postcolonial Photobureau (Califas), 1997
triptych, chromogenic prints, edition 1 of 3
59⅝ × 39½ in. (151.4 × 100.3 cm) each
Museum purchase with funds from the Elizabeth W. Russell Foundation, 1997.22.a–c

Armando Rascón's triptych *Latina Postcolonial Photobureau (Califas)* is part of a larger series of more than twenty portraits. In each, a woman appears before the spectator as a strong embodiment of the feminist movement and the new generation of Latina writers, critics, and political activists whose work has influenced the artist. Each woman is a friend or acquaintance the artist admires; each represents a particular contribution to Latino culture—by working with activist organizations, contributing to the hybrid stylistic tone of urban spaces, or playing an invaluable role in the education and preservation of younger generations.

A photobureau normally provides a structured archive of historical images. For Rascón, the photobureau becomes a process of recovery as it documents in "official" means the overlooked contributions of Latinas in contemporary U.S. social history. The term *Califas*, Mexican American slang for "California," is used by the artist to denote the heritage of Chicano art in the state. *Latina Postcolonial Photobureau (Califas)* continues the legacy of artists within the Chicano movement of the late 1960s and early 1970s who recognized a need for social and political activism in the arts.

Untitled (*from the Trojan series*), 1991
ink on cardboard
11 × 11 × 17 in. (27.9 × 27.9 × 43.2 cm) each
Museum purchase, 1992.8.1–10

ADAM ROLSTON
American, born 1942

Adam Rolston's simple cardboard boxes with printed labels do more than simulate cartons of condoms. *Untitled (from the Trojan series)* asks the viewer to address issues of safer sex, homosexuality, AIDS, and the stigma attached to the use of condoms. On these boxes, Rolston alters the instructions for the "proper" use of a condom, actively acknowledging the male homosexual community. Rolston has been lobbying the condom industry for such changes in an effort to encourage safer sex among homosexual men. Manufacturers now advertise that condoms protect against the risk of pregnancy and sexually transmitted diseases. This work has its roots in Pop art and pays homage to Andy Warhol's famously controversial handmade Brillo boxes of the 1960s.

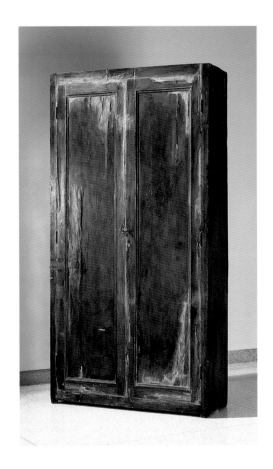

Untitled, 1995
wood, cement, steel
85½ × 45 × 15½ in. (217.2 × 114.3 × 39.4 cm)
Museum purchase, Contemporary Collectors Fund, 1996.6

DORIS SALCEDO
Colombian, born 1958

Doris Salcedo's work embodies a legacy of violence in Bogota, Colombia, where Salcedo lives and works. The incidence of violent death there has risen over the past fifty years to become the primary threat to the social fabric. Since the mid-1980s, Salcedo has been in contact with families of *desaparecidos* (disappeared ones), the thousands tortured or killed in Colombia's unrelenting military aggression and drug warfare.

Salcedo's work gives material form to survivors' stories of pain and suffering. Seeking to come to terms with traumatic narratives, she avoids the spectacle of violence and focuses on subtler references to home, family, and memory. She often utilizes domestic objects—furniture, silverware, and clothing—as surrogates for the people who once used them. In this piece, a wooden wardrobe whose cracks and seams are sealed with cement is transformed into a grave marker or a double coffin. The object now refers to an invaded household and becomes a document of silence, repression, and loss.

GARY SIMMONS

American, born 1964

Gary Simmons uses the familiar surface of a blackboard to convey his dreamlike images. In expansive white on black surfaces he explores subjects ranging from racial stereotypes to romance. Each drawing bears the evidence of the process of its creation: a trail of ghostly handprints traces Simmons' path as he pushes and pulls the images across the slate surface. The drawings call to mind lessons on schoolroom slates, and a range of art world associations from Cy Twombly's blackboard canvases of the mid-1950s to Joseph Beuys' chalked diagrams of the 1970s.

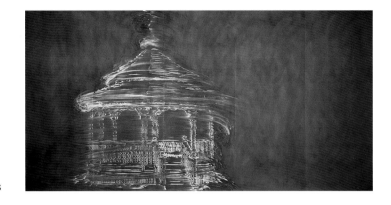

Gazebo, 1997
paint, chalk on panel
overall: 120 × 240 × 2⅛ in. (304.8 × 609.6 × 5.4 cm)
Museum purchase, Contemporary Collectors Fund, 1997.2.1–5

KIKI SMITH

American, born 1954

Kiki Smith illuminates the human condition through representations of the body. Influenced in part by medieval art, which depicted the sufferings of Christ and others in graphic, sometimes gruesome detail, Smith produces raw, often unsettling images that explore many of the paradoxical dualities of human life—inside and outside, strength and weakness, flesh and spirit. Although Smith avoids an overt didacticism, her works are often read as allegories of contemporary plagues such as AIDS and sexual violence. In an age of great medical and technological advancement, Smith produces powerful memento mori.

Untitled (Skin) transforms a medical statistic—the fact that the average human body is covered by 2,000 square inches of skin—into a work of art. Using a beeswax cast taken from a male model, she reassembles the surface of the body as a grid of tiny squares. Part scientific dissection, part sadistic flaying, the work manifests a disturbing mixture of abstract order and realistic organicism. The work seethes with a biological reality suggesting both life and decay.

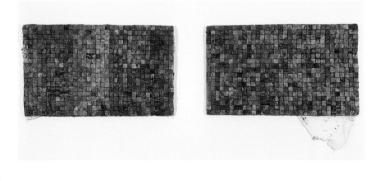

Untitled (Skin), 1990
wax, gauze, shoe polish, pigment
2 panels: 30 × 50 in. (76.2 × 127 cm) each
Gift of the Peter Norton Family Foundation, 1992.9.1–2

VALESKA SOARES
American, born Brazil, 1957

Untitled (from Entanglements), 1996
cast beeswax and oil perfume
2 × 48 × 11 in. (5.1 × 121.9 × 27.9 cm)
Museum purchase with funds from the Elizabeth W. Russell
Foundation, 1998.40

Valeska Soares avoids traditional representations of the human body and focuses instead on a reductive figural vocabulary of legs, feet, and mouths. In this untitled work, Soares distills elements of feminine sexuality into a milky-white wax sculpture combined with scented fragrance, and thereby fuses conceptions of the female body with notions of landscape. This series expresses the artist's longtime fascination with natural materials and their ability to elicit memory and sensory responses. In this piece, an amber perfume emanates from two mouths emerging from either end of a rectangular wax slab. The liquid connects the two orifices, suggesting bodily fluids or a tranquil river. The biomorphic sculpture emphasizes the power of the senses over reason.

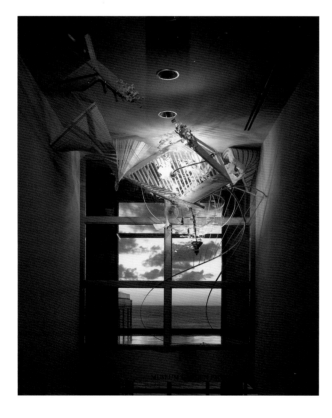

Drawn, 2000
mixed media
dimensions variable
Gift of the Alberta duPont Bonsal Foundation, 2001.20

SARAH SZE
American, born 1969

Sarah Sze transforms the miscellany of everyday life into elaborate site-specific installations. Using nontraditional art materials such as Q-tips, tea bags, pushpins, disposable razors, candy, and plastic flowers, she creates intricate and ephemeral arrangements of hundreds of objects. The ecology of our daily lives forms the basis of Sze's artistic assemblages, which simulate the complex interdependencies of our densely cluttered world.

Responding to her location, Sze emphasizes the local context by using materials purchased in the vicinity of the piece, and the architecture of a site often intervenes. Utilizing the Museum of Contemporary Art's dramatic architectural courtyard, *Drawn* leads the viewer's eye to a spectacular ocean view. A fragmented bed frame serves as the largest element of the work. It was cut, splayed, drawn, and quartered—hence the work's title. But the work also references the act of drawing. The piece is essentially a three-dimensional drawing in space, a quality emphasized by the lines of the strings that project into space and anchor the piece.

BILL VIOLA
American, born 1951

In Bill Viola's work, the electronic image is a means of sculpting time and memory, and of engaging the viewer in a real-time experience. *Heaven and Earth* explores the universal theme of life and death. Composed of two facing monitors, the images of Viola's mother in her final hours are juxtaposed with images of Viola's second son, born just nine months after the death of the artist's mother. Played in slow motion, the image on one screen reflects on the other, gently blending the faces together and completing the cycle.

Heaven and Earth, 1992

two-channel video installation, edition 1 of 2
lower column: 57 × 14½ × 11 in. (144.8 × 36.8 × 27.9 cm); upper column:
14½ × 11 in. (36.8 × 27.9 cm), height varies with ceiling height; space between
monitors fixed at 2⅛ in. (5.4 cm)
Museum purchase, Contemporary Collectors Fund, 1993.1

GILLIAN WEARING
British, born 1963

To make this image, British artist Gillian Wearing stopped two people on the street, gave them markers and paper and asked them write down what was on their minds. She then photographed them as they posed with the resulting personalized "signs." The work is part of a series of over four hundred similar images, which expresses individual opinions, worries, dreams, and occasionally the absurd irrepressibility of the human spirit. Exposing the difference between public appearance and inner feelings, Wearing explores a theme at the heart of much of English politics, art, and humor.

Signs that say what you want them to say and not signs that say what someone else wants you to say, 1992–1993

cibachrome print mounted on aluminum
16½ × 11 in. (41.9 × 27.9 cm)
Gift of Robert Shapiro, 1994.10

This selected chronology of exhibitions organized by the Museum of Contemporary Art San Diego from 1990 to 2000, was compiled by Jenna Siman.

1990

The Medical Illustrations of Frank H. Netter, MD
MCASD—La Jolla: January 13–March 25, 1990

Alfredo Jaar (Dos Ciudades/Two Cities Project)
MCASD—La Jolla: January 13–April 1, 1990

The Girard Avenue Streetscape Study
MCASD—La Jolla: March 22–April 30, 1990

Ann Hamilton: between taxonomy and communion
MCASD—La Jolla: April 6–June 3, 1990

Observatory House: Rene Davids and Christine Killory, Architects
MCASD—La Jolla: May 1–July 29, 1990

Satellite Intelligence: New Art from Boston and San Diego
MCASD—La Jolla: June 9–August 5, 1990

John Knight: Bienvenido (Dos Ciudades/Two Cities Project)
MCASD—La Jolla: October 27, 1990–January 2, 1991

Timken Exchange I
MCASD—La Jolla: October 27, 1990–January 2, 1991

Maurizio Pellegrin
MCASD—La Jolla: October 27, 1990–February 10, 1991

1991

Timken Exchange II: Portraits
MCASD—La Jolla: February 16–May 22, 1991

Celia Alvarez Muñoz: El Limite (Dos Ciudades/Two Cities Project)
MCASD—La Jolla: February 16–June 2, 1991

Allan Wexler
MCASD—La Jolla: February 16–June 2, 1991

Ruby Wilkinson
MCASD—La Jolla: February 16–June 2, 1991

Billboard Project (Dos Ciudades/Two Cities Project)
Daniel Martínez, February 1991
Alexis Smith, April 15–May 15, 1991
Gerardo Navarro, June 5–July 5, 1991

Desert Work: Steven De Pinto and Walter Cotten
MCASD—La Jolla: June 7–August 4, 1991

On the Road: Selections from the Collection
MCASD—La Jolla: June 7–August 4, 1991

Timken Exchange III: Landscapes
MCASD—La Jolla: June 7–August 4, 1991

Works on Paper 1968–71
MCASD—La Jolla: August 17–October 24, 1991

Mowry Baden
MCASD—La Jolla: August 17–November 10, 1991

SDMCA: The First Fifty Years
MCASD—La Jolla: November 16, 1991–January 19, 1992

Jeff Wall (Dos Ciudades/Two Cities Project)
MCASD—La Jolla: November 16, 1991–January 19, 1992

1992

Anish Kapoor
MCASD—La Jolla: February 1–July 5, 1992

Selections from the Koch Collection
MCASD—La Jolla: July 17–August 16, 1992

Noboru Tsubaki
MCASD—La Jolla: July 17–September 26, 1992

Julie Bozzi: American Food
MCASD—La Jolla: July 17–October 25, 1992

Norton Acquisitions
MCASD—La Jolla: August 29–September 26, 1992

Antony Gormley: Field
MCASD—La Jolla: October 4–December 9, 1992

Robert Irwin: Untitled Disc
MCASD—La Jolla: October 4–December 9, 1992

1993

Contemporary Art Downtown
MCASD—Downtown: January 29–February 21, 1993

La Frontera/The Border: Art about the Mexico/United States Border Experience
MCASD—Downtown: March 5–May 22, 1993

Robert Cumming: Cone of Vision
MCASD—Downtown: May 28–August 4, 1993

Francesc Torres: The Dictatorship of Swiftness
MCASD—Downtown: August 14–October 20, 1993

Bill Viola: Heaven and Earth
MCASD—Downtown: August 14–October 20, 1993

Contemporary Mexican Women Painters
MCASD—La Jolla: September 1–November 14, 1993

Tomorrow: Group Material
MCASD—La Jolla: October 8–December 31, 1993

Bull Story: An Installation by Jean Lowe and Kim MacConnel
MCASD—Downtown: October 30, 1993–January 6, 1994

Edward and Nancy Reddin Kienholz: The Hoerengracht
MCASD—Downtown: October 30, 1993–January 20, 1994

Maria Nordman
MCASD—La Jolla: November 17–December 31, 1993

1994

David Mach: Fully Furnished
MCASD—Downtown: January 29–April 7, 1994

Breakdown: 4 Contemporary Artists
MCASD—Downtown: April 15–June 23, 1994

inSITE 94: Carlos Aguirre, Anya Gallacio, Silvia Gruner, Yukinori Yanagi
MCASD—Downtown: September 23–November 27, 1994

Nancy Rubins: Airplane Parts, a Large Growth for San Diego
MCASD—Downtown: September 23, 1994–April 23, 1995

1995

Dan Flavin (Trolley Window)
MCASD—Downtown: March 20–August 6, 1995

Keith Haring
MCASD—Downtown: May 6–November 26, 1995

Sleeper: Katharina Fritsch, Robert Gober, Guillermo Kuitca, Doris Salcedo
MCASD—Downtown: May 20–August 6, 1995

Leonardo Drew
MCASD—Downtown: August 19–October 29, 1995

Common Ground: A Regional Exhibition
MCASD—La Jolla: November 5, 1995–February 10, 1996

James Skalman
MCASD—Downtown: November 5, 1995–February 10, 1996

1996

Russell Forester: Stars and Trites
MCASD—Downtown: March 5, 1996–February 23, 1997

Mauro Staccioli: Tondo (San Diego) and Untitled
MCASD—Downtown and La Jolla: March 10, 1996–December 1998

Inside/Out
MCASD—La Jolla: March 10, 1996–various dates

Joel Shapiro
MCASD—La Jolla: March 10, 1996–March 30, 1997

John Baldessari: National City
MCASD—Downtown: March 10–June 30, 1996

Continuity and Contradiction: A New Look at the Permanent Collection
MCASD—La Jolla: March 10–August 31, 1996

Tony Oursler
MCASD—Downtown: July 7–November 10, 1996

Works by Michael Hurson
MCASD—La Jolla: September 22–November 10, 1996

Dennis Hopper
MCASD—La Jolla: November 17, 1996–February 23, 1997

1997

Gary Simmons: Gazebo
MCASD—La Jolla: February 9–August 31, 1997

Armando Rascón: Postcolonial Califas
MCASD—Downtown: April 6–July 9, 1997

1° 2° 3° 4°: A Site-Determined Installation by Robert Irwin
MCASD—La Jolla: May 18–August 31, 1997

Jay Johnson: Look In Out 1984–1997, Painted Sculptures
MCASD—Downtown: July 13–September 14, 1997

Louise Bourgeois: SPIDER
MCASD—La Jolla: September 12, 1997–January 26, 1998

Geoffrey James: Running Fence
MCASD—Downtown: September 20, 1997–January 4, 1998

Regina Silveira: Gone Wild
MCASD—La Jolla: September 22, 1997–January 19, 1998

Blurring the Boundaries: Installation Art, 1970–1996
MCASD—La Jolla: September 22, 1997–January 26, 1998

John Altoon
MCASD—La Jolla: December 7, 1997–March 11, 1998

Peter Shelton
MCASD—Downtown: December 17, 1997–March 26, 1998

1998

William Kentridge: WEIGHING . . . and WANTING
MCASD—Downtown: January 17–April 26, 1998

Peter Dreher
MCASD—La Jolla: February 24–June 14, 1998

Sarah Charlesworth: A Retrospective
MCASD—La Jolla: March 22–June 14, 1998

Selections from the Collection of Marne and James DeSilva
MCASD—La Jolla: March 22–June 14, 1998

Roman de Salvo: Garden Guardians
MCASD—La Jolla: March 22, 1998–January 31, 1999

Silvia Gruner
MCASD—Downtown: April 5–July 19, 1998

Double Trouble: The Patchett Collection
MCASD—La Jolla: June 28–September 5, 1998

Raúl M. Guerrero: Problemas y secretos maravillosos de las Indias/
Problems and Marvelous Secrets of the Indies
MCASD—Downtown: July 26–October 28, 1998

Kenny Scharf
MCASD—La Jolla: August 29, 1998–August 31, 1999

David Reed Paintings: Motion Pictures
MCASD—La Jolla: September 19, 1998–January 3, 1999

Fabrizio Plessi
MCASD—Downtown: November 7, 1998–January 31, 1999

1999

Francis Bacon: The Papal Portraits of 1953
MCASD—La Jolla: January 16–March 28, 1999

1° 2° 3° 4°: A Site-Determined Installation by Robert Irwin
MCASD—La Jolla: January 17–May 15, 1999

H.C. Westermann: See America First, 1968
MCASD—La Jolla: February 1–April 25, 1999

Marcos Ramírez (ERRE): Amor Como Primer Idioma (Love as
First Language)
MCASD—Downtown: February 12–July 18, 1999

Sacred Mirrors: The Visionary Art of Alex Grey
MCASD—La Jolla: April 11–June 2, 1999

USNAVY: Vanessa Beecroft
MCASD—La Jolla: June 5, 1999

Valeska Soares: Vanishing Point
MCASD—Downtown: July 25–October 17, 1999

Bertrand Lavier: Walt Disney Productions
MCASD—Downtown: October 24, 1999–February 2, 2000

Ojos Diversos/With Different Eyes: Pan-American Holdings from
the Permanent Collection
MCASD—Downtown: December 1, 1999–November 26,
2000

2000

Small World: Dioramas in Contemporary Art
MCASD—La Jolla: January 23–April 30, 2000

Off Broadway: New Art from Downtown San Diego
MCASD—Downtown: February 12–May 31, 2000

Frida Kahlo, Diego Rivera and Twentieth-Century Mexican Art:
The Jacques and Natasha Gelman Collection
MCASD—La Jolla: May 14–September 4, 2000

Jean Lowe: The Evolutionary Cul-de-Sac
MCASD—Downtown: June 11–August 31, 2000

Nuno Ramos: blackandblue
MCASD—Downtown: September 1–December 3, 2000

Jonathon Borofsky: Hammering Man
MCASD—Downtown: September 2000–ongoing

Zandra Rhodes Designs the Magic Flute
MCASD—La Jolla: September 24, 2000–January 7, 2001

Ultrabaroque: Aspects of Post-Latin American Art
MCASD—La Jolla: September 24, 2000–January 7, 2001

Loren Madsen: Crime and Punishment
MCASD—Downtown: October 14–December 3, 2000

ADMINISTRATION
Hugh M. Davies, The David C. Copley Director
Charles E. Castle, Deputy Director
Trulette Clayes, CPA, Controller
Kathlene J. Gusel, Administrative Assistant
Andrea Hales, Cultural Coordinator *
Michelle Johnson, Staff Accountant
Sonia Manoukian, Executive Assistant
Robin Ross, Accounting/Personnel Clerk
Michelle White, Administrative/Special Projects Assistant

CURATORIAL
Toby Kamps, Curator
Tamara Bloomberg, Research Assistant *
Gabrielle Bridgeford, Education Coordinator
Dustin Gilmore, Preparator
Gwendolyn Gómez, Community Relations Officer *
Stephanie Hanor, Assistant Curator
Mary Johnson, Registrar
Meghan McQuaide, Registrarial Assistant
Ame Parsley, Chief Preparator
Marina Saucedo, Curatorial Office Assistant
Kim Schwenk, Curatorial Assistant
Tracy Steel, Curatorial Coordinator
Rachel Teagle, Assistant Curator

DEVELOPMENT
Anne Farrell, Director of Development and Special Projects
Jane Rice, 21st Century Campaign/Major Gifts Director
Kraig Cavanaugh, Data Entry Clerk *
Pamela Erskine-Loftus, Development/Travel Programs Coordinator
Mary Hunter, Membership Coordinator
Veronica Lombrozo, Grants Officer
Gina Mary, Database Coordinator
Synthia Malina, Annual Giving Manager
Jennifer Reed, Corporate Giving Officer

EVENTS, VISITOR SERVICES, MARKETING/PUBLIC RELATIONS
Jini Bernstein, Events and Visitor Services Manager
Laurie Chambliss, Public Relations/Marketing Assistant
Jaclyn McDonnell, Events Assistant
Jennifer Morrissey, Public Relations Officer
Edie Nehls, Special Events Coordinator
Jana Purdy, Marketing Manager *
Mike Scheer, Production Manager
Event Managers *

RETAIL SERVICES
Jon Weatherman, Manager of Retail Services
Delphine Fitzgerald, Assistant Bookstore Manager
Carlos Guillen, Assistant Bookstore Manager
Bookstore Clerks *

FACILITIES AND SECURITY
Drei Kiel, Museum Manager
Mariela Alvarez, Downtown Receptionist
Carlos Enciso, Museum Attendant
Shawn Fitzgerald, Downtown Site Manager
Tauno Hannula, Facilities Assistant
David Lowry, Chief of Security
Ken Maloney, Museum Attendant
Javier Martínez, Assistant Chief of Security
Andrea Norman, La Jolla Receptionist
James Patocka, Facilities Assistant
Demitero Rubalcabo, Museum Attendant
Jesse Tarin, Maintenance Engineer *
Museum Attendants *

* part-time

Page numbers in boldface type indicate illustrations.